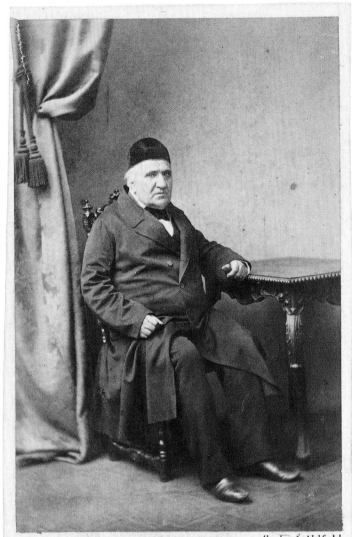

Focke & Ahlfeld.

BIBLIOTHECA ROSENTHALIANA

TREASURES OF JEWISH BOOKLORE

MARKING THE 200TH
ANNIVERSARY OF THE BIRTH
OF LEESER ROSENTHAL,
1794 – 1994

EDITED BY ADRI K. OFFENBERG,
EMILE G.L. SCHRIJVER AND F.J. HOOGEWOUD,
WITH THE COLLABORATION OF
LIES KRUIJER-POESIAT;
COLOUR PHOTOGRAPHS BY
IMAN HEYSTEK

AMSTERDAM UNIVERSITY PRESS

This publication was made possible thanks to
the generous support of:
Prof.mr. Herman de la Fontaine Verwey Stichting
Prins Bernhard Fonds
Vereniging van Vrienden van de Universiteitsbibliotheek van Amsterdam
J.C. Ruigrokstichting
Stichting Dr. Hendrik Muller's Vaderlandsch Fonds
Stichting Bibliotheca Rosenthaliana
Stichting Pro Musis
Mr. Paul de Gruyter Stichting
and others

Translations: Sammy Herman, Tibbon Translations, Amsterdam
Index of names: Janny A. Offenberg-Veldhuis, Amsterdam
Editorial assistance: Linda Bloch, University of Amsterdam
Design: Harry N. Sierman, Amsterdam
Typesetting: Cédilles, Amsterdam, in Monotype Centaur
Lithography: Color Scan, Loosdrecht
Printing: Drukkerij Mennen, Asten
Binding: Boekbinderij Jansenbinders, Leiden

Fronstispiece: Photograph of Leeser Rosenthal (Nasielsk 1794 – Hanover 1868)

ISBN 90 5356 088 2

© AMSTERDAM UNIVERSITY PRESS, 1994
Second edition, 1996

Contents

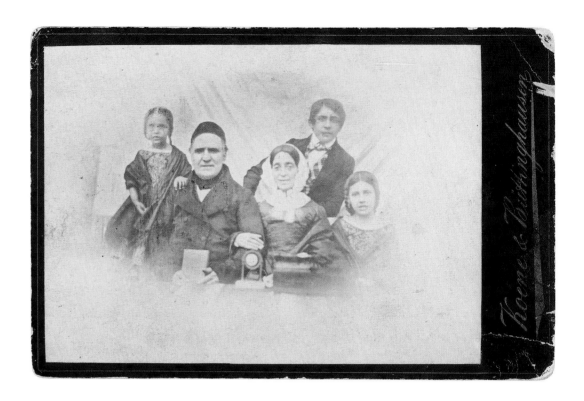

THE ROSENTHAL FAMILY [Hanover, Leeser's fiftieth birthday on 13 April 1844?]. From left to right: Mathilde – born 21 July 1838, Leeser, Sophie (*née* Blumenthal), George – born 8 April 1828 and Nanny – born 10 May 1835. Copy by Koene and Büttinghausen at Amsterdam from the original photograph. [ROS. E 6-10]

From Leeser Rosenthal to today's Bibliotheca Rosenthaliana

LEESER (ELIESER) ROSENTHAL, founder of the Bibliotheca Rosenthaliana, was born in Nasielsk near Warsaw on 13 Nisan 5554/13 April 1794 to a family of teachers and rabbis. After a period in Berlin and Paderborn he spent the greater part of his life as a financially independent *Klausrabbiner* at the Michael David'sche Stiftung in Hanover, where he married Sophie (Zippora) Blumenthal. They had three children, George, Nanny and Mathilde. Rosenthal developed an enthusiasm for collecting Jewish books. By the time of his death he owned a library of more than 5,200 volumes, including thirty-two manuscripts, twelve Hebrew incunabula and a selection of rare and important Hebraica and Judaica in the field of religion, literature and history. After the sale to Britain of the famous libraries of David Oppenheim (which had been stored in the same room in the Bergstrasse at Hanover where Leeser Rosenthal later kept his books) and Heimann Joseph Michael from Hamburg in 1829 and 1848, respectively, Rosenthal's collection was considered the largest private library in this field in Germany.

Following Rosenthal's death on 19 Av 5628/7 August 1868 his son George (1828-1909), a banker in Amsterdam, commissioned the Dutch-Jewish bibliographer Meijer Marcus Roest (1821-1889) to compile a catalogue of the entire collection, then housed at Rosenthal's large home on Amsterdam's Herengracht. This catalogue, the *Catalog der Hebraica und Judaica aus der L. Rosenthal'schen Bibliothek* appeared in two volumes in 1875 in Amsterdam. Rosenthal's own catalogue, *Yodea Sefer*, was added as an appendix. Leeser Rosenthal's heirs wished the library to continue undivided and to fulfil a suitable purpose in memory of their learned father. The German chancellor Bismarck was invited to house the collection in the Kaiserliche und Königliche Bibliothek at Berlin. He declined the offer.

Negotiations with libraries in Europe and America came to nothing. When, in 1880, the library of the city and university of Amsterdam moved to the former 'Handboogdoelen' (Archery Ranges) on Singel canal, where space was available for the Rosenthal collection, Rosenthal's heirs made the surprising gesture of presenting the library to the city of Amsterdam. It was accepted with 'warmest thanks for a princely gift' and the following year Meijer Roest, who knew the collection intimately, was appointed curator.

Since becoming part of Amsterdam's University Library the Bibliotheca Rosenthaliana has continually been extended by as homogeneously as possible in an attempt to maintain a modern, functional library covering all fields of Jewish study.

Jeremias M. Hillesum (1863-1943) succeeded M. Roest after his death and proved an able curator with a keen eye for opportunities of adding to the library. In the middle of the First World War the library fund established by the Rosenthal heirs for the acquisition of new books folded. Most of its assets had been shares in Hungarian railways. It was left to the Amsterdam Municipality to take over the fund's task.

By 1940 the first five volumes of the subject catalogue of the Bibliotheca Rosenthaliana Judaica collection had been completed by Jeremias M. Hillesum's successor, Louis Hirschel (1895-1944). But then with the occupation of The Netherlands, disaster engulfed the country and the library. The Germans closed the Bibliotheca Rosenthaliana in the summer of 1941 and transported part of the collection to Germany, where it was earmarked for Rosenberg's 'Institut zur Erforschung der Judenfrage'.

Happily, these plans were thwarted with the German capitulation. Most of the boxes of books were in storage in Hungen, near Frankfurt am Main, where they were found and shipped back to Amsterdam. But the curator and his assistant together with their families had also been deported—for them there was no return.

In the autumn of 1946 the Bibliotheca Rosenthaliana reopened its doors. Isaac L. Seeligmann acted as curator until 1949 and was succeeded by Leo Fuks until 1974. New activities were developed, publication of the Judaica subject catalogue continued and the *Publications of the Bibliotheca Rosenthaliana* series began. The first issue of *Studia Rosenthaliana*, a six-monthly journal of Jewish scholarship in The Netherlands, appeared in 1967. Separate catalogues of manuscripts, incunabula and other specialized collections were published, and various exhibitions were organised.

Today the collection of printed works consists of more than 100,000 volumes (from the fifteenth century onwards), including some 1,500 periodical titles and about 500 broadsides. The manuscript collection consists of around 1000 items from the thirteenth to the twentieth centuries. In addition, there are an iconographical collection of some 2,000 engravings, drawings and photographs and an archival collection covering twenty meters of shelves.

In spring 1993 it was suggested that the 200th anniversary of Leeser Rosenthal's birth in 1794 be marked by reproducing some of the treasures of the collection in an attractive form. Some fifty specialists from Holland and abroad were invited to contribute short articles to the proposed illustrated volume.

The response was gratifying. An effort has been made to encompass as wide a variety of subjects as possible and these are presented in chronological order. Medieval manuscripts and early typography and printed books, including blue-paper editions, historical documents, an early Hebrew map, seventeenth-century etchings and copper engravings, original Spinoza editions and eighteenth-century calligraphy, Yiddish chronicles and fine bookbindings in silver and morocco, liturgical music, highlights of nineteenth- and twentieth-century Jewish literature, a celebrated auction catalogue, modern limited editions and prints are all featured.

Many other items from the library's splendid collection could equally well have been included too. For example: 1994 marks the centenary of the Dreyfus Affair, which shook the Jewish world to its foundations and on which there is an interesting collection in the library; 1994 is also the 200th anniversary of the birth of Leopold Zunz, founder of *Wissenschaft des Judentums*, whose publications were admired and collected by his contemporary Leeser Rosenthal. There is a splendid collection of illustrated editions of Flavius Josephus, as well as a superb selection of rabbinic *Responsa* literature, an almost complete series of eighteenth- and nineteenth-century Dutch-Jewish almanacs and several fine illuminated marriage contracts. The library also has an impressive collection of Russian-Jewish early twentieth-century graphic art. The collection of Dutch-Jewish *Mediene* material is unique. But this publication is intended primarily to show a cross-section of the wealth of material at the Bibliotheca Rosenthaliana, and so we have had to make choices.

Through the enthusiastic cooperation of the numerous contributors, this volume will be certain to help stimulate interest in the wisdom and dignity, sobriety and splendour of Jewish culture as it is embodied at the Bibliotheca Rosenthaliana.

ADRI K. OFFENBERG Curator

EDITORIAL NOTE
Notes provided by the authors and suggestions for
further reading can be found on pages 123-129.

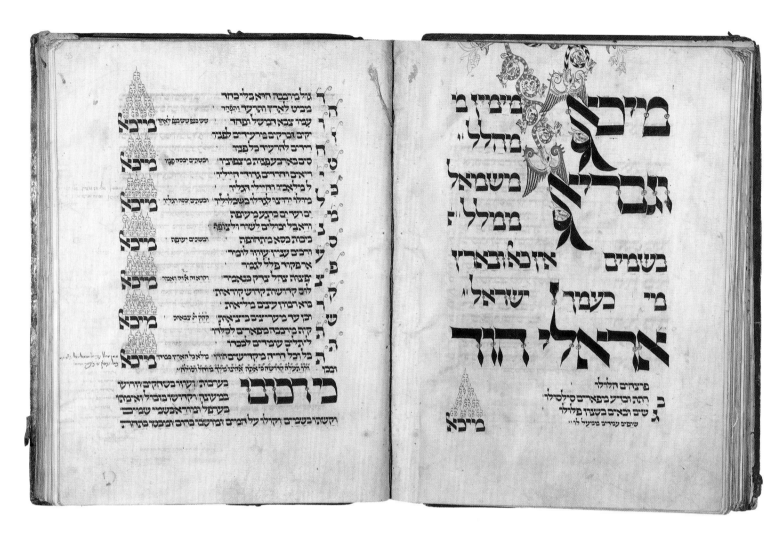

מיכא
מיכא
מיכא
מיכא
מיכא
מיכא
מיכא

מיכא

1 The completion of the *Esslingen Machzor*

(*above*) Folios 42 v – 43 r, 230 x 355 mm [HS.ROS. 609]

(*below*) Folios 54 v and 148 v of the second part of the Double Machzor,

Biblioteka Uniwersytecka we Wrocławiv [MS.OR. 1, 1]

ONE OF THE MOST FAMOUS manuscripts of the Bibliotheca Rosenthaliana is the machzor for Yom Kippur and Sukkot, completed by the scribe Kalonymos ben Judah in Esslingen, on 28 Tevet 5050 (12 January 1290). The manuscript belongs to the type of prayer-books created in Ashkenaz around the mid-thirteenth century and produced in various Ashkenazi centres over a period of around a hundred years. These codices are all of very large size, which suggests that they were produced for the use of the community, an assumption confirmed by the inscriptions found in some of the volumes, the luxurious execution, the profuse decoration and a complete iconographical program which appears in most of the codices, with identical elements but in a different style each time.

It remains unclear how this iconographical program was transmitted since in most cases the liturgical books have no colophon, and where they do, there is usually no mention of their exact place of production. The only volume that provides this sort of information is the Bibliotheca Rosenthaliana's Machzor, as was noted by Malachi Beit-Arié in 1976. In other manuscripts, the place of origin has to be inferred from specific regional features in the liturgy or from the stylistic criteria of the decoration and illustrations. Stylistic comparison with local, non-Jewish art products made it possible to date and determine the place of origin of the Great Amsterdam Machzor, produced around the middle of the thirteenth century in Cologne. The decoration of the Esslingen Machzor, and of its recently identified first part, now at the Jewish Theological Seminary (MS.MIC. 9344), can be used to localize another famous manuscript, the so-called Double Machzor, the two parts of which are kept respectively in the Sächsische Landesbibliothek of Dresden (MS.A 46a) and the University Library of Wrocław (MS.OR. 1, 1).

Although somewhat larger in size than the Esslingen Machzor, the Double Machzor contains several features which are common to both codices. Among these are the style of the script and, especially, that of the ornamental letters. The large display letters decorated with red and black rosettes at the junction of the strokes (Wroclaw, OR. 1, 1, fol. 1 v, 148 v; HS.ROS. 609, fol. 1 v), the upper stroke of the lamed protruding in a zoomorphic head (Wroclaw, OR. 1, 1, fol. 183 r; JTS, fol. 92 r); the red ink flourishes decorating the repeated initial letters of a *piyyut* (Wroclaw, fol. 54 v; HS.ROS. 609, fol. 1 v) seem to be done by the same hand in both manuscripts. The Double Machzor also includes full-page paintings, which do not appear in the Esslingen Machzor. However, these were executed by professional painters and not by the scribe, and by a different hand in each of the two parts of the Double Machzor. The style of these paintings should not therefore be a consideration when comparing the two machzorim. It is through the scribe's handwriting and his ornamental letters that a link can be established between the two manuscripts. The similarities in these aspects of the work are striking. Esslingen is therefore probably also the place where the Double Machzor was produced.

In addition, the Double Machzor provides an indirect clue regarding the date of production of the manuscript: twice the copyist mentions the name of his teacher, Rabbi Meir of Rothenburg (Dresden, fol. 285 r; Wroclaw, fol. 130 v), followed once by the benediction for the deceased (Dresden, fol. 285). Since the death of R. Meir in 1293 is the *terminus a quo* for the completion of the Double Machzor, it must therefore have been produced after the volume Kalonymos ben Judah copied in Esslingen. Whether the two codices were copied by the same scribe remains to be seen, but the possibility cannot certainly be excluded.

GABRIELLE SED-RAJNA

2 *Sefer Or Zarua* and the legend of Rabbi Amnon

Opening page of the manuscript, volume 1, folio 1v, 445 x 325 mm [HS. ROS. 3]

A UNIQUELY IMPORTANT Hebrew manuscript at the Bibliotheca Rosenthaliana is a late thirteenth-century copy of the famous halakhic work *Sefer Or Zarua* by Rabbi Isaac ben Moses of Vienna (c. 1180 – c. 1250). It was from this manuscript, one of only two surviving medieval copies, that the first edition of the work was published in Zhytomir in 1862. The *Or Zarua* preserves one of the earliest, if not the very earliest version of the story of Rabbi Amnon. At the end of the laws concerning Rosh Ha-shanah, Rabbi Isaac of Vienna recorded in the name of Rabbi Ephraim of Bonn (1133 – after 1197) that a great and pious scholar in Mainz, Rabbi Amnon, had been the target of a conversion attempt by the local ruler. Under the continued enticement of the ruler, Rabbi Amnon once faltered in his steadfastness. He deeply regretted this momentary hesitation and henceforth refused to appear before the ruler, whereupon the latter ordered his mutilation. With his last ounce of strength Rabbi Amnon asked to be carried to the synagogue on Rosh Ha-shanah. When the cantor reached the Kedushah prayer, Rabbi Amnon interrupted him and recited the hymn *u-netanneh tokef*. He passed away immediately afterwards; three days later he appeared in a dream to Rabbi Kalonymos ben Rabbi Meshullam and taught him the hymn that has since become a regular component of the Rosh Ha-shanah liturgy for Ashkenazi and Italian Jewry.

Much has been written about this story, about whether or not Rabbi Amnon was a historical figure; about the liturgical-literary problem concerning the hymn, the text of which antedates the time in which Rabbi Amnon was supposed to have lived; and about the historical setting that gave birth to the story, all of which have been subject to scholarly inquiry.

The attribution of the story to Rabbi Ephraim of Bonn is of special relevance. Rabbi Ephraim was the author of a chronicle, *Sefer Zekhirah*, on the Crusades and other anti-Jewish persecutions; of liturgical poems, some of which commemorate the martyrdom of Jewish victims; and of a commentary on liturgical hymns. In a recent article Ivan Marcus has argued convincingly that the Amnon story reflects the social and cultural reality of Ashkenazi Jewry in the late twelfth century, the time of Rabbi Ephraim.[1] The connection between the contents of *u-netanneh tokef* and martyrology, however, is unclear. In *u-netanneh tokef* there are no references to events or circumstances in the story itself, and it is devoid of any allusions to martyrology. Also deserving scrutiny is the problem of tracing the route or transmission of the Rabbi Amnon story through the ages.

On the basis of a very limited and preliminary search, it seems that unlike the standard printed machzorim, medieval manuscripts did not routinely place the Rabbi Amnon story alongside *u-netanneh tokef*. A. N. Z. Roth in his study mentions only one manuscript, a machzor (Jewish National and University Library, 8° 3037, beginning of the fourteenth century) in which the commentary to *u-netanneh tokef* includes the story, although in a version different from the one in the *Or Zarua*.[2] Roth refers to a Hamburg manuscript, dated 1317, where *u-netanneh tokef* is identified as the *silluk* (a type of *piyyut*) of Rabbi Amnon, but without the story itself. In printed editions the story first appears in the Bologna 1540 Roman Machzor and in the Venice 1600 Ashkenazi Machzor.

The occurrence in an edition of *Selichot* published in Prague in 1587 of a somewhat different version of the Rabbi Amnon story from the one commonly circulating presents a surprising twist. In this source the story appears before the selichah *ta shema*, written by the previously mentioned Ephraim of Bonn. We are told that before he died as a result of the mutilation he had suffered, Rabbi Amnon composed two poems, *ta shema* and *u-netanneh tokef*. The chronicles *Shalshelet Ha-kabbalah* by Gedaliah ibn Yahya (1515 – 1578) and *Tzemach David* by the Prague rabbi and scholar David Ganz (1541 – 1613) also mention *ta shema* along with *u-netanneh tokef* as having been authored by Rabbi Amnon. In fact, on the basis of the content of *ta shema* it may make more sense to attach the Rabbi Amnon story to it than to connect it to *u-netanneh tokef*.[3]

Whether we find the story connected with *ta shema* or *u-netanneh tokef* or both, many literary and liturgical questions and problems remain. A search for versions of the Rabbi Amnon story in other manuscripts of the *Or Zarua*, in collections of stories, in liturgical commentaries and in machzor manuscripts as well as printed editions, may one day yield some solutions to the puzzles posed by this widely known martyrological story. For now, the Amsterdam manuscript of *Sefer Or Zarua* continues to serve as the starting point of all inquiry into the history of the story of Rabbi Amnon of Mainz.

MENAHEM SCHMELZER

אבגד הוזחטי כר למב נן סעפ ה צזקר שת׃ אלה בית גיבל דלב ה א ו ד דין חת טו׃
יוד בת למד ר מם נון סמך עין פה צרי קות ריש שין תיו׃ ס אהתיות בנגד ס מיסבבתית׃
אט בשגר דיק הז הת ועה הס טויסמל׃ איך כבר גלש רמת הגר רסבו עש חפה ט צצן׃
אטם ח אצדר י יצבה לעמיס קצרה שץ תם הגר׃ אחס בטעגנת רכז הלק ו מד זן שת׃ אל
כב גן רכ העות זך חקטר יש בת׃ אבג מגר גרה ריהר הוז וזה זחט הטי סיך וכל מלם׃
למב נמס נסע סעפ ה עפה פצץ צקר קרשר רשת שתא ת אב׃ אה ר הזו ל צזיק ר גלישתרי
לב שביזה׃

ישעיה

זרע קרזותי כטס זה החזבר זהב
הנזכר יצחק כי מטה נכה מפני ה
קבה יתירה שניעותו בזה הרזקרץ
זור זרע על עזיק ולוצטרי לב טנחה
סופז תבטת ר מקיבה ונכתב כפירות
ולז כימוז ולוס כמדלוי היעז רבי
כי שץ ביזתכש ב ועמפזי הקיבה
גדולה טהטזיר הקבה זת עז עזיר מז
שניעותו זת טמו נכתב בזה הנב
הניקרץ זור זה וע לעזרזי מייכזן
שיטטכטב ר עזיקה בהזן ולז ק
כיזו וזטרזר ר עזיכו סטנתכר
דוד המוך מצזיה כספלז ו וטריך
טהריזיה הקבה תורתך לעטה רבע

בההיץ דהקזויץ רבה ר זעריב יח
יהודה זנ רב כטטעה טעזה משה
לורוס מיעוז הקבה טזוסב וזוטר
כפריס זיוזתזיזת זונ זפעו רבוט טון
שוס גר נעזכב על זידך זול זודכם
זהד שעטזר להיות כטמן כמה רהוות
ועזיכזן זך יוסף שמן וטשעזי לדרוס
ל זץ וזוץ הלז תזיס טו הלזות׃
וכן זוטבכן מיכזן טהזה רוהזס זוהזזת
כדטעזיז ביזוטפז כיתף ר עזיכה יור
עזיבזו זולז כיזתגמלז זולז מלזד סיזל
סיזטורה תורה זנזת למד פיך כדי סט
סוטבכה להיזי העוסם הזה פיך לעזד
זעת כדי טזוטכה להיי העוסם הבצ ה

מקפני זה מפני סתוקבה סהקבה זקרין זערת
טעו ין זודניס זנות כסזו מיו זוסב
שץ כזעות סונ זהוק בהסד כסז ופ
ומפעו ידעעו חסד וזעות טע הסד רזע
ויזעת זכתגו פעז זכל דכר יז דבר י
זעת סע ריזס רביך זעות זכל דמיץ
וטטפטי זעות טע מסטפזו יץ זענרד
וכל דרכזו זעות טע כל זוזרהות זלז ך
הסד וזעות רץ זזל זזפטס לסזן קה
זה הסבה זמטף פה סו כל בטר זדס
סרי סיזה מזלזזין לפעז כל זובם
זעוכזן זוטר כזרבע רהזות העוס
טיזועלז סיזה וזעזרה טזמנריס למץ
כל היזם זוזי מזיזזי זת עוסזי זוזיץ

3 Hannah bat Menahem Zion finished her copy

of the *Sefer Mitzwot Katan*

Folios 121 v – 122 r, 195 x 290 mm [HS. ROS. 558]

THIS MANUSCRIPT IS a lovely copy of the
SeMaK, the *Sefer Mitzwot Katan* ('Small Book
of Precepts'). Composed before 1280 by Isaac
ben Joseph of Corbeil, it is an abridged ver-
sion of the *Great Book of Precepts* by Moses of Coucy. The
negative and positive precepts are divided into seven pil-
lars, the seven days of the week. Isaac of Corbeil intended
his book to be in every Jewish home and it was in many: we
have about 110 manuscripts written during the thirteenth
and fourteenth centuries and about 60 during the fifteenth
and sixteenth centuries. It was well received by scholars in
northern France as well as in the Rhineland and became an
accepted authority. In time glosses and annotations were
added. It is with Meir of Rothenburg and Rav Peretz's
glosses that the *SeMaK* was copied by Hannah, daughter
of Menahem Zion.

Hebrew medieval manuscripts were rarely written by
women. We know of fewer than ten, while more than four
thousand names of male scribes are known. This number,
however, can be misleading: the scribes of most manu-
scripts (about forty-five thousand) remain anonymous,
and it is impossible to differentiate between a man and a
woman's hand. It may be that other manuscripts are also
by female hands, although there cannot be many. While
many girls were taught to read, it was not compulsory.
Writing was exceptional; women who actually wrote occur
only in families of scholars and scribes. There is no way of
knowing whether Hannah was from a scholarly family,
but her writing is so fluent and professional that it is very
probable.

Hannah's copy begins on fol. 7 v and ends on fol. 272 r.
The text is written in semi-cursive characters but Hannah
signed her work on fol. 272 r in smaller letters: 'I, Hannah
daughter of Menahem Zion, completed this book on the
eleventh day of the month of Tammuz, in the 146th year
of the sixth millennium [10 June 1386]. May God lead his
people to liberty. Deliver them from distress and sorrow
and make haste to help them. Amen. Soon.' From the di-
vorce formula (fol. 122 r) she appears to have come from
Cologne: 'in the town of Cologne, 24 Tammuz 5145'; the
date (4 July 1385) is just one year earlier than the one given
in the colophon. Perhaps she gave the place and date of the
particular day she was writing this passage so that it took
her almost one year to write from fol. 122 to fol. 272.

The book is written mostly on quires of four sheets of
parchment. It is a small, handy, pocket size, volume with a
height of 194 to 198 mm and a width of 145 to 150 mm,
while the text measures only 122 to 132 mm by 90 mm.
Each page has about 20 to 23 written lines. As in most
Ashkenazi manuscripts, the text is enclosed by ruled lines
extended at the top and bottom to give the page a more
geometrical aspect. To enhance the aesthetic effect, the end
of the text does not continue on the line, and whenever it
was impossible to finish a word in any other way, the end
of the word is found far into the margin.

The first words are written in square letters, sometimes
in red ink or alternate red and brown. Sometimes, pen dec-
orations enhance these first words or the ends of para-
graphs. These first words and decorations were penned
after the text had been written, for they lack form, while
between fol. 175 r and the end someone else has written
them very sloppily. This might have been the person who
copied a table of the precepts at the beginning of the book
(fols. 1 r – 6 v) and a commentary on the margins signing
on fol. 271 v: 'this explanation I finished on 3 Adar 1, 5217
[28 January 1457]'.

However, Hannah has left proof that it was she who did
all the delightful pen decorations found at the beginning
of the book and more frequently after fol. 103 r: she decor-
ated her own name with red ink on fol. 13 r. These decora-
tions reveal some of Hannah's favourite subjects: the be-
ginning of the precept of modesty is more ornate, so is the
illustration of the verification that no leavened bread is
left in the house before Passover. But the most lavish dec-
oration is found in the beginning of the precept about the
ritual bath. For Hannah purity was the most important
precept for women.

COLETTE SIRAT

4 Mordecai Finzi's copy of a work by Averroes

Folios 50v – 51r, 227 x 312 mm [HS.ROS. 72]

THIS MANUSCRIPT IS a handwritten copy of two treatises of Averroes' *Middle Commentary* on Aristotle's scientific works, *On Generation and Corruption* and *Meteorology*, translated from Arabic into Hebrew by Kalonymos ben Kalonymos at the end of 1316 in Arles (Provence). The copy, written in an elegant current semi-cursive Italian script, was produced, according to the scribe's inscription in a minute script at the end of the first treatise, by Mordecai Finzi in Mantua. The completion date of the first work's copying is rendered as: 18 September of the year [5]207 [of the creation]. However, the Jewish year 5207 ran from 22 September 1446 to 10 September 1447. Probably the copyist erred in the date, mixing the Christian day of the month and the Jewish year (an error in the Christian day seems more likely than one in the Jewish year), completing his work either in September 1446 or September 1447.

Mordecai ben Abraham Finzi did not mention for whom the copy was made, but there is little doubt that it was for his own use. A scion of an Italian banking family, he was a renowned physician, scholar, author and translator of scientific works in astronomy, mathematics and astrology.[1] It is tempting to ascribe to him the anonymous *Tables for the Length of Daylight*, printed by Abraham Conat in Mantua in the mid-1470s, as Moritz Steinschneider did, of which the Bibliotheca Rosenthaliana owns one of only two known copies.

The Rosenthaliana manuscript is not the only copy in Finzi's own handwriting which has survived to the present or at least until recently. There are another seven manuscripts which were written by him between 1441 and 1473 in northern Italy, particularly in Mantua. Three of the manuscripts are neat copies of his own translations, one contains mainly his own writings, and three are copies of scientific and medical works he copied for his own use, as did many other Jewish scholars.

In 1441 in Mantua, Finzi produced MS. Oxford, Bodleian Library, Lyell 96 (not included in Adolf Neubauer's Catalogue). The manuscript contains Finzi's translation and redaction of the Oxford Tables (astronomical tables drawn up for Oxford by John Batecombe in 1348). Finzi indicates in his colophon that the translation was carried out 'with the assistance of a non-Jew'.

Another autograph manuscript is found in Oxford's Bodleian Library, MS.MICH. 350, fols. 1 – 64, 83 – 96, which contains a compilation of some ten short writings, mainly in astronomy, but also in mathematics and astrology, composed and copied by Finzi on parchment quires in the course of several years. One of the works (fols. 54r – 61v) was completed on 21 June 1446 in Mantua. On fol. 22v the year 1463/1464 is mentioned, and a marginal note on fol. 49r refers to the year 1469/1470.

In Mantua on the eve of 13 December 1446, Finzi completed the copying of three philosophical works (MS. Cambridge, Trinity College, F. 12. 35). The copy was produced for his own use, as he explicitly states in the colophon. MS. Berlin, Staatsbibliothek, OR. 4° 648 (Steinschneider Catalogue no. 119), fols. 120v, line 11 – fol. 148r, is another surviving example of Finzi's scribal activity and again an owner-produced book. Finzi completed the copying of another philosophical work (by Ibn Tufayl), the beginning of which was copied by a different scribe in a Sephardi script. He finished his copying in Viadana (Mantua province) on 24 January 1460.

According to A.Z. Schwarz the manuscript HS.IV, kept at the library of the Jewish community in Vienna until the Second World War, contained a compilation of medical treatises copied by Finzi on 28 January 1446 in Legnago (Verona province), indicating Finzi's presence in another region of northern Italy in 1446.[2]

The last extant dated manuscript copied by Finzi was written in Mantua again. MS. Jerusalem, Jewish National and University Library, Heb. 8° 3915 is a neat copy of Finzi's own translation of *Algebra* attributed to Dardi of Pisa. Finzi started the translation in Mantua on 24 November 1473, and the neat copy was made some time later.

An additional autograph manuscript undoubtedly written by Finzi is an undated copy of his own translation of the *Algebra* of Abu Kanil in MS. Mantua, Jewish community, 17.

Notes written in the margins of several scientific and philosophical manuscripts are signed by Mordecai Finzi or bear his acronym. These attest, together with the manuscripts copied by him, to the scribal activity and intensive use of books of a Jewish scientist and author in fifteenth-century Italy.

MALACHI BEIT-ARIÉ

¶De cristo summopere diligendo. eodemqz toto cozde totisqz
viribus imitãdo colendo atqz adorando. Dyalogus prim9.
BELIAL.

Dditrices iam iam michi pozrige aures o
nobilis o decora et suauissima dei factura
humana caro. qñquidem dicturus ea sum
tibi ac pzobaturus que tuũ honozẽ et tuã
vtilitatẽ pmaximã cõcernũt. Quare michi
adesto tota quantũ mente vales. quantum
calles astutia. tibi vt iam dixi et mira et vera et que i rem sint
tuam magna locuturo. Collocata in te est atqz infusa speciosa
quedam ac spiritalis creatura quã animã vocant. et quã sine
modo cristus et sine fine amat. in tuũ si quicqz luminis habes
multiplex atqz ingens malum. Omnibus namqz in rebus ea
tibi resistit aduersaꝛ officit. et tue volũtati sua semp et vbiqz
volũtas cõtraria est. Vult enĩ te ieiunare: vt ipsa impugñetur
labozare: vt ipsa quiescat. tua dari pauperibus: vt ipsa diteꝛ.
Nemo ẽ sensatũ habens animũ hec omnia qui damnosa tibi eẽ
clarius ipsa lampade phebea non intelligat. Nec me talia flã
mato pzomere liuozis aculeo putes o generosa caro. qñdoquidẽ
si lapis aut bestia non es: ea ipsa que dico tũ recta equitate. tũ
summa racione plena fateberis. Caro namqz dũ ieiunat: nimis
maceraꝛ. dũ labozat: nimis atteriꝛ. dũ vigilat: nimis tozqꝛ. sua
si det pauperibus: paup et ipsa tota efficitur. si se flagris affici
at: tabescit vti ꝛ. et vibicibus maculisqz tota denigratur. Que
so ergo te atꝛ hoztoz. per si qua tibi est tue salutis cura. si tibi
vite dulcedo. si rerũ copia. si malozum inopia cara est: parcens
tibi. et michi parens esto o generosa caro. tibi hac pzo tua pa
rentia dapes atqz opes. tremendos fasces. delicias persuaues.
amena loca. decora atqz ãpla palacia cũ vniuersa mũdi pompa
et gloria daturo. Hoc vnum tibi verum dicere. atqz audacter

5 The *Defensorium Fidei contra Judæos* printed at Utrecht

Folio 3 r, 277 x 210 mm [ROS.NED.INC. 210]

THIS INCUNABLE IS not a rare one. In the *Incunable Short Title Catalogue* (ISTC), the British Library's database, 39 copies of the *Defensorium Fidei contra Judæos* are recorded. Of the ten examples in the Netherlands there are as many as four in Utrecht University Library. This is hardly surprising, since it was a Utrecht publication and the University Library there now boasts a major collection of books acquired from the former Utrecht Cloister and Chapter libraries.

The copy in the Royal Library in The Hague, bought in 1809 as part of the Jacob Visser collection, also originated from a Utrecht chapter library, that of St Jan's. At Amsterdam the University Library acquired its copy, especially for the Bibliotheca Rosenthaliana, rather late. This was some time between 1919, the year Part One of the incunable catalogue appeared and in which the *Defensorium* was not mentioned, and 1923, when Part Two appeared and the volume was mentioned under no. 210. Against the inside cover is a printed ex-libris of William Horatio Crawford of Lakelands, Cork (died 1888). In the 12 March 1891 auction catalogue of his collection the *Defensorium* does not appear.

The Amsterdam copy has a restored fifteenth-century leather binding over wooden boards. The simple lozenge-shaped blind tooling is not very detailed. An indication that this copy may have been bound in Utrecht in the fifteenth century comes from the watermark, a crown and three lilies in a circle (Briquet 1801, Piccard XIII, III 1378 – 1379), in the flyleaves (a bifolium) at the back. This watermark does not occur in the edition itself. In the work, the principal paper type used bears an oxhead with cross watermark (cf. Piccard II 2, VII 66), and here and there two types of p with quatrefoil (Piccard IV 3, X 241 – 242 and one unidentified), shield and crown (Briquet 1697), Paschal lamb and one other oxhead (Piccard II 3, XI 501). The paper sort with the circle with crown and lilies watermark (Briquet 1801) in the *Defensorium* flyleaves is the most common one, occurring in eleven other editions by Ketelaer and De Leempt.

Nicolaes Ketelaer and Gherardus de Leempt produced only one edition, the *Historia Scholastica* by Petrus Comestor, in which they included their name in the colophon together with the year, 1473. This was the first dated edition to appear in the Northern Netherlands. One other dated edition by them exists from 1474, and there are another two editions of the more than 30 attributed to them that can be dated to 1474, based on copies in the Bibliothèque Municipale in Bourges and the Bibliothèque Nationale in Paris, in which the rubricators wrote that they had completed their work in 1474.

In *The Fifteenth-Century Printing Types of the Low Countries* the Hellingas analyzed the relative chronology of the editions they attributed to Ketelaer and De Leempt. They distinguished four states of the letter type based on variations in the case. One is the occurrence of a lower case d with a straight ascender (d^1) together with one with a rounded ascender (d^2). Unfortunately, the references in Table II to these two forms in Plate 15 have been interchanged. In the *Defensorium* the use of d^1 (with straight ascender) stops. After quire f, leaves 41 – 80, only d^2 (with rounded ascender) occurs.

While this incunable may not be rare, the text certainly is. From the *Gesamtkatalog der Wiegendrucke* and the *Incunable Short Title Catalogue* we know that this is the only recorded fifteenth-century printed edition of the *Defensorium*. The two short texts that follow—Johannes de Turrecremata and Cassiodorus—are otherwise not unknown, but at this initial stage of my research I have yet to find a manuscript or another edition of the *Defensorium*.

GERARD VAN THIENEN

6 Four Italian Judaica incunabula

(*above*) Abraham ibn Ezra, *De nativitatibus*, Venice 1485, folio c1 r,

280 x 155 mm [ROS.INC.391]

(*below*) Moses Maimonides, *Aphorismi secundum doctrinam Galeni*, Bologna 1489,

folios h8 v – i1 r, 210 x 340 mm [ROS.INC.33]

ERHARD RATDOLT FROM AUGSBURG worked in Venice between 1476 and 1485, at first in a celebrated partnership with two other German craftsmen, Bernhard Maler and Peter Löslein. The Venetian period produced works of a scientific and philosophical nature, the various ephemerides of Johann [Müller] Regiomontanus (of Königsberg), books by Arab authors, then Euclid and Ptolemy. On returning to his native Augsburg in 1486, he continued to print there from 1487 to 1516.

The present text, printed in 1485, is the only one by a Jewish author to be undertaken by Ratdolt at Venice, and it is the only edition of the *De nativitatibus* known to have been printed in the fifteenth century. The *Compositio astrolabij* by Henricus Bate, which is here found added to the text of Abraham ben Meir ibn Ezra, was no doubt chosen by Ratdolt because of his interest in astrolabes, especially through the work of Regiomontanus.

Abraham ben Meir ibn Ezra was born in 1092 or 1093, most probably in Toledo, Spain. He became a poet, scientist and philosopher and was well acquainted with Arabic, although he did not write in that language. He probably left Spain in 1137, and is then found wandering through various cities of Italy: Rome in 1140, Lucca in 1145, Mantua in 1145 – 1146, Verona in 1146 – 1147; he subsequently went to Provence and afterwards lived for a time in northern France before returning to Narbonne. He died in 1167. The first edition of his commentary on the Pentateuch in Hebrew was printed at Naples in 1488.

Henricus Bate was a native of Malines (in present-day Belgium), where he was born on 23/24 March 1246. He completed the writing of his *Compositio astrolabij* at Malines on 11 October 1274. The date of his death is unknown, but it occurred after 1310.

MOSES BEN MAIMON, or Moses Maimonides, was one of the greatest Jewish scholars of all time, combining a profound knowledge of theology, medicine and philosophy. Born in Cordoba, Spain, in 1138, he was the son of a great rabbi. His wandering life took him first to Morocco and later to the Middle East, where he died on 13 December 1204 in Fostat (Old Cairo).

Maimonides completed his two major works, the *Commentary on the Mishnah* in 1168, and the *Guide for the Perplexed* in 1190. The former was printed, entirely in Hebrew, at Naples in 1492, and the latter was printed for the first time before 1480, although modern bibliographers have not yet decided whether this was in Rome or elsewhere. The printing of Hebrew incunabula is often notoriously difficult to localize, if not impossible. The first edition of Moses Maimonides' *Mishneh Torah* was probably printed at Rome before 1480. The 1489 edition of the *Aphorismi secundum doctrinam Galeni* with which we are here concerned seems to be the only incunable of Moses to be printed at Bologna. It is, of course, in Latin, not in Hebrew, which made its publication an easier task. The press at which it was printed, that of Franciscus (Plato) de Benedictis, was active in Bologna from 1482 to 1496, and Benedictus Hectoris was considerably more productive for the very long period of 1487 to 1523; but Moses ben Maimon seems to be the only Jewish author they published. The second edition of the same set of texts appeared at Venice probably in 1497.

'Maimonides was not a slavish follower of the Greeks. For instance, he rejects Aristotle's doctrine of the eternity of matter, or, in other words, the idea that the World never had a beginning.' (Herbert M. Adler, 1935.) The present selection from the works of the physician Galen shows that Maimonides extended his interest in the Greeks beyond Aristotle, even if he was not always in complete agreement with their teachings.

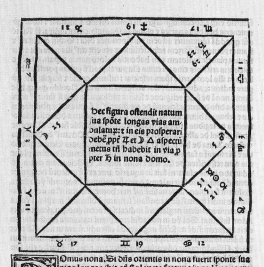

hec figura oſtendit natum
ſua ſpõte longas vias am
bulatu:z in eis proſperari
debẽ ppr ♃ et ☽ △ aſpectũ
metus tñ habebit in via p
pter ♄ in nona domo.

ᴅOmus nona. Si dñs ozientis in nona fuerit ſponte ſua
vias longas ibit qͦ ſi planeta fortune in eadē nona cũ
ipſo fuerit vel ipam reſpiciat:in vijs ſuis bene ei contin
get:ſi autẽ aliter:ecõuerſo. Saturn⁹in nona oſtendit me
tus futuros in itinere:magis aũt in mari:z adhuc ampli
us ſi in ſigno aqͤtico. Mars ſilr in nona timozē indicat:
ſed magis in terra futtuz:z adhuc ampl⁹ ſi in ſigno terreo. Si dñs ozi
entis eſt in nona:oſtendit naſcentez vias longas affectare:ſimilif dñs
ozientis in ſeptima oſtendit qm in ſua patria parũ mozabif:z ſcõm ei⁹
ſtatum inter alienos ei cõtinget:z ſm reſpectũ planetaꝝ ad ipm. Uli
denda eſt quoqͣ pars itineris in terra agendi que ſumif iuxta equatio
nem domozũ a domino none vſqͣ ad principiũ none addenda ozien
ti. Similiter pars itineris agendi per aquaz inſpicienda: que ſumitur a

quisti dominum deum tuū eo tempore quo ducebat te p uiam: & sequitur ar
guet te malicia tua & auersio tua icrepabit te. Scito & uide qa malū & ama
rum ē reliqsse te dominū deū tuū: & non eē timore eius apud te dicit domi
nus exercituū: & infra oēs dereliqstis me dicit domius frustra pcussi filios ue
stros: disciplinā nō receperunt. Vnde liqdo apparet ois iudaici erroris fontē
eē ignorantiā atq̱ sanctarū lrarū p̄iectionem: iccirco a bono ad malū trā
scendūt suoq̱ arbitrio uiuūt absq̱ omni rōne bene uiuendi atq̱ cognitiōe re
cti. Hos igitur relinquamus confusos atq̱ p̄ditos qui suo se gladio tanq̱ de
liri ac furiosi turpissime iugularunt.

Quintum caput q̱ iesus marie filius fuir ille messiach: quē prophetæ cecine
re futurum ad noua lege homines instruendos.

ONFIRMATVM est satis (ut opinor) mysterium elapsi
tēporis aduentus messiach quod falsum ducitur a iudæis &
in isto carcere stultitiæ inclusi: ueritatis lumine priuati arro
ganter inqunt christum nostrum nō fuisse uerum messiach.
Neq̱ enim uereor ut in hoc etiam tanto certamine nobis nō
faueant p̄phetarū oracula: ratio atq̱ ueritas: cuius ui ac po
testate sicut in singulis ante actis certaminibus ita & in hoc ultimo spero me
de hostibus triumphaturum: uidebimus adeo clare adeo aperte christum sal
uatorem nostrum fuisse uerum messiach q̱ poterit litterarū ignarus & ratio
nis expers dignoscere non difficile nos recta proficisci: & iudæos dillabi in
præcipitium & in mortem. Legi ipse mosi libros omnes ac prophetarum co
dices frequentius & sūmo studio & lucubratione: ex quorum clarissimo fon
te noui decem riuulos emanare: hoc est decem conditiones messiach congru
entes: quibus declarabitur non obscure omissis cæteris non opportunis chri
stum mariæ filium fuisse uerum messiach.

Prima itaq̱ conditio est q̱ messiach ante tempus destructionis secundi templi
nasci debebat: hoc etenim in quarto capite accumulate ostendimus etiā quē
admodum sentiunt hebræorum magistri atq̱ doctores: & illud ipsum habeē
itidem in beresit raba apud eos: ubi dicit rabi samuel q̱ imp̄sentiarum aiu
dæis nominatur nachmani: q̱ die qua dirruit templum natus erat messiach:
& quærit ipse doctor quomodo potest istudipsum probari: & sibi ipsi respō
det dicens habetur hoc esaiæ .c. ultimo antēq̱ parturiret peperit: anteq̱ par
turiret peperit masculum: in eadem enim hora qua dicit ipse facta est templi
destructio exclamabat israel tanq̱ mulier parturiens quēadmodum instruit
caldaica translatio anteq̱ ueniret ei angustia: & anteq̱ ueniret ei dolores par
tus: reuelatus est messiach. Hoc idem ab eodem rabi in eodem libro dicitur
& affirmatur: nam ut ipse inquit tempore quo templum cecidit: helias per

Rabi saī
nachmani

Esaias

Caldaica
translatio
Helias

Magistri Ioannis nannis uiterbiēsi. ordinis predicatorum ad
R.D.P. Barotium Ēp̄um Patauinum Questiones due dispu
tate super mutuo iudaico & ciuili & diuino.

Euerende in Christo mi pater & domine. Post filiales cō
mendationes. Die. xvi. Aprilis reddite mihi fuerūt litte
re. R.D.V. doluiq̱ nimium q̱ mox non potui opuscu
lum de monte pietatis quod ganue edideram copiandū
tradere. Nam Ganue ferme o mnia mea relicta sunt: & opus in
manibus aliorum est: uerum quoniam occupationes hebdoma
de sancte occurrunt & pascalis solēnitatis: & lectionum quas pu
blico salario lego habita uacatione a magistratu: ne tue. R.D.
desim: etiā mihi hunc assumam laborem: ut quicquid ad memo
riam reduxero: non obscuriore: sed pinguiore lucubratione ad te
transmittam: ut noscat. R.D. tua me sam seruitorem tuum esse.
Contra uero ea que'dixero siquis contrarium sentit ponat obie
ctiones in scriptis quibus cum tua dominatio ad'me miserit illico
responsiones transmittam. Me tue. R.D. commendo: quam
Deus foelicem & ad maiora conseruet. Ex Vitetbio die octauo
Maii. M.cccc.lxxxxii.

Quattuor fundamenta.
Mihi autem premittenda uidentur fundamenta quedam que
a nullo negari possint nisi ab heretico uel de heresi & malis mo
ribus suspecto. Deinde proponendus est casus & diuidendus.
Vltimo disputādus: & exemplanādus per duas distinctas & enū
cleatas questiones more theologico. Fundamenta autem sunt
hec. Primum est: q̱ siquid est expressum in diuinis litteris, cano
nicis que dicuntur solum uetus & nouum testamentum absolu
te tenendum est: & omne quod sacre scripture illi non congruit,
tanq̱ anathema est fugiendum: quia si uacillaret auctoritas titu
baret fides: ut in primo de doctrina Christiana dicit Augustinus
& in epistola prima ad Hieronymum. Si inquit ad scripturas sa
cras fuerint admissa officiosa mendacia quid in eis remanebit au
ctoritatis?que tandem de illis scripturis sententia proferetur: &
in Speculo: Vetus inquit & nouum testamentum cum omni hu
militate suscipimus: contrarios autem scripturarum sensus non
solum fugimus sed etiam anathematizamus: & omnē doctrinā :

a ii

(*left*) Petrus Brutus, *Victoria contra Judæos*, Vicenza 1489,

folio k3v, 300 x 200 mm [ROS.INC.381]

(*right*) *Pro Monte Pietatis*, Venice *c.* 1495,

folio a2r, 215 x 150 mm [ROS.INC.42]

SIMON DE GABIS (nicknamed Bevilaqua) of Pavia printed six editions at Vicenza between December 1487 and November 1491. He then moved to Venice where he worked successfully until 1503. After that he was frequently on the move: printing at Saluzzo, Cuneo, Novi Ligure and Savona until 1514, finally leaving Italy for Lyons, where his printing career came to an end in 1518.

Petrus Brutus, a Venetian, was Bishop of Cattaro (Kotor, almost at the southern tip of the Dalmatian coast, near the border with Albania) from 1471 to 1493. In 1477 he published a *Letter against the Jews* at Vicenza, a rare little book of which only two copies are recorded today at Venice and one at Vicenza. Then on 3 October 1489 a much larger book, a folio of 130 leaves, entitled *Victoria contra Iudæos* ('Victory against the Jews') appeared from the press of Simon de Gabis. This is addressed to the noblemen of Vicenza, who no doubt included Bartolomeo Pagello and the celebrated humanist Ognibene da Lonigo, who had been won over to the anti-Semitic cause.

Bishop Brutus' two books against the Jews are among the strongest pieces of anti-Semitic writing of the period. Following the alleged murder of the Christian boy Simon Oberdorfer by Jews of Trent in 1475 (for which the boy was later beatified), there was a tremendous outpouring of emotion, bitter feuding and polemical writing, resulting in the publication of a number of incunabula on the subject in such towns as Trent, Vicenza and Padua, all inflamed by the sermons of Bernardino da Feltre (1439 – 1494), who preached anti-Semitism at Padua and Treviso, and later at Vicenza. It was no doubt this last fact which led to the publication of Bishop Brutus' books at Vicenza. He was not resident there, but he knew the leading citizens of the town, who must have introduced his work to the local printers (Leonardus Achates of Basle being the printer of the letter of 1477, long before the arrival of Simon de Gabis in Vicenza).

IN 1905 PADRE HERIBERT HOLZAPFEL published a book on the origins of the *Monti di Pietà* in Italy between 1462 and 1515; and in 1974 Padre Vittorino Meneghin of Venice published a vast book of over 700 pages on *Bernardino da Feltre e i Monti di Pietà*. A *Monte di Pietà* (or *mont-de-piété* in French) is nowadays a pawnbroker's shop. These *Monti di Pietà* originated in Italy under the patronage of the Papal government in the fifteenth century and the object in founding them was to counteract the supposedly exorbitant usurious practices of the Jews. The establishments therefore existed for advancing money to the poor at a reasonable rate of interest. There is little doubt that one of the major factors leading to their foundation was the sermons of Fra Bernardino da Feltre (1439 – 1494, real name Martino Tomitani), who preached violently against the Jews in Padua, Treviso, Vicenza and other northern towns.

The full title of the book of *c.* 1495 is: *Pro Monte Pietatis. Consilia sacrorum Theologorum: ac collegiorum Patauii & Perusii. Clarissimorumque doctorum. dd. Ioannisbaptistæ Rozelli & Ioannis Campegii. Cum bulla ac breui dato fratri Bernardino Feltrensi Sanctissimi Pape Innocentii Octaui.* The theological colleges of Padua and Perugia combined to produce the texts, which include a piece by Giovanni Campeggi of Mantua (1448 – 1511), a famous professor of law at Padua and Bologna universities. It begins with *Questiones due disputate super mutuo iudaico & ciuili & diuino* by Giovanni Nanni, or Annio da Viterbo, the Dominican (1432? – 1502) best known for his forgeries; this piece is dated Viterbo, 8 May 1492, and addressed to Pietro Barozzi, Bishop of Padua. It is followed by a contribution from the celebrated Carmelite poet of Mantua, Baptista (Spagnuoli) Mantuanus (1447 – 1516) whom Erasmus called 'the Christian Virgil'. Finally there are the bull and brief from Innocent VIII (1484 – 1492) to Fra Bernardino da Feltre.

The whole adds up to an anthology of Catholic doctrine on behalf of the *Monti di Pietà* and of propaganda against the Jews. It was printed anonymously and undated at one of the most prolific presses of Venice (Joannes Tacuinus de Tridino was active as a printer from 1492 to 1538, an incredibly long period for a printer in those days), and it is believed that the book appeared about 1495. It has 46 printed leaves.[1]

DENNIS E. RHODES

7 The first printed book produced at Constantinople

Jacob ben Asher, *Arbaah Turim: Tur yoreh deah*, Constantinople 1493,

folios 10.1 v – 10.2 r, 295 x 500 mm [ROS.INC. 470]

H EBREW INCUNABLES CONSTITUTE only a tiny part of the large number of other editions published in the fifteenth century. Their total number is certainly no more than about one hundred and fifty editions, which constitutes less than half a percent of the total production of printed editions during the incunable period (ending on 1 January 1501). About two thousand copies are now kept in public collections all over the world, and there are a few hundred in private hands. They appeared in Italy, Spain and Portugal, and one edition was published in the Ottoman Empire. If not all of them, then certainly many of these editions are very rare indeed, one-third of these are known in only one, two or three copies.

Today, the Bibliotheca Rosenthaliana has a collection of thirty-four editions of Hebrew incunables, a figure that compares with the collections of libraries such as the Bibliothèque Nationale in Paris, the Public Library in New York and the Royal Library in Copenhagen.

The single incunable edition from the Ottoman Empire mentioned above, is Jacob ben Asher's fourteenth-century *Arbaah Turim* (Four Orders of the Code of Law) printed by the brothers David and Samuel Ibn Nahmias at Constantinople and completed on 4 Tevet 5254 (13 December 1493). It is the first book ever printed in Turkey, not only in Hebrew but in any language. Twelve copies of this large book of over eight hundred pages are now known in public collections, but only a few of them are complete or almost complete. Originally, the Bibliotheca Rosenthaliana had only a fragment of this book, but thanks to a gift by the Society of Friends of the Amsterdam University Library in 1992, it now boasts a splendid, (almost) complete copy.

If the historical background were not so tragic, its genesis might have been a thrilling and romantic story. It seems very probable that the establishment of the Ibn Nahmias press at Constantinople was a direct result of the expulsion of the Jews from Spain in the spring of 1492. From an analysis of the physical aspects of the book it appears that the large square Hebrew type used for the initial words of the different parts, chapters and paragraphs is identical to the type used at the press of Eliezer ben Abraham Alantansi at Hijar in Aragón between 1485 and 1490. The beautifully decorated initial alef at the beginning of the book, probably cut by the Christian silversmith Alfonso Fernandez de Córdoba, is also in the style of the decorative material of this press. However, the semi-cursive type used for the text appears to be identical to the type used by Joshua Solomon Soncino at Naples in 1490 – 1491. The Chancery paper with its running bull's-head watermark was produced in northern Italy and, according to Piccard's reference work on this type of watermark, in exactly the same years as the *Turim* were printed.

This leads us to the following reconstruction: the Spanish-Jewish brothers Ibn Nahmias were presumably connected with the press at Hijar in some way. They intended to establish a printing press outside Spain after the expulsion by the Spanish King and sailed from Valencia to Naples, together with a group of wealthy Jews led by the statesman Isaac Abravanel on 31 July 1492 and taking with them some of the typographical material from Hijar. The outbreak of plague shortly after their arrival probably caused them to flee (possibly accompanied by typesetters and pressmen from Naples) to Constantinople, where the sultan, Bayazid II, was known to welcome Jewish refugees. In Naples they had obtained their most important material, the matrices or punches of Joshua Solomon Soncino's semi-cursive type, and had purchased paper from northern Italy. During the whole year 1493 they worked on the production of their book, the best seller *Arbaah Turim* by Jacob ben Asher, assisted by the Turkish-Jewish scholar Eliah ben Benjamin Halevi as editor and proof-reader.

ADRI K. OFFENBERG

הלכות ספר תורה

רעז

רעח

רעט

שְׁמוֹת דְּבָרִים בְּאַלְפָא בֵּיתָא
אלף

Apfel	Pomum	תַּפּוּחַ	אפסיל
Adler	Aquila	נֶשֶׁר	אדלר
Antlit	Facies	פָּנִים	אנטליט
Auge	Oculus	עַיִן	אוֹג
Acken	Ceruix	עוֹרֶף	אק
Arm	Brachium	זְרוֹעַ	ארם
Armbrust	Balista	בְּלִיסְטְרַ	ארם פרושט
Achsel	Humerus	כָּתֵף	אקשיל
Arsch	Anus	תַּחַת	ארש
Acker	Ager	חֶלְקָה	אקר
Angster	Vitrũ angustũ	צְלֹחִית	אנגשטר
Angel	Hamus	חַכָּה	אנגל
Turangel	Cardo	צִיר	טור אנגל
Aier	Oua	בֵּיצִים	אייר
Aimer	Vrna	דְּלִי	איימור
Aiß	Glacies	קֶרַח	אייז
Aisen	Ferrum	בַּרְזֶל	אייזן
Aißen	Vlcus	מוּרְסָה	אייסן
Aiter	Tabes	לֵיחָה	אייטר

A 2

התלמיד לשון הקדש

n nomenclaturã he-
braicã Heliæ Leuitæ Hebræi, quã ille superiori
anno cum mecum in Germania esset, me horta-
tore, pro tyronibus et studiosis linguæ hebraicæ
obiter congessit, Et quia totus in hoc incumbo, ut quibus-
cunq; rationibus possum, sanctam linguam apud eius studio-
sos, pro mea uirili commendem ac promoueam. Arbitratus
autem fuerim istud ipsum etiam aliquo modo fieri, si quod
in alijs linguis facimus, etiam in lingua sancta rerũ uocabula
hebraice sonare discamus: curaui, ut libellus iste, quẽ in eũ
usum Helias confecit, in cõmunem studiosorum utilitatem
excusus prodiret: qui ut eo gratior esset, adiunxi ipse he-
bræis latina et germanica uocabula, que iuxta seriẽ alphabe-
ticam hoc ordine collocantur. Primus ordo continet germa-
nica uocabula, hebraicis tamen typis, quibus Iudæi Germani
cum germanica scribunt, utuntur. Secundus ordo purè hebra-
ica. Tertius latina. Quartus ordo nostra germanica. Quod
si hanc meam operulam studiosis grat am esse intellexe-
ro, operam dabo, ut à me quoq; breui habeant
librum colloquiorum hebraicorum, nec
non et conscribendarum epistola-
rũ. Vale. Ex Isna Mense Iu-
lio, anno salutis
M. D. XLij

8 Elijah Levita's *Shemot Devarim* printed at Isny

Folios A1v – A2r, 151 x 190 mm [ROS. 19 H 30]

AN INTELLECTUAL PARTNERSHIP between Elijah Levita and Paul Fagius led to the publication of a series of Hebrew and Yiddish books in the southern German towns of Isny and Constance from 1541 to 1544. One of them is the extremely rare *Shemot Devarim* (Isny 1542) on which we shall focus here.

Elijah Levita, grammarian and philologist, was born in Germany about 1468 but spent most of his life in Italy where he taught Hebrew to, among others, Guillaume Postel, Sebastian Muenster, and Cardinal Egidius da Viterbo. For many years, he worked as a proofreader in the renowned Venetian printing establishment of Daniel Bomberg, where several of Elijah's own books were printed.

Paul Fagius, later a professor of Hebrew at Strasbourg and then Cambridge, was a pastor in Isny when he decided to establish a Hebrew press. He offered Levita, then in Venice, the job of supervisor of the new press. By the time he joined Fagius in Isny in about 1540, Levita had already written a number of grammatical works, a major masoretic work (*Masoret Ha-masoret*), a treatise on accents (*Tuv Taam*), and secular works in Yiddish, which, though perhaps once published, have not survived.

Of the fewer than twenty Isny/Constance publications, Fagius was the author, editor, and/or translator of books including Ethics of the Fathers, the Book of Tobit, and the Alphabet of Ben Sira. Two of the books are significant lexicographical works by Levita, with Fagius's translation into Latin: *Tishbi* is a dictionary of Hebrew words that appear in the Talmud, and the *Meturgeman* explains the Aramaic words that were used in the Targum to the Bible. The press also published a number of books in Yiddish including the *Bovo d'Antona* (1541), Levita's adaptation of a popular romance and the Pentateuch with megillot and haftarot.

The *Shemot Devarim* was a joint work by Levita and Fagius. Max Weinreich argues that this Yiddish/Hebrew/Latin/German dictionary was not primarily meant for Jews but rather for non-Jewish students.[1] One of his arguments is the peculiar structure of the book, which starts with a list of words in Yiddish alphabetical order but then categorizes other words—about half of the book—according to subject, such as 'diseases', 'time', 'zodiac', 'occupations', etc. Presumably, this thematic arrangement was more 'user-friendly' to those who knew German or Latin and were seeking Hebrew and Yiddish equivalents. Interestingly, a useful by-product for today's scholar consists of the clues to the pronunciation of the Yiddish contained in the spelling of the words.

Within two decades of the invention of printing with moveable type in Europe around 1450 – 1455, Hebrew was being printed by Jews in Italy and the Iberian peninsula. However, no Hebrew books were printed north of the Alps until the sixteenth century. The first surviving book to contain a substantial amount of Yiddish, the *Mirkevet Ha-mishneh* or *Sefer shel Rabbi Anshel*, a Hebrew-Yiddish Bible dictionary, was not published until 1534 or 1535 in Cracow. Thus, the Yiddish books printed by Fagius/Levita in Isny/Constance are among the very earliest books in this important Jewish vernacular language.

A word about Yiddish type. The special style of Hebrew letters used to print early Yiddish books, a style that persisted for several centuries, derives from the Ashkenazi handwriting of that period. The early type designers began by mimicking the best local manuscripts, but later, printers took to copying type designs, even when they differed from the local hand. When Hebrew printing finally came to central Europe, the Sephardi/Italian semi-cursive was already so successfully used for 'Rashi' or rabbinic type that the local Ashkenazi semi-cursive alphabet proved superfluous. Whether by default or by deliberate choice, Ashkenazi semi-cursive became the model for type used by sixteenth-century printers for Yiddish. The Isny Yiddish type was a very early use of this style of letter and thus probably influenced its use by later printers.

The *Shemot Devarim* is, in every respect, a noteworthy artifact of its time and place.

HERBERT C. ZAFREN

9 Christopher Plantin's *Biblia regia*

Folios A I v – A 2 r, 412 x 550 mm [ROS. 1862 A I]

DURING THE TUMULTUOUS 1560s the Officina Plantiniana in Antwerp was at the height of its expansion. As a businessman, Plantin was forced by the rapid succession of events and the ever-changing situation to keep on good terms with the Church. The celebrated printer, naturally aware of the machinations of the 'Calvinist' press in the 'diaspora'—especially after the iconoclastic riots and the clampdown on religious freedom—was apparently attempting to make a kind of public confession of his Catholicism in order to raise his stock with the Spanish authorities. He had after all attempted rather conspicuously to obtain permission from the Spanish court to publish a polyglot Bible. His inspiration had been the first edition in this genre, a six-volume edition of 1514 – 1517 at Alcalà de Henares, known as the *Biblia complutensis*. He eventually obtained permission: Philip II provided a grant of 21,000 florins but demanded that the project be placed under the scholastic guidance of the famous Spanish theologian Benito Arias Montano. In fact the theologian revealed a remarkable broadness of mind, which immediately endeared him to Plantin and formed the basis for a friendship and cooperation that were to last their whole lives. The Spaniard was soon at home among Antwerp's scholars and humanists, who were not unsympathetic to the teachings of Hendrik Niclaes and his *Huys der liefde* ('Family of Love').

Arias Montano found assistance in his task from a group of scholars, including Plantin's son-in-law Francis Raphelengius, who later became a printer at Leiden, the brothers Guy and Nicolas Le Fèvre de la Boderie of Paris, proofreaders Cornelis Kiliaan and Bernard Sellius and the orientalist Andreas Masius of South Brabant. Their task was to ensure the quality of the editions: for the Old Testament (Parts I – IV), the Hebrew text with Latin translation (Vulgate), the Greek text of the Septuagint and its Latin translation, the paraphrase in Aramaic and its Latin translation; for the New Testament (Part V), the Syriac text and its Latin translation, the Greek text and a Latin translation (Vulgate), the Hebrew translation of the Syriac text. Parts VI to VIII, the so-called *Apparatus*, contain, some as autonomous sections, the notes, comments and registers, vocabularies and grammars and a series of treatises on biblical subjects. Remarkably, there are two editions, or partially at least: part of VI and VIII are printed in two issues. Was Plantin in financial trouble? Or did he mean to restrict the edition for fear of not obtaining papal consent after all?

Arias Montano and Plantin both saw the polyglot Bible as a prestige project. It was produced in a tempo that seems incredible today. The typesetting began in 1569 and the edition was completed in 1572, a print run of 1,200 copies on paper from various sources and of mixed quality; 13 copies on parchment were for the Spanish king. Plantin chose a large folio format. He also had to increase his supply of type: he bought Hebrew punches from Cornelis van Bomberghen in Cologne and Guillaume Le Bé in Paris; and Greek and Syriac from Robert Granjon. The rich typographical decoration is also remarkable. Moreover, he employed his best artists to produce copper engravings for the title prints whose symbolism and meaning he explained himself. Thus, the Bible was intended to promote the *unio christiana* (main title-page), while the *pietas regia* (second frontispiece in Part I) was intended to be in praise of Philip II.

With its eight splendid folios it was an impressive edition, a monument of typography and a milestone in biblical scholarship. The edition is known both as the *Biblia regia* and the *Biblia polyglotta*: a multi-lingual Bible edition produced under royal license.

ELLY COCKX-INDESTEGE

‏בראשית א

‏בראשית ברא אלהים את השמים ואת
‏הארץ : והארץ היתה תהו ובהו וחשך
‏על פני תהום ורוח אלהים מרחפת על
‏פני המים : ויאמר אלהים יהי אור ויהי אור :
‏וירא אלהים את האור כי טוב ויבדל
‏אלהים בין האור ובין החשך : ויקרא אלהים לאור
‏יום ולחשך קרא לילה ויהי ערב ויהי בקר יום אחד :
‏ויאמר אלהים יהי רקיע בתוך המים ויהי מבדיל
‏בין מים למים : ויעש אלהים את הרקיע ויבדל בין
‏המים אשר מתחת לרקיע ובין המים אשר מעל לרקיע
‏ויהי כן : ויקרא אלהים לרקיע שמים ויהי ערב
‏ויהי בקר יום שני : ויאמר אלהים יקוו המים
‏מתחת השמים אל מקום אחד ותראה היבשה ויהי
‏כן : ויקרא אלהים ליבשה ארץ ולמקוה המים קרא
‏ימים וירא אלהים כי טוב : ויאמר אלהים תדשא
‏הארץ דשא עשב מזריע זרע עץ פרי עשה פרי למינו
‏אשר זרעו בו על הארץ ויהי כן : ותוצא הארץ דשא
‏עשב מזריע זרע למינהו ועץ עשה פרי אשר זרעו בו
‏למינהו וירא אלהים כי טוב : ויהי ערב ויהי בקר
‏יום שלישי : ויאמר אלהים יהי מארת ברקיע
‏השמים להבדיל בין היום ובין הלילה והיו לאתת
‏ולמועדים ולימים ושנים : והיו למאורת ברקיע
‏השמים להאיר על הארץ ויהי כן : ויעש אלהים
‏את שני המארת הגדלים את המאור הגדל לממשלת
‏היום ואת המאור הקטן לממשלת הלילה ואת
‏הכוכבים : ויתן אתם אלהים ברקיע השמים להאיר
‏על הארץ : ולמשל ביום ובלילה ולהבדיל בין האור
‏ובין החשך וירא אלהים כי טוב : ויהי ערב ויהי
‏בקר יום רביעי : ויאמר אלהים ישרצו המים שרץ
‏נפש חיה ועוף יעופף על הארץ על פני רקיע השמים :

CAPVT PRIMVM.

IN principio creauit Deus cœlum & terra. Terra autem erat inanis & vacua: & tenebræ erant super faciê abyssi: & spiritus Dei ferebatur super aquas. Dixitq́, Deus, Fiat lux. Et facta est lux. Et vidit Deus lucem quòd esset bona: & diuisit lucem à tenebris. Appellauitq́, lucem diem; & tenebras nocté. Factumq́, est vespere & mane dies vnus. Dixit quoque Deus, Fiat firmamentu in medio aquarú; & diuidat aquas ab aquis. Et fecit Deus firmamentu, diuisitq́, aquas quæ erant sub firmamento, ab his quæ erant super firmamentu. Et factum est ita. Vocauitq́, Deus firmamentu, cælum: & factum est vespere, & mane dies secundus. Dixit verò Deus, Congregentur aquæ quæ sub cælo sunt, in locum vnum: & appareat arida. Et factum est ita. Et vocauit Deus aridam, terram: et congregationesq́, aquarum appellauit maria. Et vidit Deus quòd esset bonum. Et ait, Germinet terra herbá virentem & facientem semen; & lignum pomiferú faciens fructú iuxta genus suum, cuius semen in semetipso sit super terram. Et factú est ita. Et protulit terra herbam virenté, & facienté semen iuxta genus suú; lignumq́, faciens fructú & habens vnumquodq́, sementem secundú speciem suam. Et vidit Deus quòd esset bonum. Et factum est vespere & mane dies tertius. Dixit autê Deus, Fiant luminaria in firmaméto cæli; & diuidant diem ac nocté; & sint in signa & têpora; & dies & annos: Vt luceant in firmamento cæli, & illuminent terram. Et factum est ita. Fecitq́, Deus duo luminaria magna, vt præesset diei; & luminare minus, vt præesset nocti; & stellas. Et posuit eas Deus in firmaméto cæli, & lucerent super terrá: Et præessent diei ac nocti; & diuiderent lucem ac tenebras. Et vidit Deus quòd esset bonú. Et factum est vespere, & mane dies quartus. Dixit etiam Deus, Producant aquæ reptile animæ viuentis, & volatile super terram sub firmamento cæli.

CAPVT PRIMVM.

IN principio fecit Deus cælum & terrá. At terra erat inuisibilis et incóposita, & tenebræ super abyssú: & spiritus Dei ferebatur super aquam. Et dixit Deus, Fiat lux. Et facta est lux. Et vidit Deus lucé, quòd bona: & diuisit Deus inter lucem, & inter tenebras. Et vocauit Deus lucé diê: & tenebras vocauit noctê: & factú est vespere: & facta est mane, dies vnus. Et dixit Deus, Fiat firmamentú in medio aquæ: & fiat diuidés inter aquá, & aquá. Et fecit Deus firmaméto: & diuisit Deus inter aquá quæ erat sub firmaméto: & inter aquá quæ super firmamentú. Et vocauit Deus firmamentú cælú: & vidit Deus quòd bonú. Et factú est vespere, & facta est mane, dies secúdus. Et dixit Deus, Cógregetur aqua quæ sub cælo, in cógregatio.é vná, & appareat arida. Et factú est ita, & cógregata est aqua quæ sub cælo, in cógregationes suas: & apparuit arida. Et vocauit Deus aridá, terrá: & cógregationes aquarú, vocauit maria. Et vidit Deus quòd bonú. Et dixit Deus, Germinet terrá herbá fœni seminante semen secundú genus et secundú similitudiné: & lignú pomiferú faciens fructú, cuius semen ipsius in ipso secundú genus super terrá. Et factum est ita. Et protulit terra herbá fœni seminante semen secundú genus et secundú similitudiné: & lignú pomiferú faciens fructú, cuius semé eius in ipso, secundú genus super terrá. Et vidit Deus quòd bonú. Et factú est vespere, & facta est mane, dies tertius. Et dixit Deus: Fiant luminaria in firmaméto cæli, vt luceant super terrá, ad diuidendú inter diê, & inter nocté: & sint in signa, & in têpora, & in dies, & in annos: & sint in illuminatioué in firmaméto cæli, vt luceant super terrá. Et facta est ita. Et fecit Deus duo luminaria magni in principatú diei: & luminare minus in principatú noctis: & stellas. Et posuit eas Deus in firmaméto cæli: vt lucerét super terrá. Et præessent diei, & nocti: & diuiderét inter lucé & inter tenebras. Et vidit Deus quod bonú. Et factú est vespere, & facta est mane, dies quartus. Et dixit Deus, Producant aquæ reptilia animarú viuentiú, & volatilia volátia super terrá, secundú firmamétú cæli: & factú est ita.

ΓΕΝΕΣΙΣ

ΕΝ ἀρχῇ ἐποίησεν ὁ θεὸς τὸν οὐρανὸν ᵹ τὴν γῆν. ἡ δὲ γῆ ἦν ἀόρατο ᵹ ἀκατασκεύαστος, ᵹ σκότος ἐπάνω τ ἀβύσσου, ᵹ πνεῦμα θεοῦ ἐπεφέρετο ἐπάνω τοῦ ὕδατος. ᵹ εἶπεν ὁ θεὸς, γεννηθήτω φῶς, ᵹ ἐγένετο φῶς. ᵹ εἶδεν ὁ θεὸς τὸ φῶς ὅτι καλόν, ᵹ διεχώρισεν ὁ θεὸς ἀναμέσον τοῦ φωτὸς, ᵹ ἀναμέσον τοῦ σκότους. ᵹ ἐκάλεσεν ὁ θεὸς τὸ φῶς ἡμέραν, ᵹ τὸ σκότος ἐκάλεσε νύκτα. ᵹ ἐγένετο ἑσπέρα, ᵹ ἐγένετο πρωῒ ἡμέρα μία. ᵹ εἶπεν ὁ θεὸς, γεννηθήτω στερέωμα ἐν μέσῳ τοῦ ὕδατος, ᵹ ἔστω διαχωρίζον ἀναμέσον ὕδατος ᵹ ὕδατος. ᵹ ἐγένετο οὕτως. ᵹ ἐποίησεν ὁ θεὸς τὸ στερέωμα, ᵹ διεχώρισεν ὁ θεὸς ἀναμέσον τοῦ ὕδατος, ὃ ἦν ὑποκάτω τοῦ στερεώματος, ᵹ ἀναμέσον τοῦ ὕδατος τοῦ ἐπάνω τοῦ στερεώματος. ᵹ ἐκάλεσεν ὁ θεὸς τὸ στερέωμα οὐρανόν. ᵹ εἶδεν ὁ θεὸς ὅτι καλόν. ᵹ ἐγένετο ἑσπέρα, ᵹ ἐγένετο πρωῒ ἡμέρα δευτέρα. ᵹ εἶπεν ὁ θεὸς, συναχθήτω τὸ ὕδωρ τὸ ὑποκάτω τοῦ οὐρανοῦ εἰς συναγωγὴν μίαν, ᵹ ὀφθήτω ἡ ξηρά. ᵹ ἐγένετο οὕτως. ᵹ συνήχθη τὸ ὕδωρ τὸ ὑποκάτω τοῦ οὐρανοῦ εἰς τὰς συναγωγὰς αὐτῶν, ᵹ ὤφθη ἡ ξηρά. ᵹ ἐκάλεσεν ὁ θεὸς τὴν ξηρὰν γῆν, ᵹ τὰ συστήματα τῶν ὑδάτων ἐκάλεσε θαλάσσας. ᵹ εἶδεν ὁ θεὸς ὅτι καλόν. ᵹ εἶπεν ὁ θεὸς, βλαστησάτω ἡ γῆ βοτάνην χόρτου σπεῖρον σπέρμα κατὰ γένος ᵹ καθ᾽ ὁμοιότητα, ᵹ ξύλον κάρπιμον ποιοῦν καρπὸν, οὗ τὸ σπέρμα αὐτοῦ ἐν αὐτῷ κατὰ γένος ἐπὶ τῆς γῆς. ᵹ ἐγένετο οὕτως. ᵹ ἐξήνεγκεν ἡ γῆ βοτάνην χόρτου σπεῖρον σπέρμα κατὰ γένος ᵹ καθ᾽ ὁμοιότητα, ᵹ ξύλον κάρπιμον ποιοῦν καρπὸν, οὗ τὸ σπέρμα αὐτοῦ ἐν αὐτῷ κατὰ γένος ἐπὶ τῆς γῆς. ᵹ εἶδεν ὁ θεὸς ὅτι καλόν. ᵹ ἐγένετο ἑσπέρα, ᵹ ἐγένετο πρωῒ ἡμέρα τρίτη. ᵹ εἶπεν ὁ θεὸς, γεννηθήτωσαν φωστῆρες ἐν τῷ στερεώματι τοῦ οὐρανοῦ εἰς φαῦσιν τῆς γῆς, τοῦ διαχωρίζειν ἀναμέσον τῆς ἡμέρας ᵹ ἀναμέσον τῆς νυκτός, ᵹ ἔστωσαν εἰς σημεῖα, ᵹ εἰς καιροὺς, ᵹ εἰς ἡμέρας, ᵹ εἰς ἐνιαυτούς. ᵹ ἔστωσαν εἰς φαῦσιν ἐν τῷ στερεώματι τοῦ οὐρανοῦ, ὥστε φαίνειν ἐπὶ τῆς γῆς. ᵹ ἐγένετο οὕτως. ᵹ ἐποίησεν ὁ θεὸς τοὺς δύο φωστῆρας τοὺς μεγάλους, τὸν φωστῆρα τὸν μέγαν εἰς ἀρχὰς τῆς ἡμέρας, ᵹ τὸν φωστῆρα τὸν ἐλάσσω εἰς ἀρχὰς τῆς νυκτός, ᵹ τοὺς ἀστέρας. ᵹ ἔθετο αὐτοὺς ὁ θεὸς ἐν τῷ στερεώματι τοῦ οὐρανοῦ, ὥστε φαίνειν ἐπὶ τῆς γῆς, ᵹ ἄρχειν τῆς ἡμέρας ᵹ τῆς νυκτός, ᵹ διαχωρίζειν ἀναμέσον τοῦ φωτὸς ᵹ ἀναμέσον τοῦ σκότους. ᵹ εἶδεν ὁ θεὸς ὅτι καλόν. ᵹ ἐγένετο ἑσπέρα, ᵹ ἐγένετο πρωῒ ἡμέρα τετάρτη. ᵹ εἶπεν ὁ θεὸς, ἐξαγαγέτω τὰ ὕδατα ἑρπετὰ ψυχῶν ζωσῶν, ᵹ πετεινὰ πετόμενα ἐπὶ τῆς γῆς, κατὰ τὸ στερέωμα τοῦ οὐρανοῦ. ᵹ ἐγένετο οὕτως.

תרגום אונקלוס בקדמין

‏בקדמין ברא ייי ית שמיא וית ארעא : וארעא הות צדיא וריקניא וחשוכא על
‏אפי תהומא ורוחא מן קדם ייי מנשבא על אפי מיא : ואמר ייי יהא נהורא והוה נהורא :
‏וחזא ייי ית נהורא ארי טב ואפריש ייי בין נהורא ובין חשוכא : וקרא
‏ייי לנהורא יממא ולחשוכא קרא ליליא והוה רמש והוה צפר יום חד :
‏ואמר ייי יהי רקיעא במציעות מיא ויהי מפריש בין מיא למיא : ועבד ייי ית
‏רקיעא ואפריש בין מיא דמלרע לרקיעא ובין מיא דמעל לרקיעא והוה כן : וקרא
‏ייי לרקיעא שמיא והוה רמש והוה צפר יום תנין : ואמר ייי יתכנשון מיא מתחות
‏שמיא לאתר חד ותתחזי יבשתא והוה כן : וקרא ייי ליבשתא ארעא ולבית
‏כנישות מיא קרא יממי וחזא ייי ארי טב : ואמר ייי תדאית ארעא דתאה עסבא
‏דבר זרעיה מזדרע לזנוהי ואילן פירין עביד פירין לזנוהי דבר זרעיה ביה על ארעא
‏והוה כן : ואפיקת ארעא דתאה עסב דבר זרעיה מזדרע לזנוהי ואילן עביד
‏פירין דבר זרעיה ביה לזנוהי וחזא ייי ארי טב : והוה רמש והוה צפר יום תליתאי :
‏ואמר ייי יהון נהורין ברקיעא דשמיא לאפרשא בין יממא ובין ליליא
‏ויהון לאתין ולזמנין ולממני בהון יומין ושנין : ויהון לנהורין ברקיעא
‏דשמיא לאנהרא על ארעא והוה כן : ועבד ייי ית תרין נהוריא רברביא ית נהורא
‏רבא למשלט ביממא וית נהורא זעירא למשלט בליליא וית כוכביא : ויהב יתהון ייי
‏ברקיעא דשמיא לאנהרא על ארעא : ולמשלט ביממא ובליליא ולאפרשא בין נהורא
‏ובין חשוכא וחזא ייי ארי טב : והוה רמש והוה צפר יום רביעאי :
‏ואמר ייי ירחשון מיא רחשא נפשא חיתא ועופא דפרח על ארעא על אפי רקיע שמיא :

CHALDAICAE PARAPHRASIS TRANSLATIO.
CAPVT PRIMVM.

IN principio creauit Deus cælum & terram. Terra autem erat deserta & vacua: & tenebræ super faciem abyssi: & spiritus Dei insufflabat super faciem aquarum. Et dixit Deus, Sit lux: & fuit lux. Et vidit Deus lucem quòd esset bona. Et diuisit Deus inter lucem & inter tenebras. Appellauitque Deus lucem diem, & tenebras vocauit noctem. Et fuit vespere & fuit mane dies vnus. Et dixit Deus, Sit firmamentum in medio aquarum, & diuidat inter aquas & aquas. Et fecit Deus firmamentum: & diuisit inter aquas quæ erant infra firmamentum, & inter aquas quæ erant super firmamentum: & fuit ita. Et vocauit Deus firmamentum cælum. Et fuit vespere & fuit mane, dies secunda. Et dixit Deus, Congregentur aquæ quæ sub cælo sunt in locum vnum, & appareat arida. Et fuit ita. Et vocauit Deus aridam terram, & locum congregationis aquarum appellauit maria. Et vidit Deus quòd esset bonum. Et dixit Deus, Germinet terra germen herbæ, cuius filius sementis seminetur secundum genus suum, & arborem fructiferam facientem fructum secundum genus suum, & in eo erit semen facientis fructus, cuius filius sementis in ipso secundum genus suum. Et vidit Deus quòd esset bonum. Et fuit vespere & fuit mane, dies tertius. Et dixit Deus, Sint luminaria in firmamento cæli, ad illuminandum super terram, & ad diuidendum inter diem & noctem: & sint in signa & in tempora: & vt numerentur per ea dies & anni. Et sint in luminaria in firmamento cæli ad illuminandum super terram: & fuit ita. Et fecit Deus duo luminaria magna: luminare maius in dominatu in die & luminare minus in dominatu in nocte: & stellas. Et posuit eas Deus in firmamento cæli ad illuminandum super terram: Et ad dominandum in die & in nocte: & vt diuiderent inter lucé & tenebras: & vidit Deus quòd esset bonú. Et fuit vespere & fuit mane, dies quartus. Et dixit Deus, Serpant aquæ reptile animæ viuentis: & auem quæ volat super terrá super faciê aëris firmamentú cælorum.

A 2

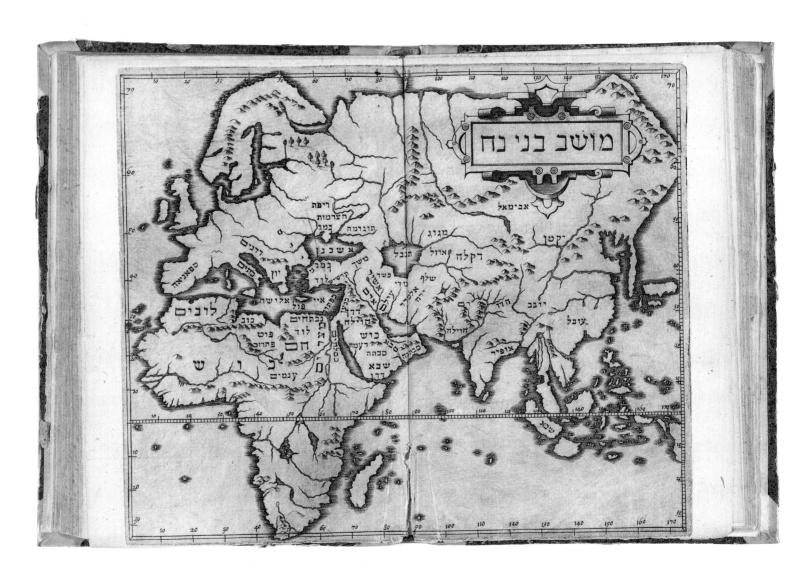

מושב בני נח

10 A Hebrew map in a work by Hugh Broughton

(*above*) *Parshegen nishtewan*, Amsterdam 1606, 185 x 300 mm [ROS. 19 G 2]

(*below*) 'Christian Knight' map, by Jodocus Hondius, 1596 or 1597

[Courtesy of the Royal Geographical Society, London]

MAPS CAN TELL US more than many a page of text. Perhaps that is why one of the few engravings in Hugh Broughton's *Parshegen nishtewan* (extract from a letter from a Jew of Constantinople, Amsterdam, 1606) is a map of the Old World. Translated, the title in the simple cartouche reads: The settlement of the sons of Noah. Similar maps from previous centuries reveal the theme in Broughton's map to be far from novel. In fact one might even call it 'old fashioned'.

Circular maps in which the earth is a round land mass surrounded by a world ocean are found from the early Middle Ages. The name T-O maps is derived from the stylized version of the map in which the Mediterranean Sea and the perpendicular Nile and Don together form the letter T in the middle of the O of the circular world. These maps appear in many shapes and sizes, from small examples of a few centimetres (sometimes no more than a decorated capital O) to the highly detailed large *Mappæ mundi*, such as the one preserved at Hereford cathedral in England. Noah maps form a special subgroup. The T separates the known world into three continents: Africa, Asia and Europe. Inspired by Genesis X, these T-O maps were filled with the names of Noah's sons and descendants with Shem, the oldest, receiving the largest part, Asia. Ham was given Africa, and Europe went to Japheth.

Despite the spectacular development of modern 'secular' cartography since the thirteenth century, the T-O map continued to symbolize the Old Testament perspective until the early sixteenth century. Particularly beautiful examples are contained in manuscripts and later printed editions of two works by Isodor of Seville, the *Etymologiarum sive originum libri* XX and *De Natura rerum*. The former contained the first printed map (Augsburg 1472).

The map with the Hebrew text discussed here forms a 'modern' but nevertheless unique variation on this old theme. Naturally, by the early seventeenth century it was no longer possible to resurrect the T-O map. This map provides a simplified but exact reflection of contemporary geographic knowledge of the Old World. Even so, the actual cartographic example on which this remarkable map was based has proved hard to locate. Quite inexplicably, the map employs the Mercator projection, seen in the increasing latitudes towards the poles, so that it does not seem to bear any cartographic similarity with other sources from the first decade of the seventeenth century.

Indeed, various essential cartographic differences mean that the famous world map of Willem Jansz. (Blaeu) of 1606, one of the first to employ Mercator's method of representation, cannot have been the source. Other contemporary maps reveal a more conservative view and generally contain a different layout and projection. However, despite the difference in projection, the map in Jodocus Hondius's first edition of the *Atlas Minor* of 1606 opens a certain perspective. Eliminating the projection difference, the two hemispheres of this world map appear, in a simplified form, to belong to the same cartographic family, based on the same source, but which?

And why was Mercator's projection used? After all, it was an unusual mathematical basis for map makers of the early seventeenth century. Moreover, the projection is only really suited to nautical charts and world maps with a similar (conformal) purpose. It was never intended and indeed was never used for an accurate illustration of a part of a hemisphere. The choice of projection was probably not made with a view to an optimum height-width proportion for Broughton's text; in fact the slightly oversized engraving had to be folded over! One can only conclude that the map, with its curious extension, was directly borrowed from part of a larger world map in Mercator's projection. A little research reveals that the source was not Willem Jansz.'s famous map, but an earlier, far rarer world map, by Jodocus Hondius, as predicted. The fragment concerned was copied slavishly in its original format for Broughton's publication from a rather obscure emulation of Mercator's method, the so-called 'Christian Knight' map of 1596 or 1597. Besides being one of the finest late sixteenth-century world maps, it had a strong religious tint. Its contents are based mainly on the work of Petrus Plancius of the early 1590s.

As far as the rest of the map's content is concerned, we can be brief here. Clearly, the maker of the Noah map—perhaps it was Jodocus Hondius, an old friend of Broughton's—attempted to provide each of the sons of Noah with a place on earth. To achieve this, all the toponyms in the original map, with the curious exception of Spain, have been omitted.

JAN W.H.WERNER

11 Isaac Franco's memorandum on the legal position of Sephardi Jews in Holland

Folio 1r, 352 x 235 mm [HS.ROS. 350/1]

THIS MEMORANDUM WAS AMONG the Hugo Grotius's papers auctioned by Martinus Nijhoff in 1864. The manuscript was subsequently acquired for the Bibliotheca Rosenthaliana in 1899 by J.M.Hillesum (1863 – 1943) at the Henriques de Castro auction. Folia 202 – 204 contain a Portuguese text and a contemporary Dutch translation; attached to this is a nineteenth-century translation. Other parts of the Hugo Grotius archive relating to his *Remonstrantie* or 'Exposition regarding the regulation pertaining to Jews in Holland and West Friesland' and preparations for this work (fols. 1 – 200 and 205 – 211) are in the possession of the Amsterdam Portuguese-Jewish Seminary library Ets Haim/ Livraria Montezinos (MSS. 48 A 2 and 48 A 5: VI; at present on loan to the Jewish National and University Library in Jerusalem).

The seventeenth-century Dutch translation of the memorandum was reproduced—with slight mistakes— in 1949 by Jaap Meijer (1912 – 1993) in his edition of Grotius's *Remonstrantie* (p. 141 – 143). Meijer suggested (p. 99) that the author had in fact been the *parnas* and merchant Isaac Franco, who led many of the negotiations with the authorities in and around Amsterdam at the time. This is plausible. We know for example that Isaac took part in 1605 in negotiations with the Haarlem magistracy about the terms on which Jews might be admitted to that city.

Here arguments are presented for the admission of Jews to Holland and for granting Jews religious freedom. The author maintains that the reason why the Amsterdam magistracy only issued a 'provisional' ordinance on 8 November 1616 (see the Amsterdam *Handvesten* edition of 1748) was that the States of Holland were expected to pass a different ruling in the near future. He cites the religious tolerance of the Dutch Republic and argues that this is the main reason that Jews, persecuted by the Inquisition, were settling in this country. Any new restrictive measures imposed on a population group that had by now been living in Amsterdam in freedom for two decades would certainly rekindle memories of the hated Inquisition. The author warns that because of the enemies the 'Portuguese' merchants face as a result of their [Jewish] religion and because of the jealousy of their competitors, a strict regulation against 'temptation' [to the Jewish religion] and 'blasphemy' [against Christianity] might be used by some Christians as a means to avoid paying perfectly legal debts. Those preparing the new regulation should remember that members of the 'Portuguese nation' had brought great wealth to this country through trade. The 'Portuguese' intended no harm. If any among them were to commit an offence by attempting to win converts or to have relations with Christian women, then the authorities should deal with them as they saw fit.[1]

 AREND H.HUUSSEN JR

Praticasse nestes Paizes que os ss dos Estados de Hollanda, avendolhe por muitas vezes dado Reporte algûs dos Portuguezes que nelles morão, seguindo a Lei Hebrea, argumentavão, e desputavão com a Nação mengua, sobre sua Relligião, e os incittavão e a seus seruentes a que seguissem a Lei Hebrea, fallando mal Relligião, e dormião com framenguas della, com outras mais couzas. queria sobre tudo isso, por ordem como se ouuessem de gouernar com penas lemittadas, e com Placartes publicos para uir á Nottícia de todos

A tenção de dittos ss he santa, e boa; porem avendosse de seguir como se prattica; parece que não conuem ao Estatíco, nem Repbublíco, e que antes se deue examinar os danos que podem se ahi uir tanto ao País, como á Portugueza. Pello que debaixo de correição, quiz fazer hû breue Projeito, para que os ss aquem toca, uee de suas Benegnidades, e prudença, ao Rezoluer do Cazo, queirão Ponderar algûs couzas importantes a todo

A Primeira que en todos estes Paizes se conceruou sempre a Liberdade de Conciencias, e abominarão todos Nome Inguisição. —

A segunda que a Nação Portugueza, se veo a estes Estados de Vinte Annos a esta parte; e só na Cidade de A Viuem oje mais de 200. Familliaz, alem de outras que vem uindo, e que uierão fogindo do fogo da Inguisição outros Desaforos que comettez se uzava, fiadas na Liberdade de Conciencias, concedida nestes Estados, e forão Recolhidos, e fauorecidos, pellos ss Estados, e pellos ss os Magistrados, com todo Amor, e Honra, tratando como aos Proprios Natturaez

A terceira que ditta Nação Portugueza, e as mais que nestes Paizes Rezidem, tendo como tem Liberdade podem seguir a Lei, e Relligião que lhes Parecer, sem lhe Perguntar por ella; pois outra se mostraria e forão sugeittos a outra Inguisição semelhante á de Hespanha. —

A quarta. que esta Nação Portugueza, por toda ser Mercantil, tem nestes Paizes muitos enemigos, tanto Por cauzo de Relligiois, como dos Negoceos que fazem. pello qual Respeito os dezeão uer fora delles, que he cauza dos reportes dão, parecendolhe que ficarão gozando de seus Proueitos, e que feitorisarão os Negoceos alheos que os dittos Portuguezes fazem. —

E a quinta que despois que a Nação Portugueza entrou nestes Paizes com seus trafícos, dão muito proueito a elle pode uer pello que Pagão nas Comuoias, que he huâ grande cantidade de Dxº cada Anno. Mchem estes Paizes Riquezas, trazendo a elles de diferentes Reinos, Muito Dxº en contado, ouro, Pratta, Diamantes, Perlas, e outros generos de Mercaduriaz: e fazendo seus cambeos licitos, e Honestos; gastã, e leuã por diferentes Reinos as Manifacturas da Terra, e todo outro genero de Mercadurias que nella Haã. com seus trafícos uiue, e se mantem cantidade de Jente Pobre destes Paizes, trabalhadores, officiais, Barqueiros, Manifactorez, e outros muitos. quexes das cazas despois que rezidem en Amsterdam Hecerão do que de antes andauão a Sô. Porto —

A seixta que nunca na Nação Portugueza se achou que fizesse, nem Procurasse couza, contra os Paizes aonde rezidem sendo como são muito fiéis, e Verdadeiros en todas suas couzas. —

A Setima que Publicandosse Placartes Publicos contra a ditta Nação, e com Penas lemittadas, fica a ditta Nação aos perigos seguintes —

Pual quer Pesoa que deuer Dxº aos da ditta Nação Portugueza, de cambeos, ou de Mercaduriaz que lhe ajão comprado seus seruentes com a Liberdade que poderão a uer da ditta Nação, as Penas que lhe lemittão; testemunharã contra elles, duzendo que os induzirão, a que deixassem a Relligião Cristam, e tomassem outra; que argumentarão com elles com desputas; que blasfemarã. e ficando como os Placartes publicos, metidos en Mãos do Pouo Meudo, com os de Nouidadez, com Mottins, os concurirão e ntendendo que ficarão Liures, com duzer que o fizerão por mal de sua Relligião. De Modo, que em Lugar da Liberdade que uierão Buscar acharião outra noua Inguisição nem os ss os Magistrados com toda sua Benegnidade poderião despois Remediar estes Dannos. —

Poderão en contra disto dizer os ss que de muitos Annos a esta parte se Proquzerão estes Reportes nos Estados e nos Magistrados destas Prouincias, manifestando que os da Nação Portugueza, dezião mal de sua Relligião fallaua Pallauraz mal compostas desputando sobre as Relligiois, induzião aos framengos, e seruentes a ditta Nação a que tomassem a Lei Hebrea, e que sendo a Iguil delles Hebreos, dormião com framengos Pello que a todo Modo conuem dar a esta Nação ordem, como se gouerne nestes Paizes não comuisem, e que ouuessem Placartes que se publiquem Mottim a que era bom que se non Publique Placartes

זהרים והיקרים שתוכל לרמוז כל דבר עם כל דבר שתרצה מה שאין הפה יכול לדבר והאזן לשמוע והזהר
אל תגלהו לשום בריה ואל ימשול זר במעין חתום שאחר שתרגיל עצמך בו ותרע להרכיב ולהתיר ר"ל
לכתוב ולקרוא אודיעך נפלאות יי בטבעיו' וכאלהיות והסוד הזה היה כמוס אצל בעל הסורות של קיסר
מהם אינו כי אם ב' אלפבתות משונות אחת כתב פולן וורולפוס הכ"לך וגלהו למורי וזה מעשהו **הסתר** הזה נשען על ב' לוהות הנגכחיות ואחד
שתרצה ותיחס המין הא' לאות **א** והמין השני לאות **ב** נאהרת כתב ספרדי או איטלקי ב' כתבים משונים איך
נרצה ר"מ לכתוב ליורעים חסור בסתר **ברח דודי** ולפי שבמלות אלו יש ז' אותיות אתה צריך לכתוב 35
אותיות על כל אות חמש והנני מרגילך איך תעשה תרהיב צערי התיבות ותחת כל אות תניח האותיות השייכות לה

לוח ראשון		לוח שני	
אאאאא	**א**		**ב** **א**
אאאאב	**ב**	6	א
אאאבא	**ג**		ב
אאאבב	**ד**	a.	ג
אאבאא	**ה**	ד	ד
אאבאב	**ו**		ה
אאבבא	**ז**	ו	ו
אאבבב	**ח**	ז	ז
אבאאא	**ט**		ח
אבאאב	**י**	ח	ט
אבאבא	**כ**	ט	י
אבאבב	**ל**	י	כ
אבבאא	**מ**		ל
אבבאב	**נ**	כ	מ
אבבבא	**ס**	ל	נ
אבבבב	**ע**	מ	ס
באאאא	**פ**	נ	ע
באאאב	**צ**	ס	פ
באאבא	**ק**	ע	צ
באאבב	**ר**	פ	ק
באבאא	**ש**	ף	ר
באבאב	**ת**	צ	ש
		ץ	ת

בלוח ראשון **ב** **ר** **ח**
אאאבכ בבאאא אאאאב

ד **ו** **ד** **י**
אאאכב אאבאב אאאכב אכאאב

והנה עד כאן כתבת בסתר ב' התיכות הנזכרות אבל קל
להגלות למבינים במלאכת הסיפרוש · לכן צריך לעשות
מ"לפרא על הסי"פרא הנזכרת ותוכל לכתוב כל מה שתרצה
ברוך זה לכל האלפ'ים · צריך שתתקן מלוח השני אותיות
המיוחסות לאלף ולכל הביתין אותיות המיוחסות לבית ·
והא לך הללו את ה' כל גוים שבחוהן כל האמים כי
גבר עלינו חסדו · וכן תכתוב מה שיעלה על רוחך
והדבר ניתר ל' חלקיו שהורכב מהם הילכך בקוראך תתיר
התיבות כך ·
הללו את ה' כל גוים שבחוהן כל האומים כי גבר
אאאא.בב כב אא אאאכ בכאאכב כא אבאבאא אב באב

על · וקל להבין · והנה זאת אות הברית ביני ובניך
אאב בכל עת שתראה· בכתבי אותיות שונות· תרע כי
תוכן רצוף אהבה · ועד לאלוה מילין נתראה בכתבים
עם מכ"ת **וכבר** יצאתי מתורת האגרת ופן אהיה על
הארון למשיא · ובכן בקירה ובכריעה אפטר ממ"כת ·
אוהילה לאל ינדל כסא כבורו· ויהי בזית הורו יראה זרע
הכמים יאריך ימים בקרב ישראל· כנפשו הגשאה מחכימת
פתי ונפש הצעיר שבתלמידי' רמה ותולעה משה בן חקצין
האלוף כמ"ר מאיר מין יצ"ו ·

שעל הכתב לק"ק ווילנא יצ"ו ·

אל הר נבוה ותלול · שם אורח ישר ומסלול · העומר
לנס התבונות · חוקר טמונות וצפונות · החכם התורני

הפלוסוף

12 Nicolaes Briot and Menasseh ben Israel's first Hebrew types

Alphabets of 'Texte' and 'Descendiane' square

and 'Descendiane' semi-cursive Hebrew.

From: *Sefer Elim*, 1629, p. 51 [ROS. 19 F 4]

IN THE PREFACE TO Menasseh ben Israel's first book, a prayer-book dated 1 January 1627, his corrector Isaac Aboab da Fonseca writes:
'Menasseh ben Joseph ben Israel, seeing the Bomberg types worn out, and since nothing can be imperfect for the Holy Work, arose from within the community and went out, and came to the house of an artisan. And behold, he was standing there at his work, the tools of his trade in his hand. He said to him: behold, the money is given to you and the shapes of the letters to make as is good in the eyes of the honourable and respected Michael Judah, first among the scribes, may the Lord consummate his work and may his reward from the Lord God of Israel be complete. The man swore in real writing to make them for him and for no other man. He shaped them with a burin and made them good to look at and fine to read, as perfect as if cast in gold. And there were two men who were amazed to see the completeness of the work and its beauty. It lifted up their hearts to bring to the work of printing a little Siddur, the like of which had never been since there were printers on the earth.'

A contract between Menasseh and Nicolaes Briot was thought to contradict this passage, but both accounts of the making of Menasseh's types have been misunderstood. In fact, the two agree closely: it is tempting to think that the written agreement referred to in the preface is the surviving contract, and that the contract's statement, 'Briot shall make the aforementioned letters as perfect as in the sheet or book already in his possession', refers to the handwritten model for the cutting, approved and perhaps even executed by Michael Judah.

The contract speaks only of 'casting' or 'making' the type, not cutting it, but this does not take away the honour accorded to Briot as the cutter of Menasseh's types. He is documented as a punchcutter from *c.* 1612 to his death, and what evidence we have suggests that he had no other

punchcutter working for him. Any types supplied by his foundry and not known before his time can be tentatively attributed to him, although this needs to be confirmed stylistically as we gradually build a picture of his work as a whole. I suspect he was the best and most important Dutch punchcutter of his day.

A more serious problem is that the contract, dated 18 March 1626, allows only 56 days for the delivery of the first two sizes (with vowel points). This cannot plausibly allow for the cutting of the punches, justifying of the matrices, and casting of the type, even if the casting could be carried out by Briot's workmen. The types must have been at least partly cut before the contract was drawn up. Briot and Menasseh may therefore have made an earlier agreement that was only formalized when the types were nearly ready to be cast. The contract also says nothing about the exclusive rights mentioned in the preface, and Briot's successors certainly sold the type to others.

The contract mentions eight sizes of Hebrew type, all with vowel points. Allowing for some spelling errors by the clerk unfamiliar with printing terminology, the size names are those well established by the end of the sixteenth century, listed from largest to smallest: Canon, Paragon, Texte, Augustine, Mediane, Descendiane, Brevier, and Nonparel. The physical measures of the metal type bodies for these sizes are unambiguous, and with non-Hebrew types it is usually easy to relate them to types in printed books. Hebrew presents special difficulties, however: in a pointed text, the letters and points are cast separately, so that the distance from line to line is the sum of the body sizes of the letters and points. Christoffel Plantin's folio specimen (Antwerp, *c.* 1585) names its Hebrews by the sum of the two bodies, but most seventeenth-century Dutch type specimens name their Hebrews by the smaller body of the letters alone, whether or not they are shown with points.

Briot was to supply 300 pounds of Descendiane Hebrew by 29 April 1626 and an unspecified quantity of Texte Hebrew by 13 May 1626, both with points. After that, he was to supply as much as Menasseh needed of the other sizes. Menasseh's first book uses three typefaces, the two principal ones with twenty-line measures of 70 mm

The largest Hebrew in Menasseh's books, probably

the 'Paragon' of the 1626 contract (*above*; original mem-height 4.2 mm)

compared with Le Bé's 'Texte' Hebrew, 1564 or earlier

(*below*; original mem-height 3.8 mm)

(Descendiane) and 115 mm (Texte), so the contract clearly refers to these types by the full bodies (the third face, probably the Paragon of the contract, is used only for single-line headings and initials). These were Menasseh's only Hebrews until 1629, and his only square Hebrews until 1631.

Briot did cut remarkable miniature types, yet it is hard to believe that he offered a Hebrew with a full body as small as Nonparel (43 mm / 20 lines). No Hebrew so small is known in Menasseh's books or in any other books of the time. The contract may therefore name types sometimes by the full and sometimes by the undersized body, and one face may be cast on more than one body. In fact, Menasseh's first book sometimes uses the Descendiane unpointed with a twenty-line measure of 58 mm (Brevier), and occasional words of the Texte in Menasseh's non-Hebrew books appear in solid lines of 82 mm (Mediane) roman.

Briot was probably only about forty years old when he died in August 1626, three months after he was to have delivered the second size of Hebrew. He left contracts with Willem Jansz Blaeu unfulfilled, so one may suspect that the three faces in Menasseh's first books are all that he delivered. His widow might have supplied some of the additional types in Menasseh's later books, but even these cannot account for all of the types named in the contract. No known Menasseh Hebrew is large enough to be called Canon, for example, although a Canon used with Menasseh's Paragon many years later matches it in style (used by David Tartas in 1665).[1]

The preface of the prayer-book also agrees with what we know from other sources. The Plantin printing office at Antwerp had matrices for several Hebrew types cut by an unidentified punchcutter for Daniel Bomberg in the years 1517 – 1523 and by Guillaume Le Bé for Plantin and others in the years 1551 – 1570. Some of these were used in the Northern Netherlands, but since the Plantin office rarely supplied other printers with type from their matrices, it may well have been difficult to acquire founts of the Bomberg types in good condition in 1626 (Plantin used the Bomberg and Le Bé types together, and Menasseh may have referred to all of them by the more famous Bomberg name).

The Bomberg and Le Bé types are clearly based on letters written with a broad-edged pen, but Menasseh's first types consistently show the swelled strokes characteristic of the pointed pen or brush, or of intaglio engraving. Unfortunately, little is known about the writing instruments of the Hebrew scribes. The Briot / Menasseh types were the first to introduce this new style, which remained the norm for Sephardi types into the twentieth century (it is still common today). Roman types gradually changed in a similar way during the seventeenth and eighteenth centuries. Stylistic changes usually appear in hand-lettering earlier than in the conservative world of type design, so the claim that Menasseh's punchcutter followed a scribal model rings true.

Only one manuscript signed by the scribe Michael Judah [Leon] (fl. 1624 – 1643) has been located. This is an Esther scroll dated [5]403 (1642/43). Although written more than fifteen years after the Menasseh types were cut, it should be compared with them. As this article went to press I had been able to see only a reduced and screened reproduction. There are few examples of formal square Hebrew lettering from the early Sephardi community in Amsterdam, and even fewer have been precisely dated or attributed to a particular scribe, so the exact relation of Briot's types to the manuscripts that preceded them remains to be investigated.

Even so, it is clear that the famous 'Amsterdam Type' begins with Nicolaes Briot cutting for Menasseh after handwritten models approved by Michael Judah Leon. Together these three men set the style of Sephardi printing types until, three hundred years later, designers turned back to older models for fresh inspiration.

JOHN A. LANE

א ב ג ד ה ו ז ח ט

א ב ג ד ה ו ז ח ט

י כ ך ל מ ס נ ן ס

י כ ך ל מ ס נ ן ס

ע פ ף צ ץ ק ר ש ת

ע פ ף צ ץ ק ר ש ת

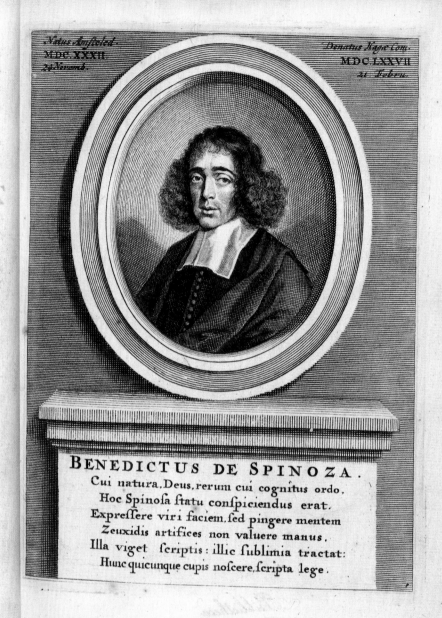

BENEDICTUS DE SPINOZA.

Cui natura, Deus, rerum cui cognitus ordo,
Hoc Spinosa statu conspiciendus erat.
Expressere viri faciem, sed pingere mentem
Zeuxidis artifices non valuere manus.
Illa viget scriptis: illic sublimia tractat:
Hunc quicunque cupis noscere, scripta lege.

13 Benedictus de Spinoza

Engraving bound with *De nagelate schriften*, Amsterdam 1677,

222 x 170 mm [ROS. 19 C 22]

BARUCH DE SPINOZA was born in Amsterdam in 1632, of Portuguese Marrano ancestors who had come to Holland to live in the Jewish community. Spinoza was educated in the schools of the Sephardi community. Apparently influenced by radical thinkers within and outside the Jewish community, he began to rebel in 1655 – 1656. He was excommunicated in July 1656 when he refused to give up his unorthodox opinions and practices. A vehement denunciation was read out, although it does not make clear exactly what the charges were. Spinoza withdrew from the Jewish community and moved in with the non-denominational Christian group, the Collegiants, and soon left Amsterdam for Rijnsburg. He participated in the activities of a philosophical group in Amsterdam, and received a life pension from one of its members, Simon de Vries. Thereafter, Spinoza lived a quiet life, grinding lenses. In the early 1660s Spinoza began writing his major philosophical works, most of which were only published posthumously.

Spinoza's first publication was *The Principles of Descartes's Philosophy*, in which he described the Cartesian system and began introducing his revised version of Descartes's metaphysics. In his second publication, the *Tractatus Theologico Politicus*, he expounded his radical ideas about revealed religion and his political philosophy. In this work Spinoza portrayed Judaism as a historical religion which made sense in ancient times, but which had now become obsolete. He denied the supernatural status of the Bible and raised basic questions about whether the text that we have is an accurate copy of what Moses and the prophets wrote or just an accumulation of ancient Hebrew writings. Spinoza insisted that the acceptance of biblical religion was a result of human superstition. Once people had accepted the 'new science', they would no longer believe in these stories.

Events can be understood in purely scientific terms and need no active purposeful god to explain them. Human behaviour should be ordered by the essential moral message of the Bible and other religious and philosophical accounts, 'that the worship of God consists only in justice and charity, or love towards one's neighbour'. Spinoza also contended that religious groups have no political authority, but should only teach people to obey the moral and social order. These views were considered outrageous at the time, and the *Tractatus* was immediately banned, though it readily circulated in the Dutch Republic and soon in France, England and Germany as well.

Spinoza moved to the area around The Hague to be able to maintain contact with various scholars. His associates included a wide range of people of many different philosophical and religious opinions. There he worked on his *magnum opus*, *The Ethics*, published after his death in 1677 in a collection, his *Opera*, which included various letters discussing philosophy. Spinoza never joined any Christian group, though he was buried in the New Church in The Hague.

His *Ethics* is presented in geometrical form, with definitions, axioms and proofs. Spinoza worked out his metaphysical system in detail, rejecting any supernatural explanation. God or Nature was the necessary cause of whatever is. Man is just a modification of God or Nature. Spinoza's God has no personality or will, and is definitely not the Divine Being of either Judaism or Christianity. In the Appendix to Book 1 of the *Ethics* Spinoza rejected traditional religious explanations as superstitions. The finale of the *Ethics* is the hope that man will see all things from the aspect of eternity. Everything can be explained by physical or psychological causes, which are two aspects of the same ultimate substance, God or Nature. Seeing the world this way leads to peace of mind through a vision of this necessary universe, and through unifying oneself with it. Spinoza's philosophy is the first genuinely modern one. It has had great appeal among those seeking understanding outside traditional religious frameworks.

Spinoza's views about historical Judaism and about the history of the biblical text provided an impetus for biblical criticism and for the rejection of what he called 'ceremonial laws', the traditional religious practices that have been handed down. This led to much re-evaluation of the Bible in historical, social and psychological terms, and has influenced the development of reformed Judaism and ethical religious formulations without any creeds or practices.

RICHARD H. POPKIN

14 Jacob Judah Leon Templo's broadsheet of his model of the Temple

Hand-coloured poster, 455 x 530 mm [ROS. A 7-1]

J ACOB JUDAH LEON was born in 1602 in a Portuguese coastal town west of Coimbra. His parents fled to Amsterdam in 1605, where they embraced Judaism. Jacob trained to become a rabbi. From a letter by the Dutch poet and statesman Constantijn Huygens it appears that as a young man he had followed lectures in Hebrew literature by Leon. Apparently, Jacob's later contacts with the courts of the House of Orange and the king of England had their origins in this friendship with Huygens.

He succeeded the first rabbi of Hamburg, Isaac Athias, in 1628 but returned to Amsterdam in the 1630s. Probably after the fusion of the three Portuguese-Jewish communities, he lost his position in Amsterdam. He moved to Middelburg, taking up a rabbinical post there. Recent research has revealed that he was supported by a Millenarian theologian, Adam Boreel, who belonged to an international group of Christian scholars including Comenius, Serrarius, Hartlib and Durie. This group also maintained contacts with Menasseh ben Israel.

With Boreel, Jacob prepared a vocalised Hebrew edition of the Mishnah together with a Spanish translation. The book was published in 1642 by Menasseh ben Israel and was financed by Boreel.

In Boreel and Leon's joint study the Temple of Jerusalem apparently played an important role. This is hardly surprising since Millenarians believed that, since Jerusalem would be the centre of the millenarian kingdom, the Temple would have to be reconstructed after the Messiah's Second Coming. This resulted in the idea of building a model Temple based on the details given in the Hebrew Bible, by Flavius Josephus and contained in rabbinic literature. This model was constructed by Jacob, again financed by Boreel, and was well received. Jacob wrote an explanatory booklet on the subject in Spanish, *Retrato del Templo de Selomo*, published in Middelburg in 1642, preceded by a Dutch translation in the same year. The work was very popular and was reprinted time and again. It was eventually published in French, German, Latin, Hebrew, Yiddish and English.

In the meantime Leon moved to Amsterdam to supervise the edition of the Mishnah. He was appointed to teach at the Talmud Torah school of the Portuguese Jewish community. His qualities as a teacher appear from his Spanish translation with commentary of the Book of Psalms, published in 1670/71. Leon ordered engravings of the model, selling them together with his booklets; he exhibited the model in his house where it attracted visitors from far and wide. He added a second model to his private museum: the Tabernacle in the desert. He wrote an accompanying booklet and had illustrations made of the model. These models were portable and he travelled around with them. In 1646 they were on show at fairs in The Hague and Haarlem. According to Leon's letters, now in the Bibliotheca Rosenthaliana's collection, he also exhibited them at the Prince of Orange's court. In 1675, he travelled to London with his family and models, with letters of introduction from Huygens to, among others, the famous architect Christopher Wren.

During the summer of 1675 he returned to Amsterdam alone, probably to take part in the inauguration of the new Portuguese Synagogue, the architecture of which may have been influenced by Leon's models. He did not live to attend the ceremony; he died on 19 July and was buried at Ouderkerk cemetery where his tomb mentions his models in a Hebrew epitaph.

That Jacob Judah Leon had a keen eye for advertising his models is clear from two extremely rare posters, both in the collection of the Bibliotheca Rosenthaliana. Each shows a different portrait of Leon. In addition, the first of three known copies, dated around 1645, displays an engraving of the Temple, also found in his books, with copious explanatory texts in Dutch.

Of the second hand-coloured poster shown here, only one other copy is known to exist. It was added to the collection recently with support of the Bibliotheca Rosenthaliana Foundation. Dated after 1652, its main theme is the Tabernacle, with some additions on the Temple, the High Priest, and, an element unknown in the published sources on Leon, a representation of the Israelites in the desert. It also supplies us with new information on Jacob himself, who we now know lived on Korte Houtstraat, in a house displaying the sign of Solomon's Temple.

ADRI K. OFFENBERG

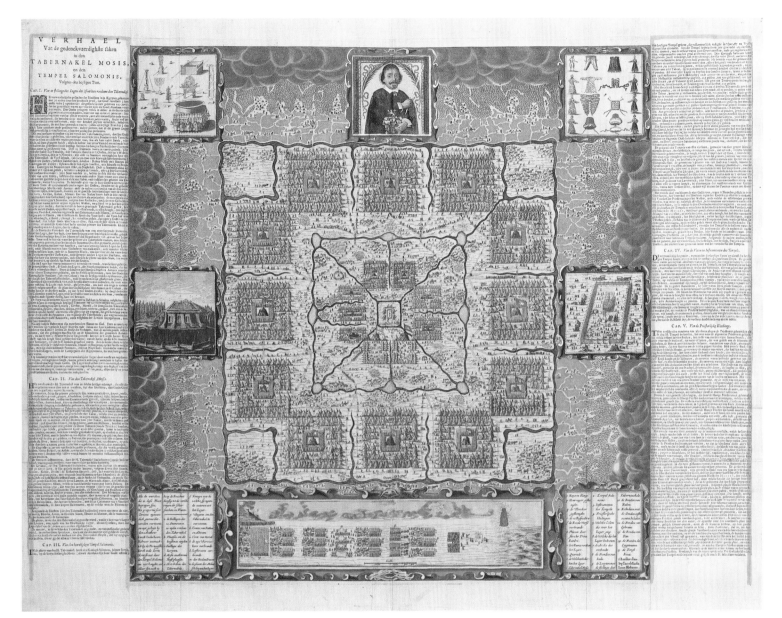

15 A show of hands by the Sephardi writing-master Iehudah Machabeu

Iehudah Machabeu's various hands, La Rochelle 1655,

353 × 249 mm [HS. ROS. PL. B-80]

ACCORDING TO A Middelburg school ordinance of 1591, the first to be printed in the young Dutch Republic, schoolmasters had to show their qualifications publicly in a *caerte* or *monster*, a sheet of parchment or paper hung on a clearly visible place or stuck on to a signboard.

Since foreign correspondence had to be written in the scripts (or hands) and languages of the countries concerned, scribes had to prove their penmanship with an exemplar leaf showing all the hands at their command. The practice was not a novel one, as celebrated examples from earlier times show. A number of these exemplar leaves have been preserved from the seventeenth century, in addition to a great many manuscript or copper-engraved copy books and other specimens of calligraphy and proficiency from an age when calligraphy flourished in the Republic.

The exemplar leaf opposite fits into this tradition. Written in brown iron gall ink on the hairside of the parchment, it measures 353 by 249 mm. A hole in the right-hand lower half has been restored with a strip of paper on the back, resulting in some loss of text, and the ink has faded or has worn in some places. Pinholes in the outer margin indicate that the leaf may have been attached to some kind of board. It therefore probably functioned as an actual notice and was not simply commissioned by some *amateur de la plume*—or collector of calligraphy. In any event, our exemplar leaf has withstood the wear and tear of time remarkably well.

As can be read in the left-hand bottom corner of the central rectangle, the exemplar was completed at La Rochelle on the French Atlantic coast, half-way between Nantes and Bordeaux, on 21 June 1655 by Iehudah Machabeu. The leaf offers a genuine show of hands with no fewer than twelve four- to six-line texts of a religious nature in Hebrew, Greek, Arabic, Gothic and Humanist scripts. The central rectangle is surrounded by a linear frame and subdivided into four compartments by rules. Above are French and Italian texts, both in Italian hands (the *posée* and the *corsiva*), a Latin text in Roman round script, and a French text in a Gothic script—an upright secretary

hand. Surrounding this rectangle are another eight texts, marked off by linear frames which are themselves contained in floral cartouches. Most of these are in a smaller format, and all but one have headings.

Clockwise from the top we see the 'Letra Hebraica', a Hebrew text with an alphabet in Sephardi square script, the 'Letra Griega'—Greek text with a capital alphabet, the 'Letra Redondilla', a Spanish upright secretary hand, five lines of German text in a bastarda, the 'Letra grifa', Spanish text in an Italian 'formata', the 'Letra Ynglesa', English text in an upright (Gothic) secretary hand, the 'Letra Castellana', Spanish text in an Italian hand much resembling the 'formata', and finally the 'Letra Arabiga'. The open spaces are filled with exquisite pen drawings, depicting various birds and a dragonfly among plants, tendrils and flowers—some of them in pots or vases.

This exemplar leaf exudes delicacy and distinction; the sustained quality of the writing testifies to an extraordinary talent. Who was this scribe? What do we know about him? Archive material and data from extant calligraphic works show that Iehudah Machabeu, also known as Louis Nunes Dovale, was a member of the Spanish-Portuguese community in Amsterdam, where he was first recorded in 1617. He emigrated to Dutch Brazil, where he resided from 1646 to 1654, gaining fame as a copyist in Pernambuco. When the Portuguese ousted the Dutch, our scribe returned to the Old World and settled at La Rochelle. In 1659 he appears to have returned to Amsterdam, where he continued practising his penmanship until his death some time after 1664. He was buried at the Jewish cemetery of Ouderkerk. As Dr. E.G.L. Schrijver of the Bibliotheca Rosenthaliana recently stressed, Iehudah Machabeu was also a master forger during the Eighty Years' War, counterfeiting Spanish documents for Dutch merchants wishing to break the Spanish embargo.

Two lines of Spanish, tucked away under the 'Letra Castellana' text, middle-left, are perhaps revealing: *La diligencia a provecha / mas que la ciencia*—industry is more profitable than science. Was this Iehudah Machabeu's vision of life?

The extant calligraphic work is impressive, compared to that of contemporary Dutch writing-masters. Best known are perhaps the calligraphic copies he made of Saul Levi Mortera's *Providencia de Dios con Ysrael y Verdad de la Ley de Moseh*, of which one (Amsterdam 1664) is preserved in the Bibliotheca Rosenthaliana (see Herman P. Salomon's article, later in this work, no. 17), but equally beautiful are his smaller works such as festival prayer-books, copy books and the like. Iehudah Machabeu, a true penman, ranks among the best scribes of the Golden Age of Dutch calligraphy.

TON CROISET VAN UCHELEN

16 An illustrated *Minhagim* book printed in Amsterdam

Simeon Levi Gunzburg, *Sefer Ha-minhagim*, published by Uri Fayvesh Halevi,

folios 62 v – 63 r, 176 x 265 mm [R O S. 15 G 36]

J E W I S H L I F E I N the Northern Netherlands is first recorded in the 1590s, when Portuguese Marrano merchants settled in Amsterdam and gradually resumed their faith. After the arrival of the first Sephardi Jews Ashkenazi Jews began to arrive from Germany and Poland too. Although granted some legal rights, the Jews were banned from all guilds, except for that of the booksellers, publishers and printers.

The first Jew to print Hebrew in the Northern Netherlands was Menasseh ben Israel, who was later succeeded by Elijahu Aboab. Aboab was the local pioneer of illustrated Hebrew and Yiddish books. In 1645 he printed Simeon Levi Gunzburg's Yiddish version of *Sefer Ha-minhagim*, embellished with woodcuts. The first illustrated edition of Gunzburg's *Book of Customs* had been published in Venice by Giovanni di Gara in 1593. Apparently, the anonymous artist of the Amsterdam edition aimed to replicate the iconographic scheme of the Venetian prototype to the minutest detail. Nevertheless, this edition of 1645 became a model in its own right for both the second and third editions of the Amsterdam *Minhagim*, published by Uri Fayvesh ben Aaron Halevi in 1662 and 1685, respectively.

Uri Fayvesh's *Minhagim* edition of 1685 is, in many ways, revolutionary. Its title-page is solely in Hebrew, without a trace of Yiddish, and it includes only twelve *Minhagim* illustrations. Yet this specific edition raises a much greater question, pertaining to the readers for which it was published, for it is here that the illustrations appear for the first time in a Hebrew book.

So far, four Hebrew books using these illustrations have been recorded: the *Minhagim* of 1685, the edition by Solomon Proops of 1708, and two editions by Solomon Levi Maduro, dated 1768 and 1774. In fact, Maduro published three different editions of the *Minhagim* in 1768, with identical title-pages, layout, and woodcuts. One of them, with Spanish insertions, was apparently intended for a Spanish-speaking public. Another version of this book deviates from the Spanish edition in three instances, where the Spanish text was replaced by a Hebrew one.

It is highly plausible that the leaders of the Sephardi community felt the need to provide manuals of conduct similar to the Ashkenazi *Sefer Ha-minhagim* for the Marranos, who wished to re-embrace Judaism. Yet while the text was abbreviated and adapted for this specific clientele, the illustrations accompanying it were taken from the Ashkenazi source unaltered. Moreover, in later editions of the Sephardi books, the Ashkenazi iconography was retained, even when some or all of the woodblocks needed replacement.

All the known books from Amsterdam that include the *Minhagim* illustrations are customals, whether Ashkenazi or Sephardi. Only in one instance were they incorporated in a broader context, and that in a non-Jewish context.

Among the prominent Dutch Hebraists and theologians was Johannes Leusden, from the University of Utrecht. One of his most important studies, the *Philologus Hebræus* (editio princeps, Utrecht, 1656), goes far beyond a philological research of the Hebrew language and is a comprehensive study of Judaism and Jewish life. Of the other works by Leusden, one is of interest here. Entitled *Philologus Hebræo-Mixtus*, it appeared in 1663 with eight illustrations based on the *Minhagim*. Leusden's woodblocks, however, are not identical to any known set. One should, therefore, assume that he either commissioned new blocks or borrowed existing panels from some source.

In 1660 – 1662 Leusden cooperated with Amsterdam printer Joseph Athias in the publication of the first Hebrew Bible with verse enumeration. Jointly with two Jewish correctors, he was asked to proof-read the text. Athias and Leusden maintained similar contacts for a number of years. It is possible that some time after establishing his printing press in 1652, Athias published the *Minhagim* with newly carved illustrations according to the traditional iconography. These could have been lent to Leusden later, for the publication of the *Philologus* of 1663.

Whether these illustrations stem from an unknown edition of the *Minhagim* or not, the woodcuts have apparently been utilized only in this edition of the *Philologus*. Later editions boast copper engravings, according to the artistic taste of the time.

The appearance of the *Minhagim* illustrations in a book on the customs of the Jews by a Christian author and their repeated use both by the Ashkenazim and the Sephardim in Amsterdam exemplify the interrelations between these socio-religious groups. Furthermore, the illustrations which have been uprooted from their original cultural-historical milieu in Ashkenazi Venice of the late sixteenth century, were transplanted into a realm both chronologically and geographically distant. Woodcuts that may have reflected contemporary Venetian-Jewish life thus lost their validity as a historical source.

N A O M I F E U C H T W A N G E R - S A R I G

היבט מן ויהי דבר ייאל משה לאמר וכו' בן אדם בית ישראל יושבים על אימאס' מג' פֿאלט
חוט' קין יונגר זול דים הפטרה גימן : מג' מיז ניט מזכיר נשמות' (מן פֿון מזי ון מזכיר
נשמות') : צו מנחה זאגט מן ואלול צדקתך :

פרשת החדש

דן יוצר פֿון פרשת החדש היבט
מן אות זה החדש' רט זולת
אל עושה נפלאות' (מין פֿון מוג'
פיהם ענרהרן זאנט מן רש אופן
כבודו משבחים) מן אתיית עת דורים' מוז היבט מוים
שויים ספרי תורת זיימט מין דער
ערטטן מין דער זאמלן סררא' רוטט
זיבן מיך' המלב קריש' מוז' רעם
דער דים הפטרה זאמנט זיימט אן מין
דער מנדר קף תורה מין בא אל
פרעה היבט מן ויאמר ייאל משה ואל
אהרן בארץ מצרים לאמר' החרש
הזה לכס' ביז בכל מושבתיכם
תאכלו מצות' מוז' זאגט דים הפטרה
מין יחזקאל היבט מן כה אמר' ברא
שון באחד לחרש' מוז בענטט ראש החש ניסן' צו מוקף
זאנטא מין קרובץ היבט מן ואל צדקתך' אן מיז ניט מזכיר נשמות'

ווען פרשת החדש מק ראש חדש ניסן מוער' צו מנחה זאגט מן ואלול צדקתך' אן מין
טט' איז' מין בריילוֹט מין רען פֿון גיטריבן' האב מיך פֿורין מין זיסן' פֿור ברכו'
דש יוצר פֿון דער וולכן פרשה' רט אופן פֿון דער בריילוֹט' זולת פֿון דער פרשה' מוז' זאנט
מך מין ווינ' פֿון רעם פֿון זולת פֿון דער בריילוֹט מין דער כראות חתן' מוז' זאנטט דים הפטרה
פֿון דער פרשה'

ווען מין ברית מילה מוער' מן מייל פֿון רעם דים פֿיר פרשיות' דא זאנט מן רט אופן מוז' זולת מן
דער ברית מילה' מוז' רט מין יוצר היבט מן דער פרשה' צו דער מנדר חפכ̇ה' זאנט מן מין
יוצר היבט מן מוים ארות מאופל' (מן פֿון זאגן מוז' פיהם זאנט מן מין יוצר היבט מן פֿני הכלך' אופן
שפך לער' זולת ייאלהיות צבאות' (צו וויר̇את חמטט מן נורת ק̇ט לענתן טמ̇ן מן אדר מוז'
זאנט סליהות ומוג' ויחל ויחל' מוז' מך מוז צו מנחה') :

תענית אסתר

אסתר איז מין תענית צבור מוז' מן מורט גֿיין ג̇אטט אנגני' מוג' ויחל ויחל מיך
גֿטריבן האב ביים מ̇ב ביים שבת ביים עשר בתמוז' מוז' אן זאגט דים סליהות' אתה האל
גֿטריבן' מוג' מך מוז מן מנחה':

תענית

ויבא עמלק וילחם עם ישראל ברפידים:

פרשת

זכור מיזדער נעהשט
שבת פֿור פורים' אן
זעט מין יוצר היבט מן זכור את אשר
עשה' מין פֿון מוג' פיהם' זאנט מן אן
אופן כבודו ינגדל' זולת אנא' זאנט
קרובץ היבט מן אכיר סלה' מוג'
פֿאלנט מוים' היבט מוים לשוייים ספרי
תורה' מין דער ערטטן רוטט מן אן
זיבן מיך' זיימט מין דער זאמלן סררא'
המלב קריש' מוז' מין דער מנדר
ספר תורה זיימט אן דעם דער דים
הפטרה זאמנט הינטן מין כיתצא
היבט מן זכור את אשר עשה לך עמלק' ביז דים סררא מוים מי מי' מוז' זאמנט מין הפטרה היבט
מן כה אמר ייצבאות פקדתי' קין יונגר זול דים הפטרה זאמן' מוז' מיזניט מזכיר נשמות' (מין
פֿון מיז אן מזכיר נשמות') : צו מנחה זאגט מן ואלול צדקתך') :

פרשת פרה

ושרף את הפרה לעיניו את
עׂרה ואת בשרה ואת דמה
על פרשׁה ישרף:

פרשת

פרה דם יוצר היבט
מן אום אשר כן
רבוקה' רט זולת אשרי כל חוסי בך
(מין פֿון זאנט אן מין אופן כבודו
יבן רבין' דן קרובץ היבט מן אצלת'
און היבט מוים לשוייים ספרי תורה מוג'
רוטט מין דער ערטטן זיבן מין מיך
מוז' זיימט דים זאמלן סררא' המלב
קריש' מוז' רטט מוק מין דער דים
הפטרה זאמנט' מוז' זיימט מיך פֿון
מן דער כרא זאת חקת התורה' ביז̇ון תטמא ער הערב' מוז' זאמנט דים הפטרה מין יחזקאל
היבט

PROVIDENCIA DE DIOS,
CON YSRAEL
Yverdad de la Ley de Moseh y nulidad de mas leyes

CAPITVLO. I

DECLARA LA INTRODVCION DESTA
obra y la obra y causa que movio al Author
a hazer este trådo para mostrar la verdad.

ON tan reñidas y obstinadas oy
las gerras entre los hombres que muchas vezes sucede que despues de
auer ynterpuesto todas sus fuerças y deligencias por no rendirse llegan
do al extremo y no hallando ya otro remedio, procuraron acabarse asi
mismos y a sus contrarios; ô quantas vezes lo vemos en las batallas navales
que despues de perdido vn nauio pone la gente della fuego à la poluora
escogiendo mejor el acabarse y a sus contrarios que entregarsele vençidos.
A este proprio termino de obstinaçion hallo yo que llega oy la guerra ycõ
tienda spritual en materia de religion con los que llaman yglesias de nueuos
reformados, los quales despues de auer valerosamente peleado y defendido
sus consçiençias, arrojando de si tantos errores (sus crueles enemigos) como es la ynorme ydolatria de la ostia a
doracion de la cruz, y demas ymagenes, cosa tan reprouada en la palabra de Dios, y ansi mismo el obstener
se del santo matrimonio pareçiendoles que sera grato a su diuina Magestad el prohibirse dd, siendo por el contra
rio expresamente encomendado a sus saçerdotes el casarse, fuera de otros graues yerros, y no çessando aun el

com.

A

17 Saul Levi Mortera's *magnum opus*

Providencia […], Amsterdam 1664, page 1, 313 x 213 mm [HS.ROS. 542]

S AUL LEVI MORTERA (1596? – 1660) is best known in history for his role as president of the ecclesiastical tribunal which in 1656 ratified the excommunication of Benedict Spinoza, his erstwhile pupil, then aged 24. Mortera, born in Venice, spent four years in Paris at the court of Queen Marie de Medici of France, where he was secretary to her personal physician, the Portuguese doctor Montalto. After he moved to Amsterdam he became the spiritual leader of the first Jewish community, made up mostly of Portuguese former New Christians. He also taught at their academy, founded around the time of his arrival (1616). In Amsterdam, Mortera was a celebrated preacher and author of several treatises originally written in Portuguese, some of them still unpublished.

In 1988, his *Treatise on the Truth of the Law of Moses*, comprising 429 folios quill-penned in his own hand during the last years of his life (Ets Haim Library, Amsterdam), was published by the present author. It is the most extensive and comprehensive work produced before 1659 by a Jewish author about all forms of Christian dogma; the first critical analysis of the New Testament in a vernacular; the only work of its kind ever written in Portuguese.

Mortera's ideas did have an influence on Spinoza's *Theological Political Treatise* of 1670, in a negative way; whereas Mortera attacked the rationalism and the authenticity of the New Testament, Spinoza applied Mortera's methods to attack the rationalism and authenticity of the Hebrew Scriptures. One of Mortera's aims, as he himself states, was to convince the adherents of the more radical branches of Dutch Protestantism to renounce their belief in the divine character of the New Testament, and to adopt a form of religion based solely on the Old Testament. But the work was never translated into Dutch.

It was, however, translated into Spanish by Chacham Moses Raphael de Aguilar. Five splendid decorated manuscript copies of this Spanish translation, entitled *Providencia de Dios con Ysrael, Verdad de la Ley de Moseh y Nulidad de las Demas Leyes* ('Providence of God with Israel, Truth of the Law of Moses, Insignificance of Other Laws') were produced in Amsterdam between 1662 and 1664 by the Dutch-Portuguese master calligrapher Luis Nunes Dovale (alias 'Iehudah Machabeu'). Little evidence remains of this scribe's life except for his signature as witness at the wedding of his sister, Debora Israel Machabeu, to David Pereira at Amsterdam in 1627 and his presence in Pernambuco, Brazil, in 1646 (but see Ton Croiset van Uchelen's article earlier in this book, no. 15). The five copies of Mortera's work are Machabeu's masterpieces. The first one, dated 20 June 1662, belongs to the Hebrew Union College, Cincinnati, the second, dated 10 July 1663, is in the Bodleian Library, Oxford, the third, dated 25 July 1663, is in the Bibliothèque Nationale, Paris, the fourth, dated 1664, is in Ets Haim and the fifth, also dated 1664, is in the Bibliotheca Rosenthaliana. While the five manuscripts seem similar, each one has its own distinctive artistic quality.

HERMAN P.SALOMON

18 The Sabbatean movement in Amsterdam

(*above*) *Tikkun* [...], Amsterdam 1666, frontispiece and title-page,

130 x 150 mm [ROS. 20 C 5]

(*below*) Sabbatai Sevi, from: Thomas Coenen, *Ydele verwachtinge der Joden,*

Amsterdam 1669, 150 x 97 mm [ROS. 15 G 50]

IN 1665 – 1666 THE JEWISH WORLD was subjected to a whirlwind of messianism such as it had not known since the Bar Kokhba revolt in 132 – 135 CE: a major part of the Jewish people throughout the diaspora believed that they were soon to be redeemed with the coronation of Sabbatai Sevi as the messianic king. The prophecies of Nathan of Gaza, the founding theologian of the Sabbatean movement, aroused enthusiasm almost everywhere in the world where there was a Jewish community. Stories of the wonderful personality and deeds of Sabbatai Sevi, the messiah of Smyrna, kindled the imagination of tens of thousands of Jews whose hopes were raised that the end of the sufferings of exile would soon come. Kabbalah in its various systems and schools had spread and become a central part of Jewish theological discourse, giving Sabbateanism, whose founders and leaders were all Kabbalists, a special tone. This came in addition to the mythical and popular traits that nourished Sabbateanism, all of which were the product of a long tradition of messianic belief that had developed within Judaism since Second Temple times, and which ramified and spread during the Middle Ages.

Amsterdam became a major center of messianic fervour for a number of reasons:

1 The city contained a large concentration of Marranos, refugees from the Inquisition in Spain and Portugal, who had returned to Judaism in the safe haven of Holland. The messianic theme played a central role in the popular beliefs and Marrano theology that had developed in a number of their circles.

2 Masses of refugees arrived from Eastern Europe, including Sarah, the woman who was to marry Sabbatai Sevi in Cairo in 1664, who had come to Amsterdam as a young girl in around 1655. Particularly important were the Lithuanian Jews who had fled from the Swedish invasion and who were imbued with the messianic hopes that had inspired the Jews of Poland and Lithuania since the time of the Chmielnicki pogroms of 1648 – 1649.

3 The Jews of the city enjoyed a high degree of toleration, which permitted them, more than elsewhere, either in Christian Europe or in Islamic countries, to give free reign to their enthusiasm.

4 The well developed printing industry among the Jews of Amsterdam made it a world centre for the distribution of Sabbatean Tikkun and prayer-books. The printing houses of Uri Fayvesh ben Aaron Halevi, of Joseph Athias and especially of David de Castro Tartas published editions of prayer-books, books of penitential hymns and Tikkun and confession books with clear references to the imminent redemption, with the date of publication indicated as 'Behold I redeem my people (...)' in which the letters of the word 'redeem' stand for the Hebrew date of (5)426 (i.e., 1666). Some of these books also contain prayers, confessions, and hymns written by Chacham R. Isaac Aboab da Fonseca and the poet R. Solomon de Oliveyra, who was later appointed rabbi of the Sephardi community. Most of the books were printed in Hebrew and intended for the world Jewish book market. Some, however, were printed in Spanish and Portuguese and meant for the Marranos who had returned to Judaism and had not yet learned the Hebrew language. Copper engravings depicting Sabbatai Sevi sitting on his royal throne are also found as the frontispieces of some of these books. In 1669 one of the best known books about the life of Sabbatai Sevi and the messianic upheaval which he aroused

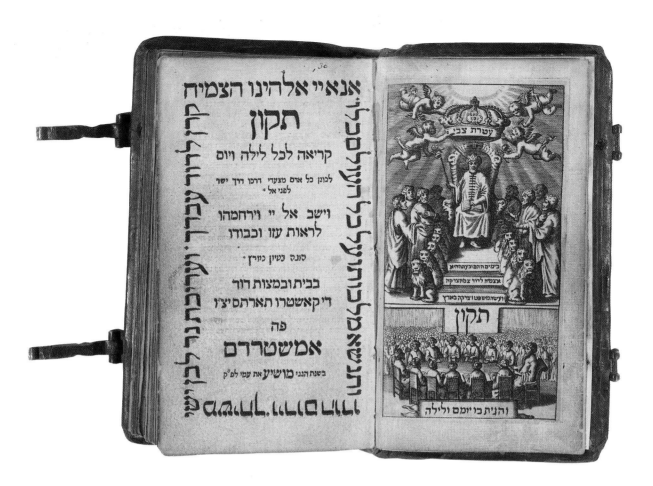

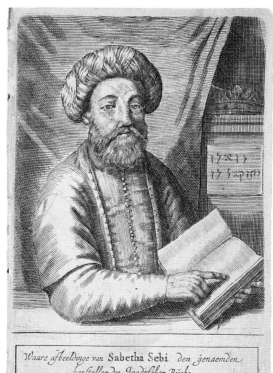

Waare afbeeldinge van Sabetha Sebi den genaemden
hersteller des Joodtschen Rijcks.
Vray pourtrait de Sabbathai Sevi qui se dict Restaura:
teur du Royaume de Juda & Israel.

Oetgunſtige Leſer, 't blijckt nyt des Autheurs
G ſchrijven van den 27. May 1667, dat dit Hiſto-
riſch Verhael al doe ter tijdt van Smyrna was afgeſon-
den. Doch 't is vele tegenſpoedige gevallen op zee,
als elders onderworpen geweeſt. Waer door het UE.
niet eer heeft konnen medegedeelt worden. Of miſ-
ſchien de nieuſgierigheyt by ſommige wat verkoelt
mocht zijn, en komt het nochtans niet ontijdigh, als
behelſende een ſake waerdigh, dat daer goede gedach-
teniſſe van gehouden werde. Buyten twijffel ſullen
niet alleen Chriſtenen, maer ook Joden hier te lande,
haerſelven vermaeckt vinden, datſe eens ſoo omſtan-
delijck en beſcheydelijck mogen verſtaen, 't gene by-
ſonderlijck tot Smyrna ontrent de Perſoon van deſen
gepretendeerden Meſſias is voorghevallen. De Af-
beeldingen van den Meſſias en Propheet en zijn niet
van den Autheur, evenwel van goeder handt ons toe-
gekomen.

HISTORISCH VERHAEL
Van
SABETHAI ZEVI
CAP. I.

𝕳Et Joodſche volck/ met welcker
Vaderen Godt een verbondt opge-
recht heeft/ haer ende hare nako-
melingen verkieſende tot zijn volck/
en eygendom/ uyt allen volckeren
die op den aerdtbodem zijn/ is wel
eer van den Hemel met allerley zegeningen ende
weldaden geſtroont gheweeſt. De Heere heeft
haer zijn woort ende de middelen der genade ver-
gunt/ ende den wegh der ſaligheyt bekent ghe-
maeckt/ ende haer den waren Meſſias en Ver-
loſſer belooft/ om door hem de ſaligheyt te ver-
krijgen. In het tijdelijcke heeft hy ſijne voet-
ſtappen laten druppen van vettigheyt/ende haer
gegeven broot om te eten/ende zaet om te zaeyen.
Voorts om haer in goede tucht ende alſoo in een
goeder ſtant te houden/ behalven rechtvaerdige
wetten/ oock gegeven bequame Overheden uyt
hare Broederen/ Deut. 17.15. die voor haer uyt
ende ingingen/ om hare oorlogen (waer voorſe
een ſchrick voor hare vyanden zijn geworden) te
voeren: eerſt nae de tijden der Patriarchen in
Egypten/ende nae den uyttocht/ Moſes, Joſua,
en de Richteren. De kerckelijcken dienſt heeft hy
voor Aaron ende zijn geſlachte laten waernemen.
Deſe alle hebben 't volck Godts nae de Wetten/
haer van Godt ſelve voorgeſchreven/ geregeert.
Waer nae heeft hy haer/ wanneerſe nae de wijſe
der volckeren begeerden geregeert te worden/ een
Koninck in zijn toorn gegeven : nochtans de Ko-
𝕬 ninckliſte

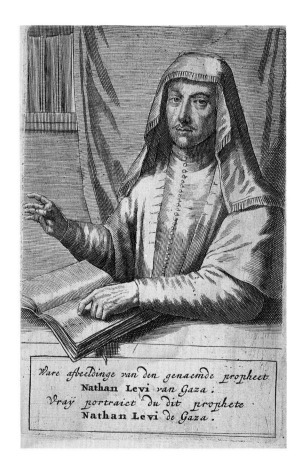

Ware afbeeldinge van den genaemde propheet
Nathan Levi van Gaza:
Vray portraict du dit prophete
Nathan Levi de Gaza.

was printed in Amsterdam. I refer to the book by Thomas Coenen, the protestant minister of the Dutch community of Smyrna, entitled *Ydele verwachtinge der Joden*. This book contains pictures of Sabbatai Sevi and of Nathan of Gaza drawn by an eyewitness in Smyrna.

5 In Amsterdam the Jewish messianic fervour found willing ears among various circles of Christians, especially among the millenarians, who were very interested in the renewal of messianic activity within the Ottoman empire. Petrus Serrarius, a theologian, published *Verklaringe over des Propheten Jesaia veertien eerste capittelen* in Amsterdam in 1666, a work in which he describes in detail his belief in the return of the Ten Lost Tribes, which was about to be fulfilled with the imminent revelation of the messiah.

However, even in 1666, when belief in Sabbatai Sevi reached its peak, some Amsterdam Jews did express lack of faith in him and opposed the activity of his followers. The city stock exchange served as a natural place for the promulgation of material condemning the false messiah, and on 3 May 1666, from the pulpit of the synagogue, the Mahamad of the Sephardi community declared a ban against anyone who circulated pamphlets against the hopes of believers in the imminent arrival of the messiah. At the time letters had already been received from Smyrna abolishing the fast of the 10th of Tevet, and reports had been received about the renewal of prophecy. Excitement among the Jews of the city grew steadily. In the summer of 1666 official letters were written to Sabbatai Sevi from the various yeshivot of the Sephardi Jews of Amsterdam. The letter from the Torah Or (Torah Light) yeshiva, signed by

Rabbi Isaac Aboab, has not been preserved. In contrast, the Ets Haim collection contains two other original letters which were preserved after the emissaries who had been supposed to deliver them to the messiah returned to Amsterdam, having learnt of Sabbatai Sevi's conversion to Islam: *1* an adulatory letter to Sabbatai Sevi from the members of the Yeshuat Meshiho (the Redemption of His Messiah) yeshiva, signed by most of the property owners and notables of the community, most of them in Spanish or Portuguese; *2* a letter from the Keter Torah (Crown of Torah) yeshiva, signed by, among others, Benjamin Musaphia, Aharon Sarfati, Moseh Raphael d'Aguilar and Abraham Cohen Pimentel.

By the end of 1666 everyone in Amsterdam knew about Sabbatai Sevi's conversion, and the news stunned the community. It should be noted that the Mahamad took a decidedly anti-Sabbatean stand by deciding to ban the Sabbatean book by Moshe ben Gideon Abudiente, *Fin de los Días* (Gluckstadt 1666), 'because what is said in the aforementioned book is contrary to the truth of our sacred law.'

As more and more detailed information was amassed regarding Sabbatai Sevi's conversion and his failure as a messiah, reservations regarding him increased within the Sephardi community of Amsterdam. In contrast to the Ashkenazi Jews, who retained messianic belief for some time, the Sephardim acted with severity in order to extirpate the evil from their midst. Their attitude to Sabbatai Raphael Supino, one of the most daring propagandists for the Sabbatean movement after Sabbatai Sevi's conversion, who arrived in Amsterdam in 1667 on the eve of Yom Kippur, shows more than anything the extreme transformation that had taken place within the Talmud Torah community. On 7 October, the authorities of the city of Amsterdam, under pressure from the Sephardi syndics, signed an order to expel Supino from the city.

YOSEF KAPLAN

19 Romeijn de Hooghe and the Portuguese Jews in Amsterdam

(*above*) 'Consecration of the Portuguese synagogue in Amsterdam',

392 x 495 mm [ROS. A 3 – 17]

(*below*) 'The Former Synagogue of the Jews', detail [ROS. B 10 – 11]

O N 2 AUGUST 1675, the new Portuguese synagogue was formally consecrated. Romeijn de Hooghe, an artist already famous in his own time, made a well-known print of this ceremony, showing the Torah scrolls being carried in. The top of this print is decorated with an allegorical scene showing the Dutch Republic and the City of Amsterdam granting Judah freedom of conscience. Medallions down the sides of the print give the names of the Parnassim, or synagogue directors, and the members of the finance committee and the building committee. There is a copy of this etching, printed on silk, in the Jewish Historical Museum; it was originally in the possession of the Mendes da Costa family. According to tradition, these silk prints would have been presented to the functionaries whose names appear on them.

But there is also another rare print of the interior of the new building: 'Tempel der Ioden te Amsteldam' (Temple of the Jews in Amsterdam). There are no names on this print, the allegory emphasizes freedom of conscience and prosperity, and it shows the procession around the building rather than the arrival of the Torah scrolls. The central figure in the print is a man with a square beard, respectably dressed as if in readiness for a journey, reaching out his hand to a diminutive servant carrying a book. These same figures also appear in two other prints in the synagogue series, which consists of eight prints in all.[1]

In the lower left-hand corner of 'The Former Synagogue of the Jews' there is a group of three men, one of whom has a square beard. An elegant gentleman in a long wig is offering his arm to lean on, and a small servant stands waiting with a hat and stick in his hand. In the print of the 'Pulpit and Inner Sanctum', a small attendant with a book in his hand is leading the man with the square beard to the platform from which the Torah is read, the tebah. On the other side of the tebah an elegant man is just walking up the stairs.

This kind of detail is never a coincidence in the works of Romeijn de Hooghe. His prints, often a form of journalism, combine a continuous story with allegorical elements and real personalities. His work is also characterized by a sharp eye for detail, as we can see in his depictions of Baron Belmonte's houses, and Messrs. Da Costa and De Pinto.[2] Who, then, is that man with the square beard who appears so often in the context of the synagogue? Apart from the Parnassim, such importance could be attached to only one man: the man who gave the order for the new synagogue to be built, whose name is incorporated into the psalm text above the main entrance, the chief rabbi from 1660, Haham Aboab (1605 – 1693). The available sources give no indications that he was blind, or so feeble that he was in need of constant support. The blindness suggested in the prints is therefore probably also not factual, but a symbolic reference to his first name: Isaac, the patriarch, who became virtually blind towards the end of his life.

Romeijn de Hooghe was an expert in the Dutch system of emblems—already somewhat antiquated by then—which lent multiple symbolic meanings to depictions of everyday reality. The reference to the Patriarchs points to the particular character of this community. Many of its members who had grown up as Catholics chose the Jewish names Abraham, Isaac or Jacob when they returned to the Jewish faith in Amsterdam. The artist may also have used Isaac's blindness to express the deficiencies in their knowledge of Judaism. The little attendant carries a book, Torah, Tenach, or prayer-book, and leads a blind man to the tebah. In this single figure we can see both the returning Jew and the rabbi, Haham Aboab.

The prints of Romeijn de Hooghe depict more than the power and wealth of the Parnassim alone; taken together, they also provide a picture of the spiritual vigour of the Portuguese community in its prime.

JUDITH C.E. BELINFANTE

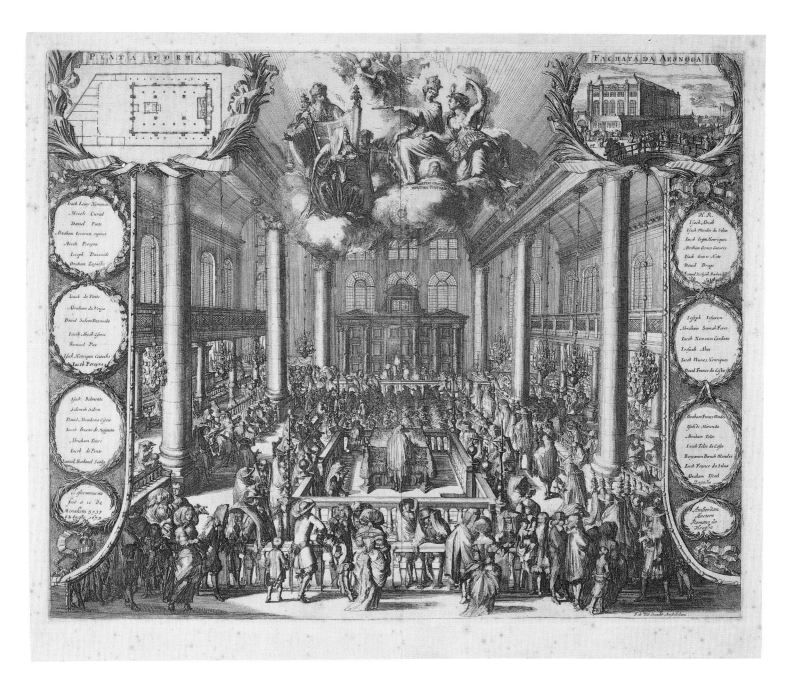

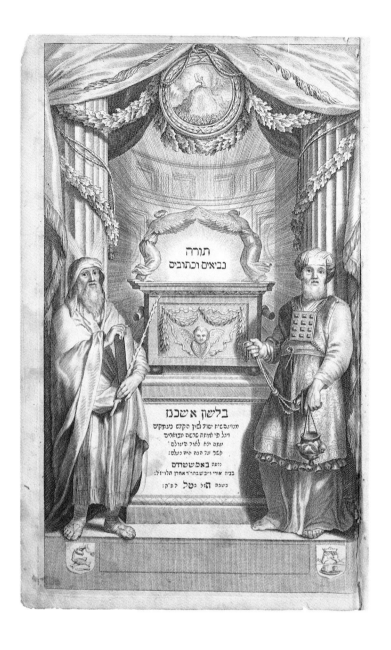

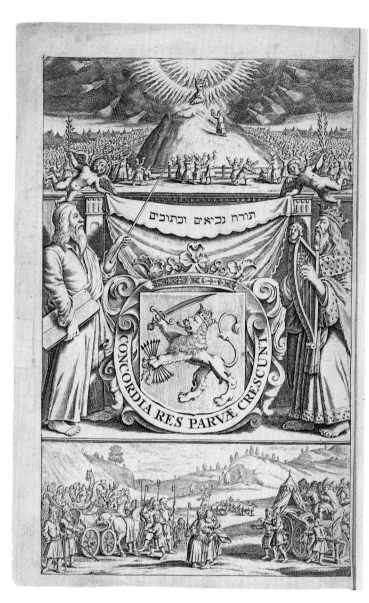

תורה
נביאים וכתובים

בלשון אשכנז
מחובר עם יסוד לשון הקדש מנוקדים
ועל פי חורת משה ונביאים
שנה יצא לאור העולם
אשר על כנה היה נעלם:

נדפס באמשטרדם
בבית אורי וישבחר ד אהרן תלי־זל:
בשנה הזל טל לפ"ק:

תורה נביאים וכתובים

CONCORDIA RES PARVÆ CRESCUNT

20 Two Yiddish Bibles printed in Amsterdam

(*left*) The translation of Jekuthiel Blitz, frontispiece, 308 x 195 mm [ROS. 15 B 35]

(*right*) The translation of Joseph Witzenhausen, frontispiece,

312 x 195 mm [ROS. 15 B 34]

THE FIRST TWO Yiddish translations of the complete Old Testament appeared almost simultaneously in Amsterdam in 1678 – 1679. Yiddish translations and glossaries of parts of the Hebrew Bible had occupied an important place in Yiddish publishing from its beginnings in the first half of the sixteenth century. The earlier texts only covered those sections of the Old Testament which are part of the liturgy: the Torah (Pentateuch), the haftarot (selected portions of the Prophets and the hagiographa which are read in synagogue after the weekly portions of the Torah), the five megillot ('Scrolls', i.e., Song of Songs, Ruth, Lamentations, Ecclesiastes, and Esther), and Psalms.

Uri Fayvesh Halevi, the first publisher to start printing a complete Yiddish Old Testament, had been influenced by the example of Sephardi Jews and Christians because they possessed good translations. In Amsterdam, where contacts between Ashkenazi Jews, Sephardim and Christians were more extensive than elsewhere, he became aware of the fact that others had a better knowledge of 'their' Bible than they themselves had. The influence of the official Dutch Bible translation, the *Statenvertaling*, was particularly important. Its first edition had appeared in 1637 and within decades it had acquired great authority and was a publishing success. Since there were many Yiddish speakers in Europe who were literate but did not understand the Hebrew original well enough to comprehend it, Uri Fayvesh assumed that there would be considerable demand for a Yiddish Bible.

Uri Fayvesh commissioned Jekuthiel ben Isaac Blitz to produce a translation. Since Blitz was not an accomplished Hebraist, he relied heavily on other translations into Germanic languages: Luther's German translation and the Dutch *Statenvertaling*. This went very far: in places the text is closer to either of these texts than to the Hebrew original and the break with the existing Yiddish translation tradition is abrupt. Blitz, who had a penchant for

polemics, also inserted attacks on Christianity in his translation. Furthermore, the text is full of Dutch and Low German words (Blitz hailed from Witmund in northern Germany), which would have made it hard to understand for the intended Polish-Jewish market.

One of Uri Fayvesh's financiers, the Sephardi publisher Joseph Athias, withdrew from the enterprise while this translation was being printed because he was unhappy with Blitz's work. Athias ordered one of his typesetters, Joseph ben Alexander Witzenhausen, to produce another translation. Witzenhausen was a more scrupulous translator than Blitz. His translation is closer in style to the traditional Yiddish translations. Nevertheless, it was a great improvement on earlier Yiddish versions. Witzenhausen also made use of the *Statenvertaling*, but he only consulted the Dutch version to solve translation problems.

Evidence of the strife between the rivalling publishers and translators can be found within the Bibles themselves. In his preface, Uri Fayvesh complains about someone he trusted but who later exploited his idea to publish a Yiddish translation of the complete Old Testament, and in the other Bible Joseph Witzenhausen makes fun of mistakes in Blitz's translation. Uri Fayvesh and Joseph Athias obtained conflicting copyrights in the Netherlands and in Poland. Copyrights were secured by publishers to prevent others from publishing the same or a similar text within a specified period. Before Athias started printing his own Yiddish Bible, he took the pages of Blitz's translation which, as one of its financiers, he had for safekeeping and used them to obtain a 'privilegie' from the civil authorities from the Province of Holland. In it, he is granted protection 'because he fears someone else might steal his idea [!]'. Later, he incorporated the pages of Blitz's Bible he still had in his possession into Witzenhausen's translation (fols. 21 – 36). Athias may have objected to the mistakes and stylistic inconsistencies in Blitz's translation, but those sheets represented a large sum of money which he did not want to waste.

Uri Fayvesh finished printing Blitz's translation in late 1678, not long before Witzenhausen's version came off the press (1679). Although large sales had been anticipated —both Bibles were printed in editions of more than 6,000 copies—neither was a commercial success.

MARION APTROOT

21 Isaac [Fernando] Cardoso's *Las excelencias de los Hebreos*

Additional title-page of Part Two, 205 x 165 mm [1180 E 5]

ORN IN 1603/4 TO A New Christian family of crypto-Jews in Trancoso, Portugal, Cardoso was taken as a child to Medina del Rioseco in Castile. His career in Spain was unusually precocious. Beginning his studies at Salamanca in his early adolescence, by the age of twenty he taught philosophy at the University of Valladolid, where he also received his doctorate in medicine in 1625. By 1630 he was in Madrid. He rapidly gained access to the highest literary and social circles and eventually became a physician at the court of Philip IV. Besides occasional poems printed in works by other authors, Cardoso published the following books while in the Spanish capital: *Discurso sobre el Monte Vesuvio* (1632), a treatise on volcanos occasioned by the eruption of Vesuvius in 1631; *Panegyrico y excelencias del color verde* (1635), a *jeu-d'esprit* on the virtues of the colour green, apparently delivered at one of the then fashionable literary academies; *Oración funebre en la muerte de Lope de Vega* (1635), a lament on the death of the great Spanish playwright; *Utilidades del agua y de la nieve* (1637), on the medicinal uses of water and of melted snow; and *De Febre syncopali* (1639), on intermittent fevers.

While in Spain, living ostensibly as a Christian, Cardoso was secretly an active Judaizer. Although never prosecuted by the Inquisition, his dual life and the need for constant dissimulation ultimately proved intolerable to him. In 1648, together with his younger brother Miguel [Abraham], he suddenly disappeared from Madrid and re-emerged in Venice where he joined the Sephardi community as a professing Jew. Abandoning his baptismal name of Fernando and known henceforth as Isaac Cardoso, in 1652 he moved to Verona, where he lived for some thirty years in the Jewish ghetto as community physician until his death in October, 1683. There he completed his two

chief works: the Latin *Philosophia libera* (Venice 1673), a huge folio (758 pp.) ranging from natural philosophy to theology, and the Spanish *Las excelencias de los Hebreos* (Amsterdam 1679), a superb defense of Judaism and the Jewish people.

Las excelencias is divided into two parts, each with ten chapters. Part One extols the 'excelencias' or admirable qualities of the Jewish people under the following headings: *1* 'A People Chosen by God'; *2* 'One People'; *3* 'Separated from all the Nations'; *4* 'Three of their Natural Characteristics' [compassion, Charity, Decency and Modesty]; *5* 'Circumcision'; *6* 'The Sabbath'; *7* 'A Divine Law'; *8* 'Prophecy'; *9* 'The Holy Land'; *10* 'Witnesses to the Unity of God' [on Jewish martyrdom, particularly on the martyrs of the Inquisition].

In Part Two Cardoso refutes ten 'calunias' (slanders) against the Jews: *1* 'They adore false gods'; *2* 'They exude a bad odour'; *3* 'Tails and Blood' [Jews have tails and Jewish males menstruate]; *4* 'They pray thrice daily against the gentiles'; *5* 'They persuade gentiles to accept Judaism'; *6* 'They are disloyal to the rulers'; *7* 'They are wicked and cruel'; *8* 'They have corrupted the text of the Holy Scriptures'; *9* 'They desecrate [Christian] images'; *10* 'They kill Christian children in order to use their blood'.

The title-page contains a woodcut showing a hand gathering flowers, with the motto: 'el que me esparsio me recogera' (He who has scattered me will gather me). Some copies contain an additional frontispiece preceding Part Two, headed: *Las excelencias y calunias de los Hebreos*, with another floral motif and the motto: 'Ellos maldiziran y yo bendizire' (They shall curse and I shall bless).

Las excelencias de los Hebreos is a masterpiece of Jewish anti-defamation, perhaps the most striking since Josephus's *Contra Apionem*. Erudite, passionate, eloquent, it is all the more impressive and interesting as the work of a former Marrano who only came into the full possession and knowledge of his Jewish heritage in middle age. For while the book is, explicitly, a defense of Jewry as a whole, it is also, on a personal level, a justification of his own choice to live as a Jew.

YOSEF HAYIM YERUSHALMI

Las
EXCELENCIAS
Y CALUNIAS
DE LOS HEBREOS.

Por el Doctor
YSHAC CARDOSO.

Triumpho del Govierno Popular,

Y de la Antiguedad Holandesa.

Dedicalo en el Año de 5443.

DANIEL LEVI DE BARRIOS.

A los muy Iluſtres Señores Parnaſim, y Gabay del Kahal Kados Amſtelodamo,

Iſhac Belmonte.	*Iacob Abendana de Brito.*
Iacob de Pinto.	*Iſhac Levi Ximenes.*
Abraham Gutierres.	*Mordechay Franco.*
	Ioſſeph Mocata.

De la Ley los Hebreos ſon las Flores,
abejas los Maeſtros, que en las Hojas
ſe ſuſtentan por ſus Mantenedores.

22 Daniel Levi de Barrios's *Triumpho del govierno popular*

Title-page, 183 x 115 mm [ROS. 19 G 12]

ALTHOUGH FIRST AND FOREMOST A POET, Daniel Levi de Barrios was also a philosopher, theologist and historian; his main subject was the Portuguese-Jewish community in Amsterdam, which he himself joined in 1662.

He was born Miguel de Barrios in Spain in 1635. His family were Marranos, which is reflected in his poetic works. He moved to Italy, where he began practising the Jewish faith openly and adopted the name Daniel Levi de Barrios. There he married, and the couple subsequently travelled to Tobago. Shortly after arriving, however, his wife died, and he returned to Europe. He would have been 26 then.

In 1662 he remarried in Amsterdam, and it was here that he penned his first work, *Flor de Apolo*. However, when, as was customary, he asked the Portuguese community's permission to have the work published, objections were raised. The poems were said to be too frivolous, and the poet's attribution of divinity to the heathen gods he portrayed was downright blasphemous. However, the work was not rejected completely, and he was advised to revise it. This he does not appear to have carried out to the community's satisfaction, for on 17 May 1663 the book was declared unsuitable for publication. It eventually appeared in 1665, in Brussels, where De Barrios served as a captain of cavalry in the Spanish army, a career which lasted until 1674. His second major work, *Coro de las Musas*, was also published in Brussels in 1672, as well as in Amsterdam.

Although he went on to write many more works after this period, no further new developments appeared in his work. He fell in with the movements which were then in vogue in Spanish literature; conceptism (using puns and playing on the various different meanings of words, or making witty comparisons, in order to startle the reader), and culteranism. The adherents of culteranism often used symbols in place of ordinary words, preferring unusual words, and delighting in displays of extensive knowledge of Greek mythology. Gongora was the leading light in this movement, and hence De Barrios admired him greatly and followed him.

In or around 1674 De Barrios's spiritual life reached a low point. The false messiah Sabbatai Sevi had prophesied that the Messianic Age would commence on Rosh Hashanah in 1674. De Barrios believed this implicitly, and it was a bitter blow when he realized that the kingdom had not come.

Financially speaking, too, he does not appear to have been in good shape. From 1676 until his death in 1701, he regularly received alms from the Portuguese community. Clearly he was now writing for a living: he dedicated his works to influential figures in order to earn fees from which to live. He generally wrote short works dedicated to particular individuals or institutions; sometimes these works were collected together, such as *Triumpho del govierno popular y de la antiguëdad holandesa*, which appeared in 1683.

This rather rare work is devoted primarily to the history of the Portuguese-Jewish community in Amsterdam. Although it was written by a poet, the facts as he relates them are generally true, especially those that relate to the time when De Barrios himself was alive.

Not many copies are known to exist. The Bibliotheca Rosenthaliana has two of them. Meijer Roest was the first person to write about the work, based on two copies belonging to the library of Ets Haim. Cardozo de Béthancourt compares three of the *Opuscula*, the name often used to refer to the miscellany volumes. Besides one of the copies cited by Roest, he also includes two further copies from Ets Haim in a diagram in which he shows the sequence of the sections, the pagination and the contents of the copies. I have done the same for the seven copies which I have seen myself. Besides the copies mentioned above, these also include one more in the British Museum; there are a further two copies in the Bodleian Library in Oxford, and two copies were lost in Germany during the Second World War.

WILHELMINA CHR. PIETERSE

23 Two Hebrew books with silver bindings

Machzor, Amsterdam 1688, 163 x 245 mm [ROS. 19 F 29]

FROM THE EARLIEST DAYS of book production, the finest materials such as gold, silver, precious stones, pearls, ivory, enamels and ancient gems were selected to adorn those volumes which, because of their exalted contents, were deemed worthy of conspicuous use and display. The covers of these antiphonaries, Bibles, books of hours, breviaries, Gospels and psalters are now counted among the most prized possessions of a few privileged churches and monasteries, libraries and museums.

But from about the seventeenth century on, when secular silver began to compete with devotional plate, prayer-books gradually became household objects. Their brass, silver or gold additions consisted mainly of one or two clasps to close the binding; sometimes their corners were decorated as well, and central motifs with religious representations or the owner's arms were added. Bindings on which front and back covers and spine were entirely covered by precious metals were always much rarer.

This applies *a fortiori* to Hebrew books. Only the very wealthiest of Jews could afford to have their tefillot decked out in gold or silver. It is therefore not surprising that the majority of those specimens which have come down to us were made mainly for members of the more affluent congregations such as existed in Italy and Holland. And it is precisely from these countries that the Bibliotheca Rosenthaliana possesses two interesting examples.

Both their mounts are unmarked, as is generally the case with this kind of silver object. Other criteria therefore need to be employed in order to determine their origins.

The first of the two volumes discussed here is a machzor of festival prayers according to German-Polish usage, printed by Uri Fayvesh Halevi in Amsterdam in 5448 (1688). Front, back and cover are made from silver sheets, finely embossed and finished with flat-chasing in a pattern of baroque scrolls, which seem stylistically somewhat earlier than the prayer-book they encase. The ornamentation applied here has a pedigree that is as interesting as it is venerable. It is similar to an Italian engraving in the print room of the Amsterdam Rijksmuseum, the description of which indicates that this can be traced back to decorative detail in the Galerie François I at Fontainebleau, which in turn was based on an antique candelabrum relief in the Vatican Museum.[1]

Front and cover are very nearly identical; they appear to have been fashioned over the same mould. It is only in the finishing that minute differences can be detected, especially in the pointed ends of the C-scrolls. The first half of the seventeenth century would not be an unreasonable estimate for a date of origin for these mounts.

The two cast clamps, however, are later additions, which may have been made at any time between 1680 and 1740. Although also unmarked, they are almost certainly of Amsterdam manufacture; they have been riveted rather coarsely onto and into the cover plaques.

The provenance of the mounts is a matter of conjecture. Apart from their design, their manufacture also looks more Italian than Dutch, and they are similar to those of another fine specimen from that country, a seventeenth-century binding in the Royal Library at Copenhagen, containing an Amsterdam tefillah, printed in 5520 (1760) by Herz Levi Rofe.[2]

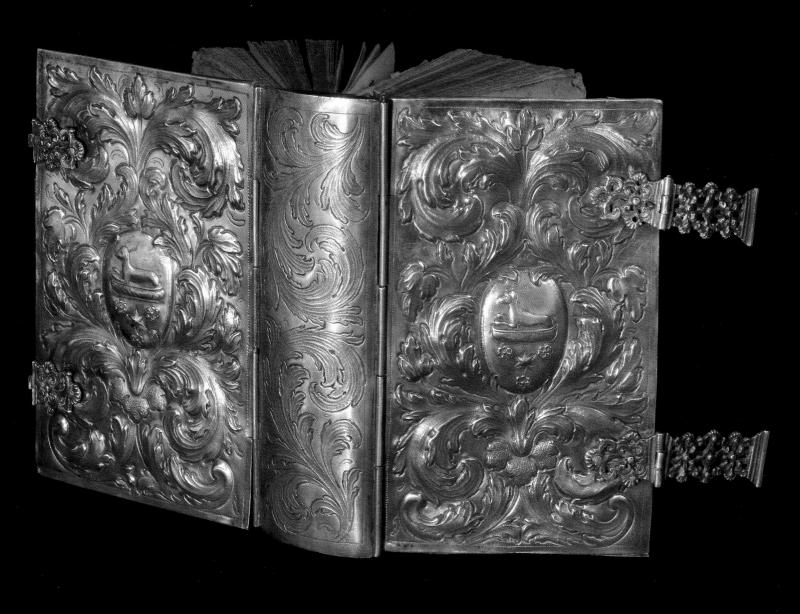

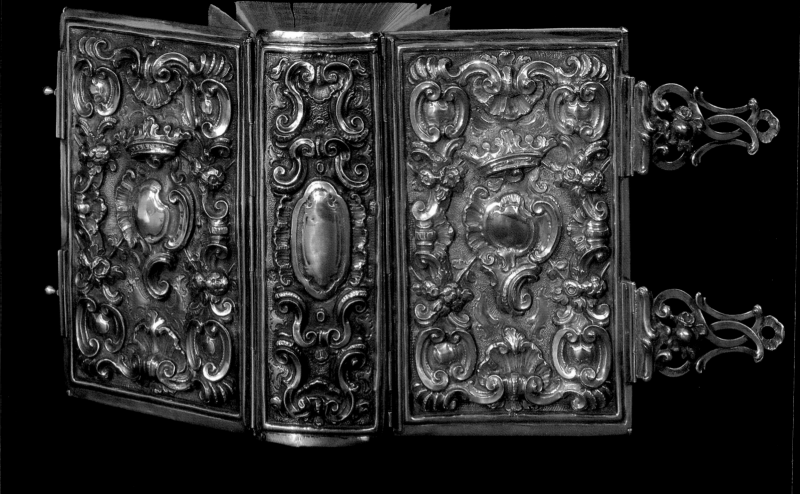

Machzor, Venice 1792, 185 x 295 mm [ROS. 20 E 9]

A closer look at the armorials on the central oval in both covers corroborates the suggested Italian origin. Contrary to custom, the arms are not engraved. They have been embossed by the same hand that carried out the decorations of the silver plaques; it may therefore be supposed that they were applied at the same time and for the first owner of the mounts. Although not divided by a line (which would be Italian heraldic usage), we believe this coat-of-arms to consist of two parts. According to a key article by Cecil Roth,[3] the lower one—a star, accompanied by three roses (two above, one below)—is that of the Sarfatti family. At present, although it is tempting, it would be too speculative to suggest attributions for the charges in the upper half—deer resting in a basket. Study of the various genealogies of the Sarfatti (and Sarphati) family may yield further information on this intriguing question.

The Rosenthaliana's second silver binding, although also no open-and-shut case, provides fewer riddles than its companion. Again it encloses a machzor, printed this time in Venice in 5552 (1792). At first, the silver mounts seem superficially to have been made by casting. However, this is not the case; they have been embossed and finished with flat-chasing in exactly the same way as the previous binding, and again the cover is older than the contents. Boldly designed, executed along current lines and, to judge from the somewhat hefty decorative detail, in Régence style, they probably date from between 1740 and 1760, give or take a few years. The cheerfully oblique crown and its accompanying shield point to the latter date; the strictly symmetrical shells and border scrolls, however, are late baroque.

It remains uncertain exactly where these mounts were made: it was either in Augsburg or Venice. From the late Renaissance to the final years of the Venetian Republic, fertile cross-influences can be detected north and south of the Alps. It is therefore difficult when assessing unmarked jewellery or silver to determine whether a piece originated north or south of the Swiss and Austrian mountain-passes. Without a coat of arms or any other indication of ownership or origin an ambiguous answer is all that can be expected here. But, since the lines of the binding do not quite show the finesse and routine of Augsburg ornament designers and, moreover, since the prayer-book in question was printed in Venice, it would appear reasonable to opt for this town for the binding as well. At least four other existing mounts, all of Italian provenance and some of them hallmarked at Venice around 1765, are significantly similar to ours; they are described and illustrated in Hava Lazar's article 'Jonah, the tower, and the lions: an eighteenth century Italian silver book binding'.[4] The extensive bibliographical notes in this article, as well as the 18 titles referred to in Edelmann's publication[5] are strongly recommended for further reading on this somewhat recondite but certainly fascinating subject.

KAREL A. CITROEN

55

24 Hebrew printing on coloured paper

Eliakim ben Jacob, *Sefer Refuat Ha-nefesh*, Amsterdam 1692,

folios 17 v – 18 r, 122 x 165 mm [ROS. 19 B 21]

E VER SINCE THE EARLIEST DAYS of printing deluxe copies of printed books were issued on parchment or vellum. As in the manuscript tradition, vellum was considered a particularly refined substitute for paper, and copies on vellum were especially cherished by bibliophiles and collectors of Hebrew and non-Hebrew books alike.

Early in the sixteenth century, under the influence of the Venetian master-printer Aldus Manutius, a new kind of 'secondary deluxe' medium was introduced into Hebrew printing by a Christian publisher of Jewish texts, Daniel Bomberg of Antwerp. The new material was blue paper, a product of Renaissance fascination with indigo dye, which became a convention of Hebrew deluxe printing in Venice and later in other northern Italian towns in the sixteenth century. A number of books from Bomberg's press, including some of his celebrated Talmud tractates, are known to exist in blue-paper copies. (It is a curious aspect of the competition between Gershom Soncino and Bomberg that the former never produced a book on blue paper; perhaps it was too costly, or simply unavailable because of an Aldine or Venetian monopoly.)

Luxury blue-paper printing was revived in Holland and in central Europe in the mid-seventeenth and early eighteenth centuries. The famous collector David Oppenheimer of Prague regularly ordered special copies printed on blue or other coloured paper (57 of which are today in the Bodleian Library at Oxford). According to a contemporary Christian Hebraist, J. J. Schudt, books printed on blue paper were considered 'good for the eyes', although this was certainly no more than an excuse for a bourgeois extravagance, as anyone who has tried to read these books knows.

The Bibliotheca Rosenthaliana is fortunate in possessing one sixteenth-century book printed on blue paper, the *Responsa* of Nissim Gerondi, issued in Cremona by another Christian printer of Hebraica, Vicenzo Conti, in 1557. Like Bomberg, Conti was apparently enamoured of blue paper, and early in his career produced blue-paper copies of half a dozen books, of which this seems to be the last. Around the same time, perhaps under Conti's influence, rival Jewish printers in Mantua began to use blue paper, as well as parchment, for deluxe copies. Their blue-paper copies of the *Zohar*, the classic work of Jewish mysticism, led to the mistaken view that kabbalistic texts were always printed on blue paper.

Of course, the Rosenthaliana is particularly rich in Amsterdam imprints on blue paper. Some dozen printers are represented in the Rosenthaliana's collection of Amsterdam Hebrew books on coloured paper of between 1649 and 1769, among them David de Castro Tartas, Moses Dias, and Solomon Proops, this last responsible for several Yiddish books, also on blue paper. (The vogue for blue paper was not limited to Jewish printers; several Armenian Bibles were also issued on blue paper in Amsterdam in the late seventeenth century.) Most interesting of the Amsterdam Hebrew imprints are the duodecimo *Seder Keriah we-tikkun* [readings for the eves of Pentecost and Tabernacles] printed on yellow paper by Tartas in 1664, and the duodecimo *pièce de résistance*, Eliakim ben Jacob's *Refuat Ha-nefesh* [precepts and prayers for the sick] issued by Asher Anshel and Issachar Baer in 1692, printed in red ink on blue paper. The latter volume, apparently intended to lift the spirit of the sufferer, is an extremely rare example of such an early use of coloured ink on coloured paper.

בצר לך ומצאוך כל הדברים האלה
ושבת עד יהוה אלהיך ושמעת
בקולו: כי אל רחום יהוה אלהיך לא
ירפך ולא ישחיתך ולא ישכח את
ברית אבתיך אשר נשבע להם:
ותשועת צדיקים מיהוה מעוזם בעת
צרה: משמועה רעה לא יירא נכון
לבו בטח ביהוה: לא יהיה לך עוד
השמש לאור יומם ולנגה הירח לא
יאיר לך והיה לך יהוה לאור עולם ואלהיך
לתפארתך: תירם ורוח תשאם
וסערה תפיץ אותם ואתה תגיל ביהוה
בקדוש ישראל תתהלל: אז תתענג
על יהוה והרכבתיך על במתי ארץ
והאכלתיך נחלת יעקב אביך כי פי
יהוה דבר: והתענג על יהוה ויתן לך
משאלות לבך: מי בכם ירא יהוה
שומע

שומע בקול עבדו אשר הלך חשכים
ואין נוגה לו יבטח בשם יהוה וישען
באלהיו: תנחה יהוה תמיד והשביע
בצחצחות נפשך ועצמתיך יחליץ
והיית כגן רוה וכמוצא מים אשר לא
יכזבו מימיו: ואת התורה זבח
השלמים אשר יקריב ליהוה:
עולת תמיד העשויה בהר סיני לריח
ניחוח אשה ליהוה: והיה אמונת
עתיך חוסן ישועה חכמת ודעת יראת
יהוה היא אוצרו: השיר יהיה לכם
כליל התקדש חג ושמחת לבב
כהולך בחליל לבוא בהר יהוה
צור ישראל: זה יאמר ליהוה אני וזה
יקרא בשם יעקב וזה יכתב ידו ליהוה
ובשם ישראל יכנה יתן יהוה את איבך
הקמים עליך נגפים לפניך בדרך
אדר ג ב ג

Sumario de las letras que se
hallan en los 5. libros de la
Ley de Mosseh.

פ	834	כ	8610	א	27057
צ	2925	ך	3350	ב	16344
ק	1067	ל	21570	ג	2109
ר	4694	מ	14472	ד	7033
ש	18125	ם	16623	ה	23052
ת	17949	נ	9854	ו	30513
61150		ן	4257	ז	2198
89792		ס	1833	ח	7186
153823		ע	11247	ט	1802
		פ	3976	י	31630
304805 Todas		89792		153823	

בראשית	78064 Tiene
שמות	63529 Tiene
ויקרא	44790 Tiene
במדבר	63530 Tiene
דברים	54891 Tiene

304805 En todo.

Pentateuch and Readings from the Prophets, Amsterdam 1726, last page of the Book of

Deuteronomy and the first page of the Haftarot, 180 x 275 mm [ROS. 19 J 14]

Hebrew books and broadsheets on coloured paper (and even a few printed on silk) continued to be issued in Amsterdam into the nineteenth century, when bibliophilic interest in such curiosities revived. A striking example is the *Gebeden en gezangen voor de buitengewone godsdienstoefening ter gelegenheid van het vijfentwintigjarig kroningsfeest van onzen geëerbiedigden Koning Willem III* [Hebrew prayers for the 25th anniversary of the coronation of William III], issued by Proops in 1874. One of the Bibliotheca Rosenthaliana's two copies is printed with silver ink on orange paper (evidently in honour of the silver jubilee of the Prince of Orange).

Deluxe printing on blue paper in earlier centuries is in no way to be confused with the unrelated convention of Hebrew printing on 'bluish' paper in Eastern Europe in the late eighteenth and nineteenth centuries, a result of the general use of cheap blue-tinted paper by indigent printers in towns throughout Ukraine, White Russia and Lithuania. As the Hebrew poet Bialik once noted, these Eastern European books printed on bluish paper had a great influence on the mind and imagination of generations of Talmud students. It is these Eastern European editions, rather than earlier deluxe copies from Amsterdam or Italy, to which the Yiddish novelist I. B. Singer referred in his memorable phrase, *bloy vi bleter fun alte sforim* ('blue as the leaves of old Hebrew books').

The collector Leeser Rosenthal was certainly familiar with these blue-paper books from his youth in Poland. One such volume, printed in Vilna in 1818, Aaron Broda's *Even Tekumah* [a legal digest in rhyme], is recorded (*nidpas al neyar bloy*) in Rosenthal's own catalogue of his library. A few months after Rosenthal's death in 1868, Meijer Roest called attention to another copy of this book, which was sold in the auction at Amsterdam of the famous Almanzi-Emden-Lewenstein collections.

Indeed, printing on coloured paper, whether in Venice, Cremona, Amsterdam, or Zolkiew, is a curious phenomenon of Hebrew booklore.

BRAD SABIN HILL

25 Stephanus Morinus's *Exercitationes de lingua primæva*

Frontispiece, 190 x 150 mm [ROS. 20 G 39]

IN 1986 AT THE FESTIVE COMMEMORATION of three centuries of Oriental language teaching at the University of Amsterdam, the Bibliotheca Rosenthaliana acquired a copy of *Exercitationes de lingua primæva*, printed in Utrecht in 1694. The book was written by Stephanus Morinus (1624 – 1700), 'S[anctæ] Theol[ogiæ] Doct[or]... et Ecclesiæ Gallo-Belgicæ Pastor Amstelodami', who was appointed as the first professor of Oriental Languages at the Athenaeum Illustre of Amsterdam in 1686.

Opening with the Dedicatio of Morinus, commending himself as a 'humilis cliens' to the authorities of the city of Amsterdam, the book continues with a *Commentarius* of an admirer to 'Decusque nostræ jam, Morine, Belgicæ (sc. gentis)' and finally the *Argumentum* in which the learned author himself assures us 'ut nihil præpostere tractarem; sed a primis principiis ad ultimos effectus procederem'.

The book's 448 pages are meticulously divided into three sections: *Exercitatio prima de linguis* (p. 1 – 171); *Exercitatio secunda de literis* (p. 172 – 338); *Exercitatio tertia de vocalibus Ebræorum* (p. 339 – 448). It also contains some fine engravings. The first, on the frontispiece, illustrates the story of the Tower of Babel and the confusion of tongues (Genesis XI) together with the story of the amalgamation of tongues at the festival of Pentecost (Acts 11). The other plates show drawings of curious coins with images and Samaritan and Hebrew characters. In keeping with the style of the learned scholars and Latin academies of the seventeenth century, Morinus's *Exercitationes* display an encyclopedic knowledge not only of languages, but also of numismatic, geographic and historical detail.

The profusion of quotations in this book is evidence of the writer's knowledge of foreign languages. Besides quotations from the oriental languages (Hebrew, Arabic, Aramaic, Ethiopic) and classical languages (Greek and Latin), the so-called modern languages are also cited (Spanish, French, some German and English and even a few words in the *Belgica lingua*).

The writer cited various Jewish scholars in his discourse on the origin and position of Hebrew as the *primæva lingua*. Frequently, however, classical and patristic sources were also consulted to support the scholarly argumentation. Quotations from Homer, Virgil and Ovid, texts from Plato, Aristotle and Sophocles and passages from Jerome and Augustine as well as from Origen and John Chrysostom enrich the *Exercitationes*.

But the book was first and foremost a typical exponent of contemporary Hebrew scholarship. Morinus expressed his admiration several times of 'Scaligeros, Grotios, Erpenios, & ceteros heroes', his great European predecessors, not all of whom were direct colleagues teaching oriental languages. Among these colleagues, the French Huguenot orientalist Samuel Bochart (1599 – 1667) must have been especially dear to Morinus. The philological and geographical dissertations written by this former student of Thomas Erpenius, the most famous of which is certainly the *Hierozoicon* of 1663, are most frequently referred to in the *Exercitationes*. Morinus also wrote a preface to Borchart's *Opera Omnia*, that almost reads as a biography. The laudatory essay closes with the remark: 'homo enim sum & a me nihil humanum puto; scio insuper esse difficillimum tanti viri vestigiis constanter insistere'.

The *Opera Omnia* contain some letters, one of which, written by Bochart to Morinus in the winter of 1658, testifies to the friendship between these former French scholars in the Dutch Republic. The heading contains a gentle reminiscence of the city of Caen, where both men had acted as ministers. The end of the letter briefly illustrates the friendship the men enjoyed, apparently both living in Amsterdam: 'De cætero gratias ago, quod librum tuum ad me reportaris, meumque remiseris, iis siquidem maxime egebam. Vale. Quam habuisti concionem die Sabbati proxime præterita omnibus perplacuit. Obstitere negotia quædam, ne interessum; magnopere doleo.'

Judging from the letter the relationship between the two scholars seems to have been rather personal. The quotations and references in the *Exercitationes*, however, demonstrate a more traditional tone: relations with colleagues apparently consisted of a display of contemporary academic scholarship in precise philology and traditional theology.

NICO A. VAN UCHELEN

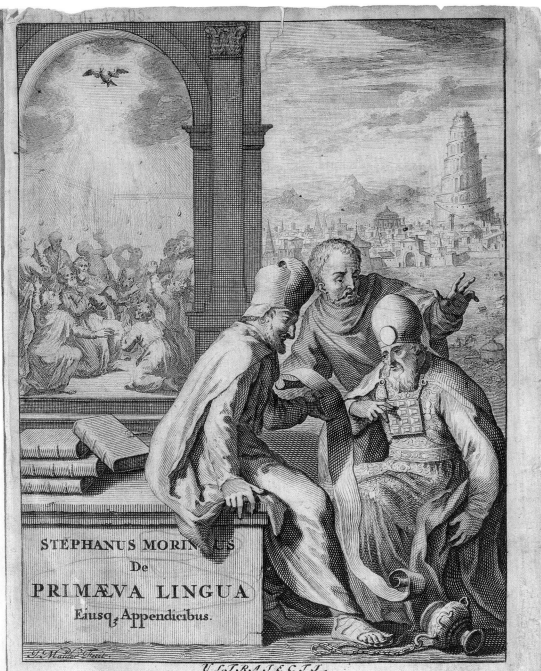

STEPHANUS MORIN US

De

PRIMÆVA LINGUA

Eiusq Appendicibus.

ULTRAJECTI,
Apud GULIELMUM BROEDELET, 1694.

CAntar deſte Iluſtrè Congreſo as alabãças,
meladas com quatro ou cinco chanças,
ſem mais nem mais me veu a memoria
duvido o ſair delas com Vitoria.

He pois o primeiro, & mayor cortezaó,
hum que a todos fala com o chapeu na maó:
he taó perfeito, & aſeado em ſeu adorño,
que todo elle pareſe feito a o torno;
pois viſte & calça com tanta perfeiçaõ.
naõ lhe faltando a ſinta, nem o galaõ.

Segue outro que eſtimo & ainda minto,
nas alabanſas que aqui Pinto
pois as merecepelas heroicas partes que tem,
em naõ ſe gavar, fazendo a todos bem
& he taõ deſtro nas artes liberais
que nao ſe pode pedir nem darſe mais

Ha mais outro manſeboſinho,
que tras o chapeu muy rebitadinho.
he ſecreto & baſtantemente calado,
& tem ſeu poco de diſimulado.
divirteſe, & paſea ſem paixaò,
y he amigo de levar as damas por a maõ.

Outro que a dias que tomou eſtado,
& que tras, Camizola de ouro, & brocado,
he faſil de ſaber quem he, em verdade,
por eſtar em pares ou nunes a dificultade.
a bolſa lhe tange com lindo tonoſinho,
mas a boz he de hum ſuave paſarinho.

26 A Portuguese festival poem from Amsterdam

Broadsheet, beginning, 194 x 145 mm [ROS.EBL. C-88]

TWENTY PORTUGUESE JEWISH YOUTHS are having a celebration somewhere in Amsterdam. The celebration and the men are commemorated in a poem written in Portuguese, printed on half a quarto page. Happily, by coincidence the print was kept; it is now one of the jewels of the collection of broadsheets of the Bibliotheca Rosenthaliana.

The poem or song consists of one strophe of four verses, followed by 19 strophes or couplets, each with six verses (sextilhas); the meter is irregular, varying from 9 to 13 syllables.

The poet promises in his opening lines 'to sing the praises of this illustrious gathering / interspersed with four or five gibes'. Then he characterizes in the mildly satirical manner of the genre one of the participants of the 'gathering' in each strophe. His Portuguese is energetic and lively, as if he were living in Lisbon rather than Amsterdam. The portraits that are evoked offer a colourful glimpse of the elegant society of the seventeenth-century Sephardi elite, and at the same time of the inner nature of 19 individuals.

Thus, we learn about gluttons, drunkards, dandies who wave their hats or parade around in brocade and gold-embroidered shirts, of someone who curses like a fishwife, or of one who is addicted to Spanish comedias, but also of generous, noble, shy and melancholy spirits...

One strophe will serve as an example:

There is one whom I see going with such haste
that I don't know if it's a rooster or a hen
it isn't a talker, no cheater, either
but a good and curious scribe.
He does not squint, and neither is he lame,
but he tends more toward the black than the white.

Although more occasional poems written by Sephardi Jews in Amsterdam are known, this *Cantar* deserves special mention. Not only is it the only poem we know of which was specifically composed for the occasion of a celebration, although the precise purpose of the celebration is not specified; it also distinguishes itself from other odes by the personal details. Other poems of this type contain stereotyped formulas which are generic and so can be mutually interchanged.

Finally, the handwritten additions to the poem add unique value. Thanks to them we know the date and location of the party as well as the poet, Jacob Torres, and we can easily identify those present at the celebration as young (between the ages of 15 and 25) descendants of primarily prominent Portuguese-Jewish families in the Amsterdam of the late seventeenth century.

It goes without saying that Jacob Torres and his *Cantar* have earned a place in the history of the rich Sephardi literature of Amsterdam.

HARM DEN BOER

27 The portrait of Jechiel Michel ben Nathan of Lublin

Engraved poster by Pieter van den Berge, 299 x 200 mm [ROS. B 4 — 12]

A S ITS HEBREW INSCRIPTION proclaims, this striking full-length portrait, reminiscent of the great Jewish portraits in Rembrandt's œuvre, represents the precentor Jechiel Michel ben Nathan of Lublin. He is seen outside his place of work, the 'German', or Ashkenazi, synagogue at Amsterdam. But the building and the other persons shown in the print are dwarfed by the impressive figure of this eminent man wearing the garments befitting his status, holding what must certainly be a Jewish liturgical book in his hand, a finger marking the page he was reading, and perhaps pondering the text—his eyes and facial expression being those of a man deep in thought. He is therefore oblivious of the elderly Jew observing him from the door of the synagogue, of the boy entering shyly through the opening in the railings on his way in, or of the two gesticulating figures following him at a short distance.

These last two may well represent the new musicians, both of them singers and one a bass, whom Jechiel Michel had introduced into the Amsterdam services in a series of innovations. Their appointment was to split the community into two opposing factions, some calling their music sweet, the others decrying it as caterwauling. The detractors supported the traditionalist cantor Leib and feelings ran so high that abuse was exchanged and even physical violence, an episode said to have been the cause of the death of a newly appointed rabbi in 1709.

The artist Pieter van den Berge signed his name in Latin at the foot of the print, between the columns of the Hebrew text: he drew the design and engraved it and, he maintains, also obtained a privilege for its sale, therefore rightfully being the publisher as well. In their articles on this artist neither Wurzbach nor Thieme & Becker mention this print, but the former describes a 'Brustbild eines Rabbiners. Rembrandt p.' as item no. 58 in the artist's inventory, revealing that his interest in the Jewish community of Amsterdam extended beyond the portrait of Jechiel Michel.

The date 5460, derived from the Hebrew text, falls between the autumn of 1699 and that of 1700.

ANNA E.C.SIMONI

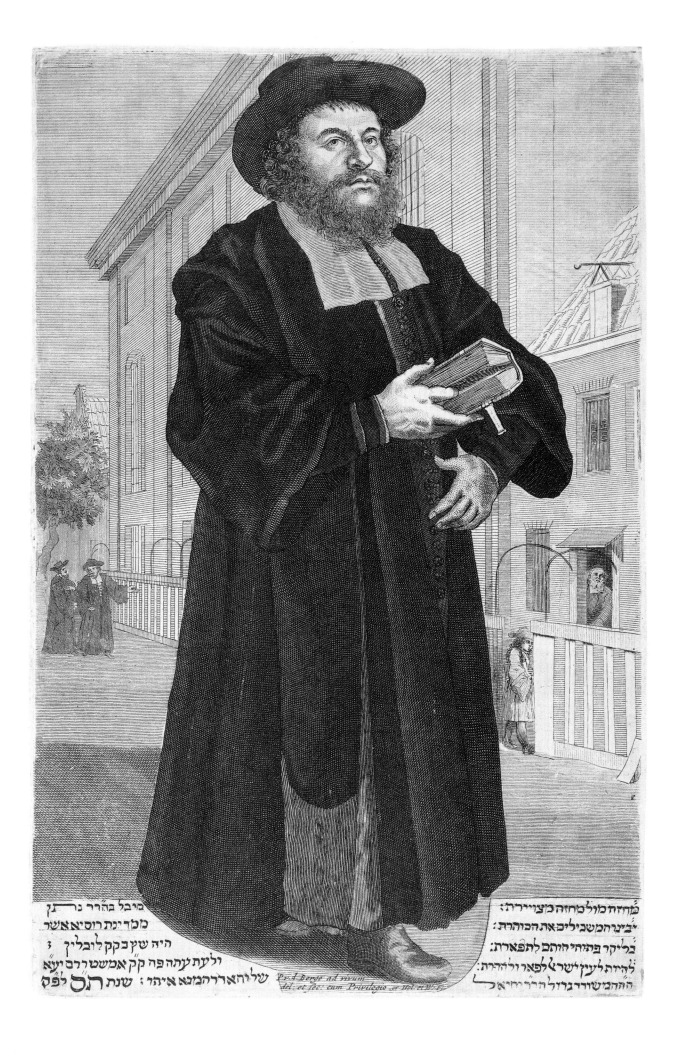

מחזה מול מחזה מצוייירת:
ביצר המשכיליב את הכוהרת:
בליקר פתהיהוהם לתפארת:
להיות לעין ישרא לפאר ולהדרת:
ההבימשודרגדול הרר יחיאל

מיכל בהרר נ ג ן
מדינת רוסיא אשר
היה שץ בקק ליבלין ;
ולעת עתה פה קק אמשטרדם יעא
שליהארדרהמנא איתר : שנת תג ג לפק

Pr. I. Beege ad vivum
del. et fec. cum Privilegio or Hol. et W.

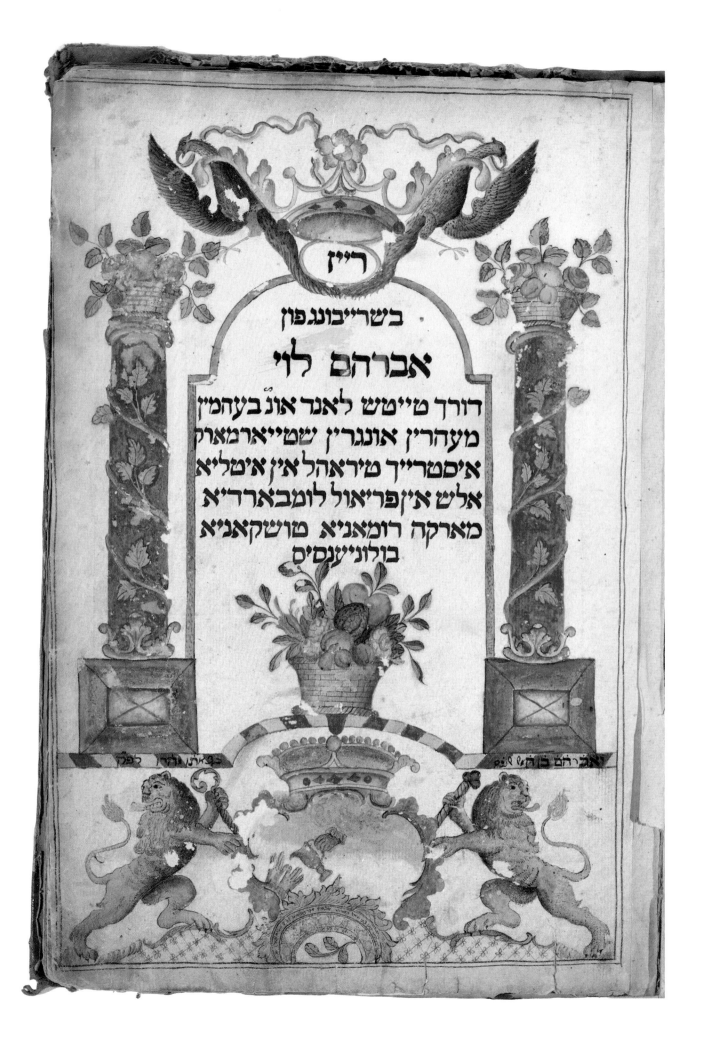

רייף

בשרייבונג פון

אברהם לוי

דורך טייטש לאנד אונ בעהמין
מעהרין אונגרין שטייארמארק
איסטרייך טיראהל אין איטליא
אלש אינפריאול לומבארדיא
מארקה רומאניא טושקאניא
בולוניענסיס

28 The Grand Tour of Abraham Levi ben Menahem Tall

Rayz beshraybung [...], first title-page, 360 x 250 mm [HS.ROS. 23]

THIS IS A REMARKABLE manuscript, containing an itinerary in Yiddish of a journey made by Abraham Levi ben Menahem Tall through Central Europe and Italy between 1719 and 1724. The manuscript, probably the only known description of a Jewish Grand Tour, was copied by a professional Amsterdam scribe, Zevi Hirsh ben Abraham of Breslau, between 1752 and 1764, long after Abraham Tall made his journey. The manuscript contains not only the text of the itinerary, but also all of the maps and prints used and collected by the traveler during his educational journey. Two hand-coloured title-pages were also added by the scribe, the first of which is shown here. The text reads: '*Rayz beshraybung fun Avrohom Levi Tall, durkh Taytsh Land un Behmen, Mehren, Ungaren, Shtayermark, Aysteraykh, Tirohl, in Italya als in Friyul, Lombardiya, Markah, Romanya, Toskanya, Bolonyensis*'.

Abraham Levi ben Menahem Tall was born in 1701 or 1702 in Horn in Westphalia, which means that at the time he began his journey he was only seventeen years old. He left his native Horn at only five years of age to live in Lemgo, not too far from Lippe. He died in Amsterdam on 21 Shevat 5545 (1 February 1785). The manuscript was donated to the Bibliotheca Rosenthaliana by Abraham's grandson, some time around the turn of the century, and the greater part of its text was published by the Bibliotheca Rosenthaliana's first librarian Meijer Roest, between 1884 and 1886.

The manuscript starts with a long Hebrew poem, which is in fact a rhymed summary of the contents of the itinerary. It is followed by a lengthy explanation and by the traveler's preface. In it Abraham tells about his ardent wish to travel around Europe, and about his eagerness not to postpone his journey any longer than strictly necessary.

At the end of the manuscript there is an interesting alphabetical list of 235 names of places mentioned in the text, together with systematic information on, for example, the distances from Lemgo, on the coinage in that particular place, or on the amount of toll that Jews had to pay. Naturally this list deserves further study. Among the many places visited by Abraham Tall are the Austrian cities of Innsbruck and Vienna, where he went to see the well-guarded house of the Wertheimer family of Court Jews and the Spanish riding-school, Prague and, in Italy, Rome and Naples.

A fascinating episode in the itinerary recounts how, on his way to Prague, Abraham Tall, his father, and another Jewish companion had to stay the night in a very small village, where no one spoke German. They found a small inn, where they ran into a soldier who did, in fact, speak German. Abraham ordered a beer, but the soldier came over and finished it. Abraham decided not to protest and ordered another beer, but, again, the soldier drank it. Abraham noticed that the soldier was not very sober and turned to the inn-keeper, asking him what to do and whether it would be better if he left. 'To hell with you', the inn-keeper answered, after which the men paid for their drinks and left the inn. But there was no other inn in the village, and the three men stood in front of the inn, thinking about what they should do, when suddenly the soldier came out with a stick, hit the father, and demanded they stay. The father managed to get hold of the stick and to break it, after which the soldier went for his dagger. Again, Abraham relates, the father managed to get hold of the soldier's weapon, apparently bending it double! Abraham then threw a stone at the soldier that hit him in the face, but that infuriated him even more, so that Abraham was forced to hide under the bed of a friendly citizen for more than an hour. Once the soldier had returned to the inn, Abraham, trembling like a mouse, went to look for his father, who had been chased by the soldier but had managed to escape. When they found each other, his father appeared to have injured his hand when bending the dagger and to have damaged his hat, but apart from that nothing serious had happened. After filing a complaint against the rude inn-keeper in the next village, the men continued their fascinating journey.

EMILE G.L.SCHRIJVER

29 Nathan ben Simson of Meseritz's *Prayers for the New Moon*

Title-page, 176 x 115 mm [HS. ROS. 683]

T O MARK THE PUBLICATION of the twentieth volume of *Studia Rosenthaliana* Dr. L. Fuks and Prof. Dr. R. G. Fuks-Mansfeld donated a 1730 *Tikkun be-erev Rosh Chodesh* to the library. Dr. E. G. L. Schrijver attributed it convincingly to Nathan ben Simson of Meseritz. Besides the four decorated opening words (fols. 2r, 4r, 8r, 13r) and a text illustration of a man saying the Ashamnu prayer in synagogue (fol. 13v), the 21-folios manuscript in 'Otiyyot Amsterdam' contains an architectural title-page with four marbled panels flanking the title. The top panel has a baroque shield held by two lions rampant. According to a contemporary inscription the manuscript belonged to the 'prominent and eminent young man David son of the prominent and eminent Rabbi Leib z.l. of Rotterdam'. Who the owner was remains a mystery.

In 1991 the Amsterdam Jewish Historical Museum acquired a Haggadah written in 1728 in 'Otiyyot Amsterdam' on vellum with colour illustrations by Nathan of Meseritz (JHM 5446). According to the vignette above the architectural title-page this Haggadah once belonged to a certain Hirsh, son of parnas Jacob de Vries, also of Rotterdam. The lower vignette, flanked by lions, contains the year in a chronogram using the Haggadah verse 'all who tell about the Exodus from Egypt are worthy of praise', a verse Nathan also used for dates in other Haggadot.[1] The illustrations are based on Abraham bar Jacob's copper engravings for the Amsterdam Haggadah (1695 and 1712). The printers of the first edition of this Haggadah, Asher Anshel and Issachar Ber, used printing materials acquired from their predecessor Moses Kosman Gomperts, son of the wealthy purveyor to the army of the Dutch Republic, Elijah Gomperts of Cleve. Moses Gomperts married Zipporah, daughter of Glückl Hameln in 1673. However, although it is Moses ben Joseph Wesel who is mentioned as

the financier of this edition, it is likely that Moses Gomperts also had a hand in this lavishly illustrated printed edition. And the fact that he emigrated to Prossnitz in Moravia in the late 1690s also helps explain why the Amsterdam Haggadah was so popular among Moravian scribes.

The presence of Bohemian and Moravian scribes in Germany is generally thought to be a consequence of demand among Court Jews for illustrated manuscripts for personal use. A previously underestimated factor is the so-called Familiants Law introduced by Holy Roman Emperor Charles VI in 1726 – 1727 and aimed at limiting the number of Jews in Bohemia and Moravia. This 'pharaonic' law contributed to large-scale emigration to Holland as well as Germany, as the marriage registers published in *Trouwen in Mokum* show.[2] Nathan of Meseritz stayed in Rotterdam in 1728 to write a Haggadah for a certain Solomon, now in the Prague Jewish Museum (MS. 240). In the same year he also wrote another *Tikkun erev Rosh Chodesh* for Kossman Segal of Leinz (Library of the Jewish Theological Seminary of America, New York, MIC. 4433f). He returned to Rotterdam in 1735 to write a *Sefer Tehillim* (Sotheby's New York, 26 June 1985, lot 94) together with Judah Leib ben Elchanan Cohen and finally in 1739 to produce a Haggadah, his last known dated work.

His earliest dated manuscript is a 1723 *Tikkun erev Rosh Chodesh* now in the Library of the Jewish Theological Seminary in New York (JTS 4432c). Also of that year is an Omer calendar now at the Jewish Historical Museum in Amsterdam (JHM 3184). On the title-page Adam and Eve flank the text panel. Psalm LXVII on the reverse side is written in the shape of a menorah; apart from the introductory verse this psalm contains 49 words—the number of Omer days. Each successive page contains one word from the psalm in the bottom right-hand corner, while in the centre, with one exception, is a single letter from the 48-letter verse 5 of the psalm. Bottom left is a word from the 42-letter prayer *Ana be-koach*. By using the first letters of this seven-line text the writer reaches the sum of 49 here too. The 42 words refer to the days between the end of Passover and the beginning of Shavuot as well as to the 42-letter name of God. Each time the Tetragram contains other vowels, followed by the name of one of the Sefirot —a testimony to the popularity of Jewish mysticism in the eighteenth century.

In the same year that Nathan wrote the Rosenthaliana Tikkun, he also produced a Haggadah for Alexander Segal of Hanover (Jerusalem, Jewish National and University Library, 8°2237), a fact which might have pleased the Hanovarian Leeser Rosenthal.

EDWARD VAN VOOLEN

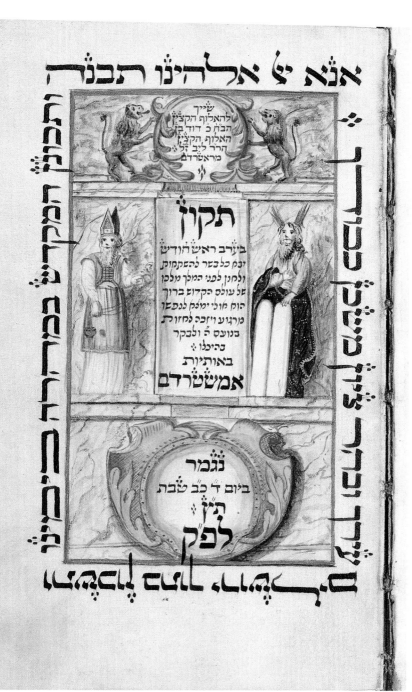

אנא יי אלהינו תכנה

שייך
להאלות הקב...
הבח כ דוד ב...
האלות הקב...
הרר ליב ז״ל
מראטרדם

תקון
בערב ראש חודש
יבא כל בשר להשתקות
ולחנן לפני המלך מלכו
של עולם הקדוש ברוך
הוא חולי ימלא נפש אשר
מרגיע ויזכה לחזות
בנועם ה׳ ולבקר
בהיכלו ׃
באותיות
אמשטרדם

נגמר
ביום ד׳ כב טבת
ת״ן
לפק

30 A 'Konstboeken-binderij' luxury binding

The binding of the Michael Lopez manuscript, 162 x 300 mm [HS.ROS. 499]

MICHAEL LOPEZ DE PINTO was an important copyist of texts in Dutch and Spanish within the cultural circle of the Amsterdam Sephardim of his time. Three of his manuscripts are at the Bibliotheca Rosenthaliana and five at Ets Haim library. These date from 1688 to 1739. Lopez wrote in a carefully edited style and added illustrations to some of the texts. Illustrations are absent in his *Ordre Van het Joodsche Gebeth Overgeset uyt den Hebreusche In NederDuytsche. Geschreeven in Amsterdam. door Michael Lopez Pinto* 5494 AET:S:68 (HS.ROS. 499). The only decoration that was added to the manuscript consists of inscriptions on the first title-page and the second title *Ordre van het Joodse Feest Gebeth.*

It is not known for whom Lopez wrote this prayerbook. We do know, however, why the text was written exclusively in Dutch. Daniel de la Penha Iosephzoon explains in his dedication to *Hisuk Emuna, dat is Versterkinge des Geloofs...* (1729, Ets Haim): 'there are many among us who do not understand [Spanish] very well; the more [of us who] are born in this country, the more [of us] will be familiar with the Dutch language as if it were their mother tongue; and since we have to deal with arguments and resolve questions and matters of this nature with our adversaries in the Dutch language, our community shall by being able to read this language be more capable of replying to them and by so doing to defend our true and holy Law and Belief'.

The unknown client had the manuscript beautifully bound and chose durable and precious morocco leather for the binding. The rich gold tooling on the covers shows three closely drawn frames. The second frame, a decorative roll, has tools on every corner and the inner one, a double line, tools on and in the corners. The centre is decorated with drawer handles and rosettes. The fields on the spine were decorated with special tools in the corners and the centre; the sides of the boards and the turn-ins were carefully done with a roll. The name of the binder is not known. Like his colleagues he did not sign his products.

Yet something can be said about him, because other bindings from his workshop are known. This is because the tools that binders used in those times were hand carved and were, in fact, unique. From the more complicated designs we can tell by the imprints if they were made by the same tools, enabling us to differentiate particular workshops.

By comparing stamps, 27 (series of) luxurious bindings were found, which must have originated from the workshop in which Lopez's manuscript was bound. Some of them can be dated and hence we know that the binder worked from 1705 to 1741. Among these bindings are some that could have been made for Sephardim: one from the *Orden de las Oraciones quotidianas* (Amsterdam, 5466 (1706); The Hague, Koninklijke Bibliotheek), a binding with the name of Sarah de Abraham Cortissoz 5499 (1739) on the front cover (published in Gans's *Memorbook*) and perhaps the bindings of Ambrosio Morales' *Chronica general de España* (Cordova, 1586; Oxford, Shrewsbury School Library) and Francisco de Pisa's *Discripcion de ... Toledo* (Toledo, 1617; The Hague, KB).

This does not prove that the binder belonged to the Amsterdam Jewish community. He was known in several circles. At some time he bound the prize books of the Haarlem Latin school; one still has the prize dedication from 1741 that was sewn in (Amsterdam, University Library). He bound at least one presentation copy of the *Privilegien, willekeuren...* of the Amsterdam Surgical College (Amsterdam, 1736; The Hague, KB). On the covers there is the coat-of-arms of the city. Furthermore, he bound the presentation copies of the first part of Arnold Houbraken's *Groote schouburgh der Nederlandsche konstschilders* (Amsterdam, 1718) for Pieter de la Court van der Voort (The Hague, KB) and François Fagel (Dublin, Trinity College). Technically speaking the binder could do anything, from small song books and almanacs interleaved with guards to architectural books in oblong broadsheet format, containing many pictures. Finally, he also could make 'konstboeken' (art books), of which no fewer than five copies have survived, books with blank pages in broadsheet format, with strips for holding pictures and drawings. Because of this, the bindery has been provisionally named the Konstboeken-binderij (art books bindery). The binder had a preference for the sort of decoration we see on the binding in the Rosenthaliana. They are found on almost all the bindings, big or small.

JAN STORM VAN LEEUWEN

31 The Rosenthaliana *Leipnik Haggadah*

Title-page, 359 x 270 mm [HS.ROS. 382]

THE ROSENTHALIANA Leipnik Haggadah was written by Joseph, son of David of Leipnik, who was by far the most important and influential scribe of the Hamburg-Altona school of Hebrew illuminated manuscripts. This particular school must be seen as part of the broader revival of Hebrew manuscript illumination in the eighteenth century, long after the general acceptance of the printed book. Joseph came originally from Leipnik in Moravia and belonged to the second generation of eighteenth-century scribes who followed the original Moravian school where this revival had started. Compared with other contemporary scribes, Joseph of Leipnik does not appear to have been a very prolific scribe. Yet he introduced some changes and innovations. So far, only thirteen manuscripts written by him, all of them Haggadot, have been discovered. From the colophons of his manuscripts, we learn that he was active between 1731 and 1740. He wrote his first Haggadah in Frankfurt am Main in 1731. He then moved to Darmstadt, and in 1737 he reached Altona, at that time part of Denmark. He remained in Altona and Hamburg, where he continued to produce manuscripts.[1]

Although the Rosenthaliana Haggadah was probably written to be presented as a personal gift, there is no indication as to the identity of its original owner. Its provenance remains enigmatic, until 1923, when it was donated to the Bibliotheca Rosenthaliana by M.A. and S. Keizer. The Haggadah, which includes an abbreviated version of the commentary on the Haggadah by Isaac Abrabanel, as well as a short mystical commentary, appears to have been written for an Ashkenazi patron. This is indicated, for example, by the fact that the captions to the illustrations were written in Yiddish and Hebrew. Yet, following the model of the printed Amsterdam Haggadah, the instructions are given both in Yiddish and Ladino, and the Grace after Meals is copied in both Ashkenazi and Sephardi versions.

Leipnik's colourful, elegant parchment Haggadah gave expression to the sentiments of a new class of wealthy Jews who adopted a life-style similar to that of the non-Jewish aristocracy. This style is reflected not only in the genre scenes, such as the one depicting a couple performing the ceremony of the blessing over the wine at the Seder table (fol. 3a), but also in biblical scenes, in which the patrons' dress, hair style, houses, and cultural aspiration are reflected. Thus, the daughter of Pharaoh, in the 'Finding of Moses', is portrayed as a Nordic fair-haired princess in ermine robe (fol. 10a). Even the Four Sons of the Haggadah narrative are portrayed as four figures of different ages, all dressed in contemporary attire, and depicted within an elegant house.

Like all eighteenth-century Haggadah manuscripts, Leipnik's Haggadah was primarily modelled after the two editions of the Amsterdam Haggadah (1695 and 1712), illustrated with copper engravings by Abraham bar Jacob. Occasionally, however, an illustration is taken from a different source. The title-page of the Rosenthaliana Haggadah for example, was modelled on the title-page of *Sefer Yad Yosef*, printed in Amsterdam, by Immanuel son of Joseph Athias, in 1700. This title-page is based on a similar title designed by Abraham bar Jacob for the book *Shene Luchot Ha-berit*, printed in 1698 also by Athias.[2] As indicated in its Yiddish caption, the title-page illustrates the crown of the Torah, the crown of priesthood, the crown of kingship and the crown of 'a good name' (Sayings of the Fathers 4:17), represented respectively by the figures of Moses, Aaron, King David, and King Solomon.

Both iconographically and stylistically the Rosenthaliana Haggadah bears similarities to the 1737 Leipnik Haggadah, which is in a private collection in London, and to a lost 1738 Haggadah by Leipnik, that was formerly in the possession of Dr. Linel in Frankfurt am Main. While some of Leipnik's Haggadot were not painted by the scribe himself, it appears that in the case of the Rosenthaliana Haggadah, Leipnik was responsible for both the writing and the painting.

IRIS FISHOF

מהר ישראל

DE
BRUIDSCHAT ISRAELS,
OF
ONDERWYS
DER
HEBREEUWSCHE
SPRAAK-KUNST.

Door welkers behulp men in een zeer korten tyd, zonder
onderwys, met een weinig zig te oeffenen, de kennis van
deeze oudfte en allervoortreffelykfte Grondtaal kan
machtig worden;

Met Twee Bygevoegde

WOORDENBOEKEN,

Vervult met alle de Woorden, die in den Heiligen Text vervat
zyn, tot gebruik der genen, die zig in deeze Goddelyke Taal
willen oeffenen;

OPGESTELT DOOR

ELEASAR SOESMAN,

Joods Rabbyn, en Onderwyzer der Hebreeuwfche Taale te Amfterdam.

Voorzien met een GETUIGSCHRIFT van den Hooggeleerden Heer

CORNELIUS HUGO VONK,

*Leeraar der H. Godgeleerdheid, en Hoog-Leeraar der Oofterfche Taalen en
Oudheden in de Doorlugtige Schoole te Amfterdam.*

Te AMSTERDAM,
Gedrukt voor den AUCTEUR, alwaar dezelve te bekomen zyn,
EN
By ARENT van HUYSSTEEN, Boekverkooper
op 't Rokkin op den hoek van de Gaperfteeg, 1741.

De Staaten van Holland en Weft-Vriefland, doen te weten:

ALzoo ons te kennen is gegeeven by *Eleafar Soesman* (van de Hoogduitfe Joodfe Natie), Ingeboorne
en Poorter der Stad Amfterdam, dat hy Suppliant hadde afgedrukt een Hebreeuwfche Grammatica
in het Nederduitfch, genaamt *de Mohar Ifrael*, of *Bruidfchat Ifraels*; achtervolgt wordende met twee
Woordenboeken, zynde het eene Nederduitfch en Hebreeuwfch, en het ander Hebreeuwfch en Neder-
duitfch daar agter; ende hy Suppl: beducht zynde, dat het gemelde Werk fomtyds tot zyne merkelyke
fchade mogte nagedrukt, ofte in eene andere taale overgezet worden, zoo keerde hy Suppliant zig tot ons,
ootmoedig verzoekende ons Octroy, om het bovengemelde Werk alleen met feffelve van alle anderen te
mogen drukken, SOO IS 'T: dat wy de zaak en het voorfz. verzoek over gemerkt hebben-
de en genegen wezende, ter bede van den Suppliant uit onze regte wetenfchap, Souveraine magt en
authoriteit, denzelven Suppl: geconfenteert, geaccordeert en geoctroyeert hebben; Confenteeren,
accordeeren en octroyeeren hem by deeze, dat hy geduurende den tyd van Vyftien eerft agter een vol-
gende Jaaren de voorfz. *Mohar Ifrael*, of *Bruidfchat Ifraels*, agtervolgt wordende met twee
Woordenboeken, zynde het eene Nederduits en Hebreeuws, en het ander, Hebreeuws en Nederduits,
in diervoegen als zulks by den Suppl: is verzogt, en hier vooren uitgedrukt ftaat, binnen onze
voorfz. onzen Lande alleen zal mogen drukken, doen drukken, uitgeven en verkopen, Verbieden-
de daarom alle en een iegelyk de voorfz werken in 't geheel of ten deele te drukken, naar te druk-
ken, te doen naar drukken, te verhandelen of te verkoopen, of elders naargedrukt binnen denzelven
onze Lande te brengen, uit te geven of te verhandelen, en verkoopen, op verbeurte van alle de
naargedrukte, ingebragte, verhandelde, ofte verkogte Exemplaaren, ende een boete van drie duizend
guldens daar boven te verbeuren, te appliceeren, een derde part voor den Officier die de Calange doen
zal, een derde part voor den armen der plaatze daar het Cafus voorvallen zal, en het refteerende derde
part voor den Suppl:; en dit telkens, zoo meenigmaal, als dezelven zullen werden, agterhaalt, alles in
dien verftande, dat wy den Suppl: met dezen onzen Octroye alleen willende Gratificeeren tot ver-
hoeding van zyne fchade, door het nadrukken van de voorfz. Werken, daar door in geenigen
deele verftaan den inhoude van dien te authorifeeren of te advoueeren, en veel min dezelve onder onze
protectie en befcherminge eenig meerder Credit aanzien of reputatie te geven; nemaar den Suppl: in
Cas daar in iets onbehoorlyks zoude influeeren, al het zelve tot zynen lafte zal gehouden weren te ver-
antwoorden; tot dien einde wel Expreffelyk begeerende, dat by aldien hy dezen onzen Octroye voor
dezelve Werken zal willen ftellen, daar van geene Geabbrevieerde of Gecontraheerde mentie zal mogen
maaken, nemaar gehouden wezen het zelve Octroy in 't geheel en zonder eenige omiffie daar voor te
drukken ofte doen drukken, en dat hy gehouden zal zyn een Exemplaar van de voorfz. Werken op
groot papier, gebonden, en wel geconditioneert te brengen in de Bibliotheecq van onzen Univerfiteit
te Leiden, binnen den tyd van zes weeken, na dat hy Suppl: dezelve Werken zal hebben beginnen
uit te geven, op eene boete van zes honderd gulden na Expiratie der voorfz. zes weeken by den
Suppl: te verbeuren, ten behoeve van den Nederduitfche armen van de Plaats alwaar den Suppl:
woont: en voorts op poene van met der daad verfteeken te zyn van het Effect van dezen Octroye.
Dat ook den Suppl:, fchoon by het ingaan van dit Octroye een Exemplaar gelevert hebbende aan de
voorfz. onze Bibliotheecq, by zoo verre hy geduurende den tyd van dit Octroy dezelve werken zoude
willen herdrukken met eenige Obfervatien, Noten, Vermeerderingen, Veranderingen, Correctien, of
anders hoe genaamt, of ook in een ander formaat, gehouden zal zyn wederom een ander Exemplaar
van dezelve Werken, geconditioneert als vooren, te brengen in de voorfz. Bibliotheecq binnen den
zelven tyd, en op de boete en penaliteit als voorfz. Ende ten einde de Suppl: dezen onzen Con-
fente en Octroye moge genieten als naar behooren, laften wy alle en een iegelyk, dien het aangaan
mag, dat zy den Suppl: den Inhoude van deze, doen, laten en gedoogen, ruftelyk, vreedelyk
en volkomentlyk genieten en gebruiken; Cefferende alle belet ter Contrarie. Gegeven in den Hage,
onder onzen Grooten Zegel, hier aan doen hangen op den zes en twintigften Augufti, in het jaar onzes
Heeren en Zaligmaaker, Duizend zeven honderd en veertig.

J. H. V. WASSENAER

Ter Ordonnantie van de Staaten,

WILLEM BUYS.

De Aucteur erkent geene Exemplaaren voor de zynen, dan die met zyne hand ondertekend zyn.

E. Soesman

32 Eleasar Soesman's *Mohar Yisrael*

Title-page and verso of the title-page, 250 x 190 mm [ROS. 1855 B 29]

ELEASAR SOESMAN'S *Mohar Yisrael* ('Israel's Dowry') which appeared in Amsterdam in 1741, is properly speaking not a rare book. Many libraries own copies, and more are offered in antiquarians' catalogues every year. This is amazing for a sizeable grammar and dictionary of Biblical Hebrew written in Dutch, even more so because the author was a Jewish scholar of some distinction: nearly all other Hebrew grammars in Dutch were written by and for Protestant theologians. Soesman published a number of books on various subjects, such as Bible commentaries and translations, an edition of a polemical work, grammars and a translation of Isaac Aboab's celebrated *Menorat ha-maor* during the thirty years of his active career in Amsterdam. Some of these were clearly aimed at a Jewish audience, others were meant for Christian readers. His *Mohar Yisrael* evidently belongs to the latter group. The book was published by the Christian printer Arent van Huyssteen who also printed a number of other books dealing with Jewish subjects, such as a work about the Jewish ban (1734) and Jacob Fundam's Dutch translation of portions of Tractate Berakhoth of the Babylonian Talmud (1737), which were all intended for the Christian market.

In 1742 Eleasar Soesman became involved in a heated polemical exchange of pamphlets about religion, which also provides some information on the way in which this book was edited and published. It appears that Soesman received the help of a Christian merchant from Amsterdam, David Brunings, who corrected his Dutch style and suggested adaptations to the usual appearance and contents of Hebrew grammars being published at the time; there is a manuscript of Soesman's own version of the grammar, which indeed turns out to be significantly different from the published version.

As the title of his book implies, Soesman held to the theory that the Hebrew language had a very special position among the languages of the world and could only be studied in the light of Jewish cultural and linguistic tradition. This had been the opinion of Christian scholars for a long time, but during the eighteenth century the emphasis of the Christian study of Hebrew at the universities of Europe shifted from the use of rabbinical and medieval Jewish literature for understanding the Hebrew text of the Bible to the clarification of Biblical Hebrew through the evidence of comparative Semitic studies, especially through supposed or real parallels with the Arabic language. Soesman's opponents in the 1742 debate, one of whom was the Joannes Guilielmus Kals who also wrote several grammatical works on Hebrew, were adherents of Albert Schultens, who was a professor of Oriental Languages in Leiden from 1729 and eloquently advocated the new approach to Hebrew linguistics. The theological side of this change in linguistic interest became clear in the exchanges between Soesman and his opponents.

After the beginning of Humanism in Europe in the late fifteenth century and the revival of interest in the Hebrew language among Christian theologians and laymen, one of the ways in which Jewish scholars were able to make a living was by teaching interested Christians the Hebrew language and Jewish literature. In Amsterdam during the seventeenth and early eighteenth centuries, there were several rabbis who supplemented their usually meagre salaries in this way. The number of Jews who wrote and published grammars and dictionaries especially for Christian audiences was, however, very small. It is remarkable that Soesman's *Mohar Yisrael*, written at the end of this remarkable period in the history of Hebrew studies, was published in such a beautiful form. In format, contents and success Eleasar Soesman's book deserves a place of honour among Hebrew grammars published in the Netherlands.

JAN WIM WESSELIUS

33 The 'Otiyyot Amsterdam' of Jacob ben Judah Leib Shamas

Haggadah, title-page, 302 x 215 mm [HS.ROS. 573]

ONE OF THE MOST productive representatives of the eighteenth-century group of scribes responsible for the remarkable renaissance of Hebrew manuscript production in Europe is Jacob, son of Judah Leib Shamas of Berlin. Jacob Leib, or Jacob Sofer (scribe) of Berlin as he occasionally called himself, was active between 1718 and 1741 in the communities of Hamburg and Altona. Between 1671 and 1811 Altona and Hamburg, together with the community of Wandsbek, formed the so-called AHW congregation. Since Jacob only mentions Hamburg in his colophons after 1721, it is certainly possible that he started work in Berlin. The Bibliotheca Rosenthaliana has no fewer than five manuscripts by this scribe, while a sixth that used to belong to the collection is now in Amsterdam's Municipal Archives. Not only can the Rosenthaliana boast the second largest collection of Jacob Leib manuscripts in the world (only the Israel Museum in Jerusalem holds more manuscripts) among them are his first known work, dated 1718, and one, a Haggadah, that was possibly his last. It was produced in 1741, as were two other manuscripts, now in the Jewish National and University Library in Jerusalem and in the Klau Library of Hebrew Union College in Cincinnati. In 1987 Iris Fishof published a list of manuscripts written and illustrated by Jacob, which contained 27 works known from public and private collections. In 1990 at least two more manuscripts were added to Fishof's list, while since then several other manuscripts of his have been described in auction catalogues.

As is so often the case with Hebrew scribes, from both medieval and later times, biographical information is scarce. Jacob Leib was a descendant of the Prague rabbi Mordecai ben Abraham Jaffe (*c.* 1535 – 1612). His father hailed from Berlin and was a shammash, a synagogue beadle. Once in Hamburg Jacob soon married, probably some time around 1720. He had at least one son, Israel, who in 1748 finished a manuscript that his father had left unfinished in 1719. As we have seen, no manuscripts by Jacob's hand are known after 1741, and in 1744 his son signed a manuscript as follows: 'Copied by Israel, son of the late Yokev, scribe of blessed memory, of Berlin'.

Two trends can be observed in the decoration of eighteenth-century Hebrew manuscripts. In the Bohemian / Moravian centre artists set great store by the exact copying of printed books, so that these books often contain black and white pen-and-ink drawings imitating printed copper engravings and even Amsterdam Hebrew lettering. In Hamburg / Altona a tendency toward multi-coloured decoration can be observed, with Joseph ben David of Leipnik as the most impressive example. It has to be admitted, however, that although Jacob Leib did produce some manuscripts with coloured illustrations, most of his works contain only black and white illustrations. Moreover, compared with some of his contemporaries, his coloured manuscripts are not particularly impressive. Scribes in northern Germany also used to emphasize the fact that their manuscripts were written 'Be-otiyyot Amsterdam', i.e. with Amsterdam letters.

The title-page of the 1741 Haggadah reproduced here is a fine example of the impressive penmanship of Jacob Leib and of his ability to copy printed books. As Iris Fishof has shown convincingly, the imagery was copied slavishly, although in reverse, from a printed title-page of a Frankfurt am Main 1687 edition of the *Yalqut Shimeoni*. In 1957 the Hungarian scholar Ernest Naményi described the art of Jacob Leib as 'l'ensemble de l'œuvre est d'une médiocrité peu intéressante', the scribe's œuvre is uninterestingly mediocre. It cannot be denied that much of his work may indeed be described as such, but one should, at the same time, give credit where it is due, for the tremendous skill with which, at least toward the end of his career, Jacob Leib was able to copy printed images and, above all, for his stunning ability as a scribe. In fact, I would go so far as to suggest that his Hebrew letters are the ultimate 'Otiyyot Amsterdam'.

EMILE G.L.SCHRIJVER

בה

זה השער לײ
צדיקים יבאו
בו:

סדר
הגדה של פסח
עם פירוש אברבנאל ופירוש על פי הסוד
וכל סדר קדש ורחץ וליורים נתים זהלחותי
והמנהגתים שעשה
הק בה
בית המקדש תובב לכיר: כמנהג אל
חשכמזים וכמנהג הסכלרדיס אשר לה נדפם
כדמין הזה:
פה המבורג
בשנת אײ מפטי בין אֿקר הפסק ל
מיקונן אײן לפר:

אנכי
יײ יהוך
לא לא יהיה
תרצרד
לא לא
תנאף תשאא
לא שם ײהֿ
תגנב לא
לא זכור
תענה את
כבר את השבת
אבין ואת לא
אמר למען תרהמד
יארכון ארכון
ב×תרע×

אהרן ⟶ ⟵ משה

זכרו תורת משה : עברי :
אשר צויתי אותו : בחרב :

כתר תורה

וידבר אלהים את כל
הדברים האלה לאמר

לוח ימני:

אנכי יי אלהיך
לא יהיה לך אלהים
אחרים על פני
לא תעשה לך
פסל
לא תשא את שם
יי אלהיך לשוא
זכור את יום
השבת לקדשו
כבד את אביך

לוח שמאלי:

לא תרצח
לא תנאף
לא תגנב
לא תענה ברעך
עד שקר
לא תחמד בית
רעך לא תחמד
אשת רעך
ועבדו ואמתו
ושורו וחמרו

זאת כתבתי במצות האלוף הקצין כה׳ לוי בהמנוח ג׳
שמשן בארקום ז׳ל
נכתב על ידי יקותיאל סופר בן כהר׳ יצחק סופר
שנת בעלהי ההרה לקרת לוחת האבנים לוחת הברי׳

34 The Tablets of the Law at the Bibliotheca Rosenthaliana

Jekuthiel Sofer's Tablets of the Law, 612 x 502 mm [HS.ROS. PL. A-33]

DECORATIVE TABLETS of the Ten Commandments, nowadays a common feature of synagogue interior decoration, are a relatively new phenomenon in Jewish art and tradition. It was in the eighteenth century that they became one of the most widespread Jewish symbols among Europe's Sephardi and Ashkenazi communities. In addition to the familiar Ark, it appears on numerous ritual objects related to the Torah (for example, curtains and valances, Torah crowns, breastplates and mantles), as well as amulets, marriage contracts, and title-pages of Hebrew books. Although some rabbinical authorities objected to the practice, large ornamental Tablets of the Law were sometimes displayed on the walls of the synagogue.

The Rosenthaliana tablet comes within this last category. It is drawn on a large parchment, measuring 612 by 502 mm—obviously for public display. The page is divided into two round-topped columns, set in a delicate border of flowers and butterflies. The wide floral central column is topped by a large jewelled crown labelled 'Torah Crown'; above, two oval wreaths of bright flowers contain the verse: 'Remember ye the law of Moses My servant / Which I commanded unto him in Horeb' (Malachi III, 22). Paralleling the top wreaths are two smaller ones underneath, with the following inscription: 'Written by Jekuthiel Sofer, son of the h[onored] r[abbi] Isaac Sofer, in the year "When I was gone up into the mount to receive the Tables of Stone, even the Tables of the Covenant" [Deut. IX, 9] / I wrote this for the eminent Levi, son of the late h[onored] Samson Borcum of b[lessed] m[emory]'. The numerical value of the larger, marked letters in the carefully selected words of Moses yield the date [5]528, namely 1767/8 CE.

Jekuthiel Sofer was a prolific scribe in eighteenth-century Amsterdam, and many of his manuscripts are preserved. His proficiency is shown in the square Sephardi script, in which each letter is unusually crowned. Although Jekuthiel was probably not responsible for the decoration, the style, colours and selection of motifs undoubtedly point to Dutch provenance. The stiff, brightly coloured lines and the feeling for flat surfaces are reminiscent of popular hand-coloured Dutch engravings of the seventeenth and eighteenth centuries. Moreover, the combination of various local flowers with hovering birds or butterflies is also familiar from Dutch-Jewish art, notably the extremely popular copper-engraved border which adorned Sephardi ketubbot of Amsterdam since the 1650s for almost two centuries.

The most curious feature in Jekuthiel's tablet is the actual text of the Ten Commandments. On closer examination the words from Exodus xx appear to deviate significantly from the familiar Decalogue of Jewish and Christian works of art. Jekuthiel's tablet is evidently not inscribed with the two or three opening words of each commandment. It is even more puzzling that the first column appears to contain not five but six commandments. In fact, this peculiar division agrees with the Calvinist system in which 'I am thy Lord' serves as a prologue while 'Thou shalt have no other gods' and 'Thou shalt not make unto thee a graven image' constitute two separate commandments. Except for this difference, Calvin's method is identical with the rabbinic enumeration, and, in contrast with the Catholic division, here the two parts of 'Thou shalt not covet' are merged as the tenth commandment.

Why did Jekuthiel employ this peculiar arrangement? An almost identical wording of the Ten Commandments appears in the large wooden tablets above the monumental Hekhal in the Portuguese synagogue of Amsterdam, the Esnoga, erected in 1675. But is it possible that Calvinist ideas influenced the Decalogue displayed in the Esnoga? Because of the importance attached by Calvin to the Ten Commandments, a special rounded-top tablet, called a 'Tiengebodenbord', decorated the otherwise bare walls of Reformed Dutch churches. These popular tablets clearly inspired Rembrandt and his pupils in their work. Indeed, Rembrandt's famous painting of 1659 'Moses and the Tablets' shows the tablets inscribed in Hebrew with an unusual mixture of Jewish and Calvinist methods of enumerating and dividing the commandments. Although the painting's patron is not known, the same peculiar formula was later incorporated on the two tablets in the Esnoga. In fact, placing the Decalogue above the Ark in the Esnoga was apparently influenced by a similar practice in Reformed churches. Under the influence of the Esnoga, other Sephardi synagogues in Holland and elsewhere adopted this practice and placed Tablets of the Law above their Holy Arks (although with the standard rabbinic formula). Living in Amsterdam and undoubtedly familiar with the magnificent Decalogue at the Esnoga, Jekuthiel Sofer elected to emulate this venerated monument in this attractive parchment tablet.

SHALOM SABAR

35 The priestly blessing: publishers' bindings by Proops

The Yokef Pinto parnassim binding, 158 x 210 mm [ROS. 19 D 13]

ONE OF THE FOREMOST BINDERS in eighteenth-century Amsterdam was the so-called Van Damme binder. He acquired this name from his many bindings for Peter van Damme, the first Dutch antiquarian bookseller. According to Jan Storm van Leeuwen, the authority on Dutch eighteenth-century bookbindings, he was active between 1749 and 1786.

The Amsterdam University Library possesses a couple of attractive bindings produced by this binder, decorated with baroque gilt-work. On a presentation copy of Lucretia Wilhelmina van Merkens's *Nut der tegenspoeden* (1768), I noticed a stamp with two hands positioned similarly to the publishers' imprint of the Proops family of Jewish printers. Inspection of the bindings in the Bibliotheca Rosenthaliana revealed several examples bearing the Van Damme stamp, among them a parnassim binding with the *Reglementen van de Hoogduitse Gemeente* (Regulations of the Ashkenazi Community) including supplements to 1771. The front cover depicts the arms of this community in Amsterdam, with a crown held by two small angels—the symbol of the parnassim (governors) of the community. Under these arms is the name of the *gabbay tzedakah* (charity treasurer) Yokef Pinto. The back cover again shows the crown with angels above a stamp where the priestly blessing and the name Proops can be seen. The hands are a symbol of the Kohen, a member of the priestly family. A similar parnassim binding dating from around 1770 for *gabbay tzedakah* Leizer, son of Jacob Ganz, also bearing the Proops stamp, is depicted in Gans's *Memorbook*. The Royal Library has a similar parnassim binding with the 'Reglementen' updated to 1768, for *gabbay tzedakah* Jokef, son of Aberle Segal.

Why are these bindings stamped with the Proops printing mark? Was Proops a prominent governor of the community whose name had to be included in the 'Reglementen', or was it the mark of Proops firm which had to be added to the binding? The last supplement to the Reglement was published by Proops. The regulations must have formed part of the firm's publishing list.

Until the nineteenth century, publishers generally supplied books in loose sheets, but there are some exceptions. For example, in 1643 the Amsterdam binder Magnus Hendricks was contracted by Francisco Vaz Isidor and the printer Immanuel Benveniste to bind a set of 8,000 Jewish prayer-books using publishers' bindings. There are even examples of bindings stamped with a publisher's imprint from the sixteenth century.

The Bibliotheca Rosenthaliana has two other works with a variant of the Proops binder's stamp: a Haggadah printed by Solomon Proops in 1726 (ROS. 3808 A 2) and a machzor printed by Orphans Proops in 1750 (ROS. 1894 C 3 – 5). The imprint on the parnassim bindings is therefore probably a publisher's imprint. Could the Van Damme binder have been a Jewish binder connected with the Proops firm? The Hebrew punches show that the parnassim bindings were the work of a Jewish binder. A Christian craftsman would have had no use for Hebrew punches, and publishers' imprints were too expensive for an occasional commission.

There are various objections to identifying the Van Damme binder with this 'Proops binder'. No bindings stamped with the Van Damme binder's material have as yet been found on a Jewish book dated with certainty before 1767. And surprisingly, the priest's hands on the Van Damme binding actually provide an argument against equating the Proops binder with the Van Damme binder. While the material used for stamping the parnassim bindings is largely identical with that of the Van Damme binder, the priest's hands themselves are not. Not only is the name Proops missing from the Van Damme stamp; the position of the hands differs, too. Here the little finger and the thumb are spread out while the other fingers are held together. In contrast, the Proops stamp shows the hands with a gap between the middle finger and the third finger. This is the conventional position used by Proops and other Jewish printers as an imprint. The Van Damme stamp would appear to be a non-Jewish interpretation of the blessing.

Perhaps this is what happened. The Van Damme binder died around 1768. His material was acquired by a Jewish binder. This binder left the stage in 1786, the same year Joseph Proops died; he was the last of Solomon ben Joseph Proops's three sons active in the Amsterdam book trade. His brother Jacob died in 1779, and at about the same time Abraham transferred the business to Offenbach. Could Joseph Proops himself have been the Proops binder? Perhaps the archives will hold the answer.

KEES GNIRREP

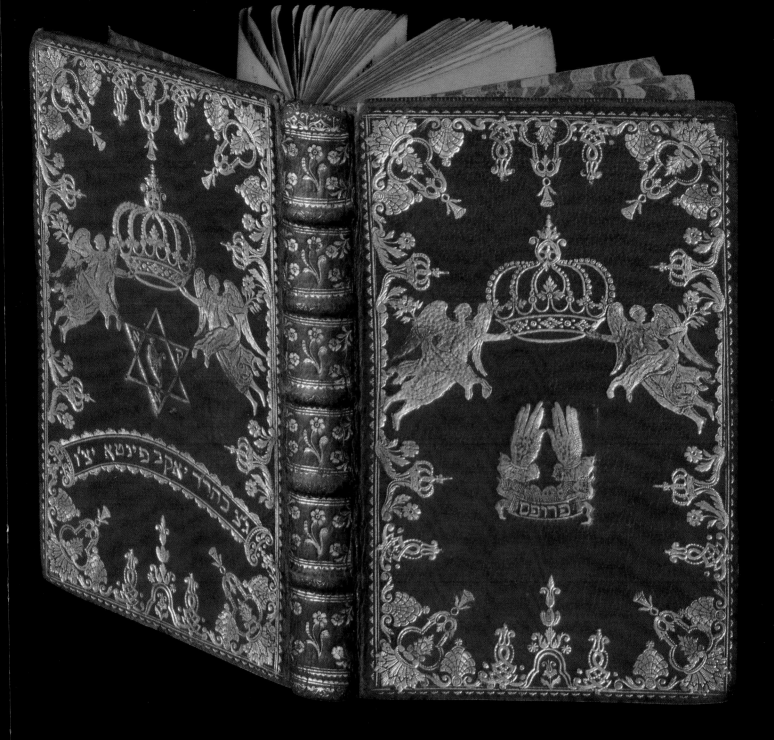

Römische Zahlen.

I, II, III, IV, V, VI, VII, VIII, IX, X. XI, bis
XX, XXX, XL, L, LX, bis C, D, M, XM, CM.

§. 8.
Gebräuchliches jüdisches Alphabet im Schreiben.
Siehe die Kupfertafel.

Leßübungen.

Der Mit-lei-di-ge, der dem E-len-den nicht zu na-he kom-men will, weil er E-kel fürch-tet, ver-räth Weich-lich-keit, und Här-te zu-gleich.

Was du thust, thu-e recht; sprichst du mit je-man-den, so den-ke auf das, was du hö-rest, lie-sest du, so prü-fe was du lie-sest.

Ge-he nie-mals mü-ßig, so hast du nie-mals lan-ge-wei-le, und lan-ge-wei-le macht Ver-druß.

Sprich und thu-e nichts, wo-von du nicht willst, daß es die gan-ze Welt se-hen und hö-ren kön-ne.

Grund-

zur pagina 8

36 David Friedländer's *Lesebuch für jüdische Kinder*

Page 8 and added illustration, 170 x 225 mm [ROS. 1886 H 28]

'MATZATI MATZATI—I found it!' I cried when I finally managed to find the original copy of the first edition of David Friedländer's *Lesebuch für jüdische Kinder* on my 1989 visit to the Bibliotheca Rosenthaliana. To the best of my knowledge, the Rosenthaliana is the only library which has a copy of this book on its shelves.

David Friedländer's *Lesebuch für jüdische Kinder* can be regarded as the first modern book for Jewish children. It was published in Berlin in 1779 for the use of the pupils of the Jüdische Freischule in Berlin. Its publication is something of a turning point in the history of books for Jewish children, primarily because it was the first to call itself a *Lesebuch* in the modern sense of the word and secondly, because it gave expression to a process that dramatically changed the nature of Jewish education in Germany.

Edited by David Friedländer with the help of Moses Mendelssohn, it was the first to be written in the framework of the Haskalah movement (Jewish Enlightenment). Since its appearance hundreds of non-religious books have been published in a German-Hebrew bilingual format in German-speaking countries, specifically addressing Jewish children, in an attempt to influence their Jewish identity and their world-view.

Written in German and with no more than 34 pages, the *Lesebuch* includes almost all the components of both old and contemporary German readers. It contains various German texts and translated Hebrew texts, quite a few of which were written and translated by Mendelssohn himself.

The *Lesebuch* presents a unique attempt to 'translate' the ideology of the Haskalah movement into practical terms, particularly into terms of educational programs. It also reflects a unique effort to create a new kind of symbiosis between the German and Jewish cultures. This was achieved by emphasizing the similarities between the two cultures: points of appropriation were searched for, and part of the Jewish-German tradition was used to fulfil functions originally filled by German texts. In the process, Friedländer presented his belief in new and different rela-

tions between German and Jewish-German culture. This meant that part of the repertoire of Jewish culture was to be translated into a new Germanized version of Jewish-German culture, mixed with German elements to constitute a new Jewish-German repertoire. To give an idea of Friedländer's mode of operation, I would like briefly to analyze the nature of the fables included in the *Lesebuch*.

The inclusion of fables in the *Lesebuch* was an outcome of progressive educational theories of the time, which saw fables as the most appropriate reading material for children. However, Friedländer chose fables written by Berakhiah Ha-nakdan in the thirteenth century and translated by Mendelssohn. Obviously, these were not meant for children. The difference between these and the German fables for children is categorical: German fables for children, and their morals in particular, were characteristically unequivocal and were based on the assumption that texts for children should be simple and easy to comprehend. The moral in Berakhiah Ha-nakdan's fables is unquestionably enigmatic, even without comparing it to German fables. There can be no doubt that German educationalists of the time would have found Berakhiah Ha-nakdan's fables inappropriate for children.

Despite this, Friedländer chose to incorporate the fables, because his main concern was to supply Jewish equivalents for the German elements. The Hebrew fables allowed him to introduce Jewish texts which appeared, on the face of it, to conform to the most progressive German educational theories, thus implying that the Jewish heritage can be unreservedly integrated into the current German culture. The fact that these texts resembled the German ones only ostensibly, was of lesser importance.

Such considerations were typical of Friedländer in compiling the reader. For him, it was much more important to prove through the reader the affinity between the Jewish and German cultures, than to provide texts which could genuinely function as texts for children.

More than anything else, Friedländer's *Lesebuch* typifies the cultural puzzle of the Jewish world of the Haskalah with its German and Jewish components. In its complete form, this puzzle reveals the attempt to adjust Jewish culture to German, in part by forcing the Jewish heritage through the strainer of German culture.

The heterogeneity of the *Lesebuch*, as well as the vacillation between alternative cultural models, make this text one of the most interesting pieces of evidence relating to the Berlin Enlightenment's endeavour to create a Jewish-German culture.

ZOHAR SHAVIT

37 A Yiddish chronicle of the Batavian Republic

The chronicle of B. I. Benjamins, volume 1, folio 1 r, 230 x 183 mm [HS. ROS. 74]

TWO MANUSCRIPTS IN the Bibliotheca Rosenthaliana collection were written by Bendit ben Eizek Wing, known in Dutch as B. I. Benjamins. In fact, these are two copies of the same manuscript, entitled *Le-zikoron*—'in remembrance'. HS. ROS. 534 consists of 7 volumes and is clearly the original version with its many repetitions, alterations and deletions. The other version, HS. ROS. 74, consists of 3 volumes. Both appear to be by the same hand, although the 3-volume version is much neater and contains no deletions. The two versions appear to differ somewhat in style and spelling. It seems that the writer copied the draft version out in a neat version, and made improvements, although some have suggested that the copy was by another hand, namely the writer/copyist Solomon ben Jehiel Levi van Maarssen, in Amsterdam around 1815. The 'neat' version contains 422 pages and the last part has not been properly finished.

Le-zikoron is a chronicle of the years 1795 to 1812 describing all sorts of events in the Netherlands and more specifically in Amsterdam during the Batavian Republic. Wing discusses the civil rights given to the Jews, the escape of the Prince of Orange, the founding in 1795 of the Felix Libertate Society by Jews and Christians together, the controversy that resulted when the new community ceded from the old Ashkenazi community—the so-called *Alte* and *Neie Killes*—in which he makes no bones about his own adherence to the *Alte Kille*. He sketches a picture of how Jews and non-Jews lived in the period following the French Revolution.

As they assimilated into Dutch society, the Jews of Holland began increasingly to write in Dutch. So Benjamins's Yiddish was already considerably influenced and coloured by his Dutch, as his use of Dutch words and his literal transfer of typically Dutch expressions into Yiddish in the text show. The following are a number of examples transliterated from Hebrew: *chrot* (for the Dutch word for large: 'groot'), *pleihn* (square: 'plein'), *weihk* (district: 'wijk'), *kihzers* (voters: 'kiezers'), *oizstel frehgen* (to ask for postponement: 'uitstel vragen'), *wetten* (laws: 'wetten'), *kerken* (churches: 'kerken'), *untershepte briven* (intercepted letters: 'onderschepte brieven'), *das greste gedehlte* (the largest part: 'het grootste gedeelte'), *rewihr* (river: 'rivier'), *wudende* (furious: 'woedend'), *mehr dan* (more than: 'meer dan'), *genohtzakt* (necessary: 'genoodzaakt'), *beloften* (promises: 'beloften'), *bestihr* (rule: 'bestuur').

In August 1795 there was a tremendous shortage of fruit and vegetables. Individual entrepreneurs made enormous profits by buying up produce. Wing described it as follows:

'Den 3 augustus izt ein shwere temult gewezen unter das hamoin am bishvil di epel un' grinte mark / un haben an hakol di oif koifers welche genent werden shacherers geremewirt / un' haben an di poiern getswungen um bezoler tsu fer koifen zi haben di erdepel min 12 zhu' el 5 zhu' gebracht / di klubisten min das gemein sohrt zein dorch das gantse mokem arum gelofen bei di ehrdeppel kelders / un' haben getswungen um bezoler tsu ferkoifen / di burgers haben das nit kenen stillen / ad order miserore jirtseshem gekumen iz das prowizionehl de shacherers lo joiter derfun zein / un' das di poiern nur an hakol partikulihren burgers muzen fer koifen tsu redliche preiz / gam hajehudem welche mit grihntes un' frait in mokem gihn um ire parnose haben godl tsores gehat.'

Which translates as:

'On 3 August there was considerable tumult among the people because of the apple and vegetable market. And all the buyers—whom people called shacherer—were thrown out. The farmers were forced to sell more cheaply [;] they reduced the potatoes from 12 guilders to 5 guilders. The lower [Felix Libertate] club members walked through the whole city past all the potato cellars forcing them to sell more cheaply. Citizens were unable to stop them, until an ordinance was issued by the authorities that no more shacherers should be allowed and that farmers could sell to all private citizens for a reasonable price. In addition Jews who sold fruit and vegetables on the streets for a living had considerable problems.'

Yiddish contains German and Hebrew as well as some Romance elements. In certain areas it contains Slav words, and here Dutch. In Wing's text the German and Dutch elements in the Yiddish vocabulary are stressed all the more. A remarkable element in Wing's Yiddish is his unusual use of the imperfect and his frequent insertion of the Dehnungs h, as the text shows.

Benjamins was one of the last to write in Dutch Yiddish, which makes this manuscript particularly important, not only historically, but as a linguistic document too.

ARIANE D. ZWIERS

שנת תקנה לפ״ק 1795

... 1740 ...

17 Januarij 1795

... 18 ...

Daandels

Straalman

Krayenhoff

דיסקורש

נהאלטן

וועגין דיא נייאי קהלה באמשטרדם

אונ פער פאלג פון ביא אזאמן קומשט אן הנובר פון
פייבל משה חו ליפמן :

אונ בעיון בלשונן האבון דם פער סרייבר אודר סרייברס פון דיא **רשעת**
פר דיא נייא קהלה פו לשון הקודש מיט אפלעטין זיז אפשר וריא
פר קדושה מי ׳ מויך לר גאמק לר פורטוקולדים ׳ אונ ורפרו וריטרר מיט לשון הקודש
אונ פין איזוך זיז ורפרו אונטמסיחומ :

№ 3

דיש חייסט קל

דיסקורש

אן זיך ב"ה נירד זפלש ׳ סטיהט ואסו ורדר ב"ה האל
גתנגן סטיהם איר דחליו ׳ איך קטו פיזו סיו סטיהל גהוד ׳ חבר ב"ים מין איסט
מהן ׳ מיה סטק קטו מך רות לו ׳ חמבו ׳ רש פרו טאם
מין נים לם

גיואר קהלה מאן מיט סהו משל ׳ ביים מיה גלוילן לא איסט
אים קיש רעם עם ׳ איר וחבל מחר ב"ם מהו ושחרו זם נים זמחנן
אשור נש קהלה

אלשר קהלה מאן הללה וחללה הם מלהזביר ׳ הל
פאחב אבל סטבאס ב"ים אשם אלם חוטי **קהלה** וטו
בסורם אל תבוא נפשי ובקהלם
אל תחד כבודי ׳ דם טוהר עו ריסקוהרש פייבל לב
פייבל מאן קיך גם סהור אמן ׳ נהחם ביה זם ׳ נבהל עוך עין מן
כאמשטרדם ׳ מיהר חגט ׳ דאם ב"ה פ"ח השעת שם
ליפמן הללה ׳ מין קטן מין פר ילכו דם ׳ איר חבין ב"ה שלם
חל לגמרי לין **רשעת** ׳ מול לם מאבל ׳ איר ואבו **ב"ה**
שרירות של חסר ׳ עולי קיו רשעת מצרי צרדים
 העגטורתינג באמשטרדם **יצ"ה** ׳ חל דם
העפפיעזענטאמענטן ׳ כהואג יד"ה ׳ ה"ל בעי"ה שרדוה
של יחסר ורחמים ׳ ל ליוד זמהר מטיב ב"ה חונם ב"ה ׳
פיטבל ב"ה אשר לא עוב חסרו מעמו ׳
מאריך ׳ ימם ושנים ׳ יני אמן

ניא
משה ׳ ייטל ליפמן יו היולו אולדר **אי"ה** איט דיא שתחל
דאך נאמ זה זה אם **קאסיל פייבל**

פייבל ׳ מ"ך ׳ גם א אי"ק ׳ אבר דם קול מאך **להנובה** דם טוער מין
עים ד וזר אין זלכן ׳ מין ד דשם דלוק פר גטי קומפאניג ׳ מן
אטה מין **דזד מזל ופרשה והצלחה** ׳ מול איר אין מך פן לי קשי
קשה ׳ מין מ רם ביהטבל ׳ רם פון זמר **אי"ה** ׳ רפן ויטר ספרתבל
קשה מין **ליפמן** ׳ אנרה חחנם אלו ליט **אי"ה** מיכב אחוו לא מספולוירה
דן גואמל חנט רם מיהר גם פיער גם **שמאל** ׳ מל מחס ועבר מט זאה
הקינעתהם וין ׳ איר וייכטן מיך מלבפלם נירך כהום **מזל ובכה והצלחה**
ה"ה ׳ מם מכל מאנין סדיך איזה איי"ר ודי פאחם **כהנובר**

א ׳ עט ׳ פער פאלג מהנובר אישיה הירשנאוקך **יש"ל**
מי סיה טיח ׳ ודיא פיידא פון איו כי ליט וחחי

38 The *Diskursen* of the *Neie* and the *Alte Kille*

Diskursen about the *Neie Kille*, 163 x 257 mm [ROS. 19 E 18]

THIS POLEMIC BETWEEN two Ashkenazi communities forms a unique literary phenomenon. Written in the typical Amsterdam Yiddish of the time, these documents are far from accessible. The first *Diskurs* appeared in late July 1797 on the initiative of the Nieuwe Gemeente (*Neie Kille*), a small community that had ceded from the twenty-thousand strong old Jewish community (*Alte Kille*). It was published in advance of the elections to the National Assembly and the plebiscite on the new Dutch Constitution, in which Jews were to be allowed to participate for the first time.

The *Diskurs* began in the style of a dialogue but later extended to include other characters. In the eighteenth-century Republic, dialogue was often used as a literary device in satirical writings by the Patriots and their opponents. As convinced Patriots, the activists for emancipation and democracy in the old Jewish community naturally used the same genre for the propaganda they spread among community members. Experience has shown that most Jews were unable to read Dutch and only barely understood it. In consequence, they wrote in Yiddish, the patois of Amsterdam Jewry.

Following the Dutch example, the first *Diskursen* took place on a barge (from Utrecht to Amsterdam) and in a coach. Later, *Diskursen* took place in coffeehouses, which allowed more people, casual visitors, to participate.

In the first *Diskursen* three persons appear: Anshel from the Nieuwe Gemeente, Gumpel of the old community, and Yankev the intellectual who explains the issues, such as the new democratic system of government and the mismanagement by the parnassim.

The success of these dialogues was apparently tremendous; the juicy literary style and the subject matter attracted many readers. The old community realised it had to react to this propaganda and did so in a remarkable way. The day before issue 13 of the *Diskursen* appeared, the old community published its own number 13, which was actually their first issue. In it Anshel, Gumpel and Yankev continued their debate but with the roles switched. From then on, two issues of the *Diskursen* appeared each week, one published by the new and the other by the old community.

Since they were written for a Jewish audience that lived in the same neighbourhood in which everyone knew each other, the *Diskursen* soon became increasingly personal and the jibes ever nearer the bone. Clearly, the authors on either side had a tremendous sense of humour, as witnessed in their fictitious titles of plays, concerts and ballet performances, and in their sham news articles and mock regulations.

There is, however, a clear distinction in style and content between the *Diskursen* of the two communities. The new community used more Dutch idioms and Gallicisms in its articles, while the old community tended to employ more expressions and quotes from traditional Jewish literature. Moreover, writers from the old community showed a poorer command of the Dutch language.

Between late July 1797 and mid-March 1798, 24 *Diskursen* by the new community and 11 *Diskursen* by the old community appeared, producing a corpus of nearly 600 pages. When on 16 March 1798 the parnassim of the old community were replaced by supporters of the new community by the radical government, the polemic naturally came to a halt—but only after the Nieuwe Gemeente had published a victory issue.

JOZEPH MICHMAN

39 Leeser Rosenthal's only Yiddish manuscript

Isaac Abraham Euchel, *Reb Henoch oder wos tutme domit,*

pages 58-59, 125 x 320 mm [HS.ROS. 130]

F EW YIDDISH BOOKS or manuscripts were found
in the original collection of Leeser Rosenthal.
And it would have been strange indeed if this
learned collector had been interested in the
literature of his mother tongue, having been schooled in
the Hebrew rabbinic tradition of his native Poland. The
spiritual atmosphere which he found in Germany when he
arrived in 1814 was equally unconducive to an interest in
Yiddish. The spirit of enlightenment and cultural recon-
struction that reigned among the Jews in Germany and
Western Europe in his day was accompanied by a clear
rejection of Yiddish in favour of the European languages.

The relatively few Yiddish books contained in Leeser
Rosenthal's library when it was removed to Amsterdam
and catalogued by Meijer Roest Mzn in 1875 are all either
translations of prayers or exegetical paraphrases of the
Pentateuch and other biblical books. The only Yiddish
manuscript in the collection was an early nineteenth-
century satirical enlightenment play by Isaac Abraham
Euchel, *Reb Henoch oder wos tutme domit.*

After 1880, when the Bibliotheca Rosenthaliana came into
its own as a department of the Amsterdam University Lib-
rary, nearly all its successive keepers were far more inter-
ested in Yiddish literature than most Jewish scholars in
Western Europe. Not only did Meijer Roest Mzn, Jere-
mias M. Hillesum, Louis Hirschel and Leo Fuks complete
and enlarge the collection of Yiddish books and manu-
scripts, they took great care to draw special attention to
Yiddish books printed in Holland from 1634 onward.

Roest and Hillesum were able to take advantage of the
importance of Amsterdam as a centre for Jewish book auc-
tions before the First World War. They attended all the
auctions of famous collections sold in Amsterdam and
managed to buy rare Yiddish books very cheaply at a time
when the general Jewish public was not particularly inter-
ested in Yiddish literature.

Louis Hirschel was one of the few Dutch Jewish
scholars who took an interest in the spectacular develop-
ment of Yiddish studies and literature in Eastern Europe
after the First World War. Thanks to his insight a good
many Yiddish scholarly works and periodicals from Poland
and Russia found their way into the collection, items
which have since become harder to find.

Leo Fuks collected modern Yiddish literary and schol-
arly books from all over the world after the Second World
War. Moreover, he was responsible for opening up a whole
new field of study in the Dutch Jewish literary heritage of
the past. Through the concerted efforts of these men and
their successors, the Bibliotheca Rosenthaliana has become
one of the most important repositories of Yiddish books
and manuscripts by Dutch Jews in the seventeenth, eigh-
teenth and nineteenth centuries. These sources of Dutch
Jewish culture are available now, together with the hand-
books and scholarly monographs necessary to enable study
and research.

RENATE G. FUKS-MANSFELD

ל״	75	
ל״	50	
ל״	50	
ל״	50	
ל״	50	
ל״	18	
ל״	25	
ל״	36	
ל״	14	
ל״	25	
ל״	25	
ל״	25	
ל״	25	
ל״	25	
ל״	10	
ל״	14	
ל״	15	
ל״	12	10
ל״	18	
ל״	10	
ל״	10	
	577	10

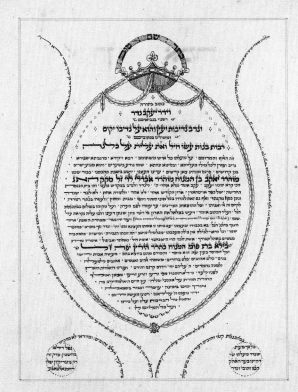

40 The *Protocol* of the Jewish community of Uithoorn

Folios 30 v – 31 r, 274 x 480 mm [HS. ROS. 59]

THE MANUSCRIPT COLLECTION in the Bibliotheca Rosenthaliana contains several documents that, because of their origin and purpose, constitute valuable archival records. The 'Protocol' of the Jewish community of Uithoorn is in this category. It contains all the details relating to the purchase, renovation, consecration and maintenance of the local synagogue. It starts in 1805 with the establishment of the congregation and ends in 1847.

According to the manuscript the idea for a synagogue in Uithoorn surfaced during a circumcision ceremony conducted by the Amsterdam mohel Abraham Aron Prins of Alkmaar (*c.* 1766 – 1821). The plan to turn the local Mennonite church (which was not in use as such at the time) into a synagogue was then born. Amsterdam's chief rabbi, Jacob Mozes Löwenstamm, consented after it was ascertained that the church had not actually been used for four years and contained nothing that would constitute an impurity for a synagogue such as graves. The church was duly purchased on 1 June 1805. The transaction was conducted by mohel Abraham Aron Prins and his brother-in-law Samuel Levy together with Daniel Abraham Rachmonus, Aron Isaac Cohen and David Emanuel Kalker. All were prominent members of Amsterdam's Ashkenazi Jewish community. Remarkably, besides handling the financial side, these five benefactors are repeatedly referred to as the synagogue's 'directors'. The Protocol actually contains the contract between these financiers and the members of Uithoorn's Jewish community. The contract clearly reveals the strong link that existed with the parent community in Amsterdam—the Uithoorn Jews were wholly subject to the authority of Amsterdam's chief rabbi and that of its five directors who were also resident there. In fact it was even arranged for the title deeds to the Uithoorn synagogue to be kept with the records of the Ashkenazi Jewish community in Amsterdam.

Although the terms and conditions of the purchase are reproduced in the Protocol the original deed of purchase can no longer be found in the archives of Amsterdam's Jewish community. However, the records do show that there was a Jewish presence in Uithoorn even before 1805. The Protocol contains the community's bye-laws; these are signed by twenty-six members and a list of Amsterdam contributors, with pride of place taken by Jacob Abraham Levie (Jacob ben Eberle Levie Haag, The Hague, *c.* 1732 – 1811). In 1761 Sandrina Salomons (Tzerule bat Aaron), born in Uithoorn, married the Hamburg widower Isaac Philip Hollander in Amsterdam at the age of thirty-five. The first chuppah in Uithoorn for which a ketubbah still survives took place on 10 Heshvan 5541 between Juda Leib ben Eberle Levie and Gittele bat Juda Leib. The bridegroom's brother was Jacob ben Everle Levie, probably the same person named in the manuscript as the principal benefactor. According to the records the synagogue's consecration feast on Sabbath Nachamu (15 Ab/9 August) and the day after (a Sunday) attracted many day trippers from Amsterdam and the surrounding area. The festivities made such a deep impression that they were reported in the chronicle kept by Bendit ben Eizek Wing (*Le-zikoron*, 1795 – 1812). The synagogue suffered storm damage at the end of 1836 but was restored. The necessary funds were raised in Amsterdam, The Hague, Rotterdam, Gouda and elsewhere. Although the actual restoration was completed in 1838, the financial side was not entirely settled until 1847.

Samuel ben Abraham is responsible for the fine calligraphy on the early pages of the manuscript. The languages in this section are Hebrew and Yiddish, although later on we do see entries in Dutch. For the same occasion Samuel ben Abraham also produced an equally exquisite work of calligraphy on a sheet of parchment (HS. ROS. PL. B-81); this work consisted of prayers and texts in honour of David Emanuel Kalker, one of the synagogue's five directors, and the text was partially reproduced in the Protocol (fol. 39 v – 40) by Abraham Aron Prins himself. The Bibliotheca Rosenthaliana purchased the protocol from J. H. Davids of Haarlem for fifty guilders in 1933.

This fine manuscript is an important source of information about the early history and composition of Uithoorn's Jewish community and its links with other Jewish communities in the Netherlands.

ODETTE VLESSING

41 The Binger manuscript: the case of the vanishing illustrator

Prayer-book, folios 50 v – 51 r, 205 x 300 mm [HS. ROS. 681]

A FRIDAY EVENING early in the nineteenth cen-
tury. Father has just arrived home from the
synagogue and is greeting his small son in the
living room, where granny is already seated—
feet up on a warm footstove—at a fully laden table. This
charmingly domestic scene—right down to the cat under
the table—is to be found in an illustrated prayer-book
that is one of the finest of all the nineteenth-century manu-
scripts in the Bibliotheca Rosenthaliana.[1] Does the scene
portray the living room of the Binger family? After all, the
book was produced by father Hijman (Hayyim) Binger and
his two sons Marcus (Mordecai) and Anthonie (Aaron) in
1820/21; Hijman did the calligraphy for the Hebrew texts,
Marcus the Dutch and German translations, and Antho-
nie all the illustrations. A singular enterprise. What kind
of people were the Bingers? We know nothing about their
ancestors, and from what we do know about the lives of
father and sons, the fact that the manuscript was ever
created is nothing short of miraculous; the document is a
testimony to faith and devotion in a hard-working family
of Jewish tradespeople.

At the time he penned the Hebrew script father Hijman
Binger (1756 – 1830) ran a clothes-hire business in Am-
sterdam's Zwanenburgerstraat,[2] hiring out formal dress
and costumes for the type of fancy-dress balls held, say, to
celebrate Purim. Given that for patent tax purposes four
types of clothing hirers were differentiated (i.e., for bap-
tisms, mourning, fancy dress and dance)[3] and that Bin-
ger's company is not described in any greater detail, we
must assume that he was active across the board and there-
fore at the very top of his profession. Although he seems to
have been a businessman first and foremost, his exquisitely
drawn Hebrew letters reveal a scholar with a love of the
study that was later to reach a peak with his namesake and
grandson Hijman (1824 – 1890). It is interesting that in
his introduction Hijman Binger writes that, inspired by a
friend, he copied the Hebrew prayers at a time when he
had already withdrawn from business as a way of spending
his time usefully and for his daughter and two sons to re-

member him by. A leisurely retirement was the last thing
on his mind. By the time Hijman senior died of dropsy ten
years later,[4] he was still working in Zwanenburgerstraat
—but 'hiring' books instead of clothes. He had inherited
a lending library, probably from his brother Meijer who
died in 1827.[5]

His son Marcus (1796 – 1872) was a bookkeeper, a pro-
fession that requires good handwriting but entails long
working hours and makes heavy demands on the eyes.
Marcus' beautifully executed calligraphy is redolent of a
sense of order and perseverance. He was later to write a
play, become a bookseller and—in itself status symbol
enough—a member of the prestigious 'Association for the
promotion of the interests of the book trade'. In 1858 he
was even made an honorary member. He also published
books, ran a printing business and invented a new repro
technique called glyphography, which was apparently used
for the ten-part, deluxe edition of Vondel's works pub-
lished by Hijman junior and Jacob van Lennep.

The other son, Anthonie, illustrated the manuscript.
He probably based most of the decorations on examples,
but his depiction of the living room is different. Here we
see an amateur expressing himself. Moreover, what likelier
explanation is there than that he was portraying the famil-
iar surroundings of his parents' home? And if that really
is the case then the elderly lady would presumably be Ra-
chel Alexander Polak, at that time aged around sixty and
married to Hijman Binger. The illustrator was her young-
est son—Anthonie Binger was born in 1797. We know
that in 1827 he had already worked for a few years in his
uncle Meijer's lending library before furthering his career
as a woodcutter, etcher and illustrator. According to
Scheen's Lexicon he also worked as a type-founder in Paris
as late as 1867 – 1870.[6] In 1870 he was taken into the
Jewish home for elderly and mentally ill ladies and gentle-
men, at 110 Nieuwe Keizersgracht. In 1877 he was 'offici-
ally' discharged at the age of eighty, however, and what
happened to him after that remains a mystery. There is no
record of his death in Amsterdam and he is not buried in
the Jewish cemetery at Muiderberg. Did he simply abscond
from the home and vanish? The archives are silent. How-
ever, it must be feared that our illustrator never again
found the kind of cheerful living room that he had de-
picted sixty years earlier.

Fortunately, the manuscript remained in the family.
It was presented to the Bibliotheca Rosenthaliana by
Mrs L. H. Drijver-Binger in 1982.

MARJA KEYSER

Right page

וְאַחַר ...

וְתִכֹּן ...

שָׁלוֹם עֲלֵיכֶם מַלְאֲכֵי הַשָּׁרֵת מַלְאֲכֵי עֶלְיוֹן מִמֶּלֶךְ מַלְכֵי הַמְּלָכִים הַקָּדוֹשׁ בָּרוּךְ הוּא : בּוֹאֲכֶם לְשָׁלוֹם מַלְאֲכֵי הַשָּׁלוֹם מַלְאֲכֵי עֶלְיוֹן מִמֶּלֶךְ מַלְכֵי הַמְּלָכִים הַקָּדוֹשׁ בָּרוּךְ הוּא : בָּרְכוּנִי לְשָׁלוֹם מַלְאֲכֵי הַשָּׁלוֹם מַלְאֲכֵי עֶלְיוֹן מִמֶּלֶךְ מַלְכֵי הַמְּלָכִים הַקָּדוֹשׁ בָּרוּךְ הוּא : צֵאתְכֶם לְשָׁלוֹם מַלְאֲכֵי הַשָּׁלוֹם מַלְאֲכֵי עֶלְיוֹן מִמֶּלֶךְ מַלְכֵי הַמְּלָכִים הַקָּדוֹשׁ בָּרוּךְ הוּא :

וְאוֹמֵר

Left page

מִי מָלַכֵי יִצְחָק לְשַׁמֵּרְךָ בְּכָל דְּרָכֶיךָ :

רִבּוֹן כָּל הָעוֹלָמִים אֲדוֹן כָּל הַנְּשָׁמוֹת מֶלֶךְ אַבִּיר מֶלֶךְ גָּדוֹל מֶלֶךְ בָּרוּךְ מֶלֶךְ דּוֹבֵר שָׁלוֹם ...

אֵשֶׁת חַיִל מִי יִמְצָא וְרָחֹק מִפְּנִינִים מִכְרָהּ : בָּטַח בָּהּ לֵב בַּעְלָהּ וְשָׁלָל לֹא יֶחְסָר : גְּמָלַתְהוּ טוֹב וְלֹא רָע כֹּל יְמֵי חַיֶּיהָ : דָּרְשָׁה צֶמֶר וּפִשְׁתִּים וַתַּעַשׂ בְּחֵפֶץ כַּפֶּיהָ : הָיְתָה כָּאֳנִיּוֹת סוֹחֵר מִמֶּרְחָק תָּבִיא לַחְמָהּ : וַתָּקָם בְּעוֹד לַיְלָה וַתִּתֵּן טֶרֶף לְבֵיתָהּ וְחֹק לְנַעֲרֹתֶיהָ : זָמְמָה שָׂדֶה וַתִּקָּחֵהוּ מִפְּרִי כַפֶּיהָ נָטְעָה כָּרֶם : חָגְרָה בְעוֹז מָתְנֶיהָ וַתְּאַמֵּץ זְרוֹעֹתֶיהָ : טָעֲמָה כִּי טוֹב סַחְרָהּ לֹא יִכְבֶּה בַלַּיְלָה נֵרָהּ : יָדֶיהָ שִׁלְּחָה בַכִּישׁוֹר וְכַפֶּיהָ תָּמְכוּ פָלֶךְ : כַּפָּהּ פָּרְשָׂה לֶעָנִי וְיָדֶיהָ שִׁלְּחָה לָאֶבְיוֹן : לֹא תִירָא לְבֵיתָהּ מִשָּׁלֶג כִּי כָל בֵּיתָהּ לָבֻשׁ שָׁנִים : מַרְבַדִּים עָשְׂתָה לָּהּ שֵׁשׁ וְאַרְגָּמָן לְבוּשָׁהּ : נוֹדָע בַּשְּׁעָרִים בַּעְלָהּ בְּשִׁבְתּוֹ עִם זִקְנֵי אָרֶץ : סָדִין עָשְׂתָה וַתִּמְכֹּר וַחֲגוֹר נָתְנָה לַכְּנַעֲנִי : עוֹז וְהָדָר לְבוּשָׁהּ וַתִּשְׂחַק לְיוֹם אַחֲרוֹן : פִּיהָ פָּתְחָה בְחָכְמָה וְתוֹרַת חֶסֶד עַל לְשׁוֹנָהּ : צוֹפִיָּה הֲלִיכוֹת בֵּיתָהּ וְלֶחֶם עַצְלוּת לֹא תֹאכֵל : קָמוּ בָנֶיהָ וַיְאַשְּׁרוּהָ בַּעְלָהּ וַיְהַלְלָהּ : רַבּוֹת בָּנוֹת עָשׂוּ חָיִל וְאַתְּ עָלִית עַל כֻּלָּנָה : שֶׁקֶר הַחֵן וְהֶבֶל הַיֹּפִי אִשָּׁה יִרְאַת יְיָ הִיא תִתְהַלָּל : תְּנוּ לָהּ מִפְּרִי יָדֶיהָ וִיהַלְלוּהָ בַשְּׁעָרִים מַעֲשֶׂיהָ :

לְנִשְׁמַת אִשְׁתִּי כִּי יְקָרָה הִיא

הֵא ...

en zijne daden zijn goed, in de oogen van God en alle menschen.

רָאָה שָׁם אִישׁ טוֹב הָלַךְ עֶסְדֹּב וּמַרְבֶּה לְדַהְבוֹת בְּתוֹף
מְדַבֵּר כְּמַלְאָךְ אַךְ פָּנָיו כְּמֶלַח מִתְנָאֶה כְּמֶלֶךְ אוּלָם הוּא
כְּבַתּוּ אוֹכֵל פִּתּוּ בְּמֶלַח וְכַאֲשֶׁר בָּא מִן הַפֶּתַח וַיִּשָּׂא לָחֹג
דֶּפֶּסַח עַל שָׁכְמוֹ כְּשָׂב וְלוֹקֵחַ מִכָּל אִישׁ כֶּסֶף וְהִנֵּה בְּרַוּוֹף
הָרָאִים שְׁנֵי רֵעִים אֹמְרִים: חָלִילָה עַל דָּבָר כָּזֶב כַּזְב לֹא נִתֵּן כָּסֶף ·

שֶׁם הֹלֵךְ אִישׁ הֹלֵךְ שָׁב וּבְיָדוֹ כַף מְלֹא מַיִם וְהוּא זָב וַיֹּאמֶר
אַהָה מַה יְהִי בְּסוֹף אִם תָּמִיד יוֹב וַיֹּעֵף וִיכַב לְבֵיתוֹ וַיִּתְאַב
לֶאֱכֹל וַתָּבִיא לוֹ בִּתּוֹ אֶת פַּרְתּוֹ וַיִּתְעַב בְּעֵינָיו

JAGTLIED DER KANADISCHE WILDEN.

בְּטֶרֶם בֹּקֶר אֲנִי אָקוּם עֲלוֹת עַל רֹאשׁ הַגִּבְעָה כִּי
נִכְסְפָה וְגַם כָּלְתָה נַפְשִׁי לִרְאוֹת: אֵיכָה תְגָרֵשׁ הַשֶּׁמֶשׁ
בִּגְבוּרָתָהּ עֲנָנִים לַאֲלָפִים · וְתָנִיס עֲרָפֶלִי רִכְבָּהּ · בְּאוֹרָהּ
לְהָאִיר הַבֹּקֶר · אָנָּא אֵל הוֹשִׁיעָה נָּא · וּלְפָנוֹת עֶרֶב
עֵת תָּבוֹא הַשֶּׁמֶשׁ תֵּלֵךְ לָהּ וְאֵינֶנָּה · בּוֹאִי נָא אֶת לְבָנָה
יְקָרָה וְנָתַתְּ מֵהוֹרֹדְעִי דַּרְכִּי הָאֹהֱלָה · כִּי אָשׁוּב לְנֶגֶד
אוֹרֵךְ שֶׁקֶט וְצִידִי עֲלֵי שִׁכְמִי ·

Vóór de zonne wil ik oprijzen, en den top des heuvels bestijgen, om te zien, hoe haar nieuw licht, nevel en wolken verdrijft. Groote geest geef mij geluk! en wanneer de zon verdwenen is aan den avond-hemel, als dan, o maan! wijs mij, beladen met jagt-buit, veilig, het pad tot mijne tent aan.

WOORD-REGISTER. (*)

VERKORTINGEN.

m. beteekent: mannelijk; v. vrouwelijk; g. s. gemeenslagtig; k. kal; n. niphal; pi. piël; pu. puäl; hi. hiphil; hit. hitpaël; gen. 2de naamval; m. v. meervoudig.

א		אָז	alsdan
אָב	vader	אָח	broeder
אָב	in genit.	אַחִים	meerv.
אָבוֹת	meerv., ook ouders	אֲחָדִים	eenige
אָבַד	verliezen	אֲחָיוֹת	zuster
אָבָה	willen	אַחַר	na
אָבָל	echter	אַחֲרֵי	daarna, achteraan
אָדָם	mensch	אַחֵר	andere
אֲדָמָה	aarde	אַיֵּה	waar
אָהַב	beminnen	אַיֶּכָּה	waar zijt gij
אַהֲבָה	liefde	אֵין	niet
אֲהָבִים	liefelijkheid	אֵינֶנּוּ	hij is niet
אוֹ	of	אִישׁ	man
אוֹיֵב	vijand	אֲנָשִׁים	meerv.
אוּלָם	maar	אִישׁוֹן	oogappel
אוֹר	lichten	אַךְ	maar, edoch
אוֹר	licht	אָכַל	eten, verteren

(*) Het woordenboek van de Heeren LEMANS en MULDER is in vele opzigte hier aan te bevelen, (zie bl. 63. noot.)

4 *

42 The Hebrew textbooks of David Abraham Lissaur

Praktische handleiding [...], 1835, p. 50 – 51, 220 x 320 mm [ROS. 1857 D 14 b]

IN THE SPRING OF 1815, diamond polisher Samuel Mulder and his friend Mozes Loonstein, two Amsterdam Jews in their early twenties, founded a Hebrew literary society: 'Tongeleth' ('The Public Weal'). What started as a weekly gathering of six enthusiasts soon developed into a prestigious if small centre of Hebrew learning, with as many as fifty members. Each Sabbath afternoon and every Sunday and Thursday evening, study groups would listen to laborious lectures in Hebrew or discuss the recent insights into Scripture and contemporary Hebrew belles-lettres. Often, a member would read from *Ha-meassef*, the organ of the influential Berlin Enlightenment, that by 1812 had in fact ceased to publish. But whereas the German movement had been characterized by a strong modernist, even anti-traditionalist trend, its Amsterdam counterpart displayed a peculiarly Dutch restraint. When it came to society in general, Tongeleth's young and often well-to-do members harboured rather more modest ideals. Through their pursuit of the ethically and aesthetically edifying literature of the Bible, they merely hoped to advance 'moral improvement and refinement of heart and spirit'.

The almost exclusive stress on the study of the Hebrew language in its purest, biblical form scarcely helped recommend the society beyond its own private circle. In the first anthology, *Bikkure Tongeleth*, chairman Samuel Mulder complained that 'the surprise that greets a man in this city who practices the rules of grammar seriously is equal only to the wonder of a boy seeing a lion or an elephant for the first time in his life'. Because of the emphasis on Hebrew style rather than on social issues such as the advance of emancipation, Tongeleth's Hebrew rhetoric clearly had its limitations. In 1825 the last anthology, bearing the promising title *Peri Tongeleth* Part I, appeared. Part II was never published.

Modern scholars have characterized the society's literary products as superficial, fossilized, and as a deathblow to Jewish Hebrew studies in the Netherlands. This cannot be said, however, of the linguistic efforts of David Abraham Lissaur, a young teacher of religion and one of

Tongeleth's chief grammarians. At society meetings, he was entrusted with the important task of 'solving any linguistic problem that might arise in the course of a session'. His contributions to the Tongeleth anthologies were sparse and their contents far from stimulating. It was not in these tedious moral expositions but in his concise Hebrew grammars and textbooks that his talents shone. They contain no reflections on linguistic methodology *per se* but were written exclusively from a teacher's perspective. Thus Lissaur had learned from experience that 'a tireless and continuous pursuit of the Holy Scriptures' was the safest way to a thorough knowledge of the holy tongue. At the same time he was deeply concerned that too abrupt a transition from the mere reading to the actual linguistic analysis should not lead to 'a sudden dislike' of learning Hebrew altogether.

In order to guide both teacher and student past these obstacles, he provided a set of complementary textbooks. In 1825 he wrote *Reshit yediat Ivrit* as an effective introduction to biblical orthography. Parsing could be practised from *Mahir be-nittuach ha-millot* (1828). *Torat Ivrit bi-meat yamim—Praktische handleiding tot eene spoedige kennis der Hebreeuwsche tale* (1835) contains a systematic treatment of Hebrew grammar, interspersed with exercises that contain dramatic sentences such as: 'Eve, why did you break the Lord's commandments by eating the fruit of the tree as the serpent suggested?' Equally torpid constructions can be found among the *Zamenspraken* in Lissaur's *Hebreeuwsche Nomenclator* (1838), a book of conversation that contains an additional glossary to help pupils discuss God and man, vice, virtue and bodily imperfections, in purely biblical terms.

While, sometime after 1825, Tongeleth began to fade into non-existence, Lissaur's textbooks continued to retain their popularity. In 1828 we read that his books 'have been most favourably reviewed by the most meritorious Dutch periodicals'. The *Mahir* of 1835 and the *Nomenclator* could each boast an impressive list of subscribers (84 and 113, respectively). Among these subscribers we find fellow-Hebraists such as Mulder, members of other literary societies and, occasionally, a professor of Christian theology. Representatives from Jewish educational boards throughout the country often ordered several copies at once. Thus, from Steenwijk to Rotterdam and from Rheenen to Hoorn, Jewish pupils acquainted themselves with the holy tongue through Lissaur's linguistic efforts.

IRENE E. ZWIEP

43 Hanover loses Leeser Rosenthal's library

Zeitung für Norddeutschland (Hannoversche Tagespost), 10 August 1868,

full size [Archive Rosenthal family]

THIS EXCERPT FROM THE *Zeitung für Norddeutschland* (with the subtitle *Hannoversche Tagespost*) dated 10 August 1868 and originating from the Rosenthal family archives is perhaps the best illustration of the miraculous fact that the Bibliotheca Rosenthaliana is in Amsterdam at all; and that being so, it constitutes the core of an ever expanding collection of Judaic and Hebraic material—a collection that is entirely appropriate for Amsterdam.

Leeser Rosenthal built up his library in Hanover during the first half of the nineteenth century. That he was able to do so is due to the generosity of his wife's forebears, who were themselves descendants of the eighteenth-century Jewish banker Michael David of Hanover. Another file in the Bibliotheca Rosenthaliana archives contains documents relating to the eighteenth-century German Court Jews. They dispatched their bills of exchange throughout Europe—including Amsterdam, then as now an important trading and financial centre.

When Leeser Rosenthal—presumably in close consultation with his brother-in-law, Commerzrat Meijer Blumenthal—was looking for a good apprenticeship place for his only son George, it is not surprising that he found one in Amsterdam with Jacob Meijer Jacobson, the grandson of a Hanover banker. Leeser's son would have commenced his apprenticeship at his stock broking office in Amsterdam around 1845, and he would certainly have been no exception—at the time there were a great many Jewish bankers in Amsterdam, most of them from Germany.

Despite a difficult start George was later to enjoy a highly successful career with the banking house of Lippman, Rosenthal & Co, which eventually moved to new premises on Nieuwe Spiegelstraat. His success may well have been the real reason for the marriage of his two sisters with prominent members of Amsterdam's Jewish community: Dr. Jacques Cohen (b. Düsseldorf 1833, d. Amsterdam 1881), managing director of 'N.V. Nederlandsche Koolteerstokerij', and Mr. Isaac Abraham Levy (b. Doetinchem 1836, d. Amsterdam 1920), lawyer and politician.

Today, quite a few of Leeser Rosenthal's many descendants live in Amsterdam. Several descendants of George Rosenthal's stepdaughter also live in the Netherlands. Almost sixty members of the family attended a meeting in 1990 to commemorate the presentation 110 years ago. Of the direct descendants of Leeser Rosenthal, the library has documentation, including letters and photographs relating to his children, sons- and sisters-in-law and grandchildren. From this it is evident that in the first years of the Bibliotheca Rosenthaliana (when it was housed at Amsterdam's University Library) a large number of highly noteworthy purchases were financed by George, who had by then been created a Portuguese baron. He also supported many other activities in Amsterdam. For instance, he donated to the university the large marble sculpture of Pallas Athena by F.K.A.C. Leenhoff, which originally graced the university hall. To pay for a custodian for the library, he set up a fund for the city of Amsterdam which still exists and can now be used to finance special purchases. Upon his death his wife bequeathed another, generously endowed fund which, owing to the nature of the investments, unfortunately lost a great deal of its value at the end of the First World War. Although a few of his grandchildren displayed no great interest in their scholarly forebear, most were proud of the collection at Amsterdam University. Some added to it by also donating archive material. This part of the Bibliotheca Rosenthaliana therefore gives a living picture of the *haute juiverie* as it was in Amsterdam before the Second World War.

It is a miracle that the Bibliotheca Rosenthaliana even came to Amsterdam in the first place because in 1868 and also later (around 1875) definite attempts were made to secure the collection for Germany. This is evident from the newspaper report cited above. The second miracle is that after having been transported to Germany right at the end of the war it was found there practically undamaged and brought back to Amsterdam. Only the posthumous portrait of Leeser Rosenthal, a gift from his son George dating from 1884, failed to re-emerge from Germany. These days, Leeser Rosenthal's grave is again accorded due respect in the entirely renovated Jewish cemetery at 'An der Strangriede' in Hanover.

NORBERT P. VAN DEN BERG

Berechtigung, nach zurückgelegter vorschriftsmäßiger Lehrzeit nur noch des Nachweises einer zweijährigen Condition als Apotheker-gehülfe, worunter ein Jahr der Beschäftigung bei der Receptur sein mußte.)

†† Der Minister des Innern, Graf Eulenburg, besichtigte am Sonnabend das Rathhaus.

W. (Ein drohender wissenschaftlicher Verlust.) Durch den am jüngsten Freitag erfolgten Tod des hiesigen Stiftsgelehrten Herrn Rosenthal droht unserer Stadt ein literarischer Verlust, der schwerlich wieder zu ersetzen sein dürfte. Mit großem Sammlerfleiße und seltener Fachkenntniß hat der Verstorbene innerhalb eines Zeitraums von mehr als 40 Jahren eine hebräische Bibliothek zusammengebracht, wie sie sich in Rücksicht auf Reichhaltigkeit und seltene Druckwerke — auch viele Incunabeln und selbst einige Unica sind in ihr vorhanden — im Privatbesitze auf dem ganzen Continente nicht wiederfindet, und das bekannte Wort „habent sua fata libelli“ bewährt sich auch hier wiederum, denn in denselben Räumen, welche jetzt die Rosenthal'sche Büchersammlung enthalten, war vor etwa 150 Jahren die berühmte Oppenheimer'sche Bibliothek aufgestellt, welche später ins Ausland wandern mußte und nunmehr eine Zierde der Bodleiana in Oxford ist. Wir würden es auf's tiefste beklagen, wenn es mit der Rosenthal'schen Bibliothek in ähnlicher Weise gehen und dieser gleichfalls auf deutschem Boden und in unserer Vaterstadt gesammelte literarische Schatz den deutschen Forschern entzogen werden sollte, indem die Erben, wie wir hören, beabsichtigen, die überaus schätzbare Büchersammlung nach Amsterdam bringen zu lassen, wo sie für die deutsche Wissenschaft fast so gut wie verloren wäre. Sollten die jetzt hier anwesenden Kinder und Schwiegersöhne des Verblichenen sich nicht dazu verstehen wollen, sich und dem Dahingeschiedenen hier in unserer Mitte dadurch ein Denkmal zu setzen, daß sie diese Hinterlassenschaft ihres Vaters der hiesigen königlichen oder städtischen Bibliothek einverleibten. Durch eine solche Hochherzigkeit würden sich die Erben nicht allein um ihre Vaterstadt ein großes Verdienst erwerben, sondern auch alle deutschen Fachgelehrten sich zu dem innigsten Danke verpflichten, und wir würden uns freuen, hierzu die Anregung gegeben zu haben.

(Baubeamten-Prüfungen.) Dem Vernehmen der „H. M.-Z.“ nach erscheint in der nächsten Zeit eine neue Bestimmung betreffs der Studien und der Examina der zukünftigen Staats-Baubeamten. Nach Ablegung des Abiturienten-Examens

Pferd (Einsatz v.
B. v. Maltzahn, d
Der Sieger i
Rennens) der „Ro
Ort und Stelle ver
vom 19. Inf.-Regi
Pferde folgten: Nr
br. St. „Belladonn
Grafen Otto Stolb
Trial“, Preis 200
der Rennkasse zu.
Die folgende
ren-Reiten. D
von den Anwesende
Unruhe derselben
zurückgezogen. Von
Sieger der „Arg
Rittmeister v. Ro
Preis (Hälfte des
„Gitana“; den dr
„Hannovers
Pferden liefen nur
v. Bülow siegte
200 Thlr.) war die
tes Pferd (Eins.
v. d. Lühe; vierte
„Bummler“. — C
zweimal um den P
Zu dem letzte
corps oder Offizier
Generalin v.
eines silbernen Po
det, doch ritten
v. Bernewitz, Lieut
mierlient. v. Treb
Hrn. Rittmstr. v.
v. Jansen-Osten.
Ganz in der Nähe
meisters Wüsten vo
berg um eine halbe
hin den 2. Preis (
muth“ den dritten),
hatte, aus den Händ

Jerozjid. Antoni Jehouda

Hij was te Parijs met Schlouz. Zij erkennen
de Europeesche Joden niet als waardig.
Ze spreken dezelfde taal. De Priesters spreken
Hebreeuwsch. Geen relatie.
 (Op acht j. waar zee.
geloopen. Vita...)
 | Vrouwen eindigen met 25 jaar.
Mama: hij voelt 't als een regel.
 Ze hebben dokters.
Verpel is gekruist met caucasius.

 Het oogenblik: waarin milljoen stralen
 zich vereenigen en heten vanen.
 De Eeuwigheid heeft zich ook nooit herhalen,
 Alles wisselt, wanneer 't begrip wisselend is.

Naken Schlouz te New-York 1920.
Onderwerpt. Navijdens is niet voldoende.
Ook Z.C. Ook de Haas. (vildprofennes
 Anthropologisch: Franz Boas
New-York. Prof. Maret. Oxford England.
Hij gaf daar lezen in anthropologie.
 Balfour hoort hem ook.
Miss Haudan noodigde hem uit te lezen over
zijn volk. Ook Hadama geloofde hem.

(8 jaar, 42 dagen. Met 2 en veertien. Te
zien de stoomsloepe. | Ze hebben niet zahun Zee
ministers, te zijn de weg door 't hoek. Plaa
Onida (Whydah |
 Bij j. terug. Tot M.j. Toen weer terug. Op't w.j. in Glasgow.
Andere school Edinlog: George Harrechulod
2 j. t 7 m. Dahony. Drie vrouwen alg. 1½ j.
Universitit 3 j. t 5 m: anthropologie. | Frankfijker
Rusland: Kieff, Wilma.

44 The Rosenthaliana's Jacob Israel de Haan Archive

Notebook, 190 x 145 mm [Jacob Israel de Haan Archive, No. 64]

THAT THE ARCHIVE OF Jacob Israel de Haan still exists can be attributed to the poet's unexpected and violent death at the age of 42. It was not De Haan's habit to keep things. He destroyed almost all of the letters written to him, writes his biographer Jaap Meijer. 'He begged his friends to do likewise with his letters. Luckily for us, they did not always do as he requested.' Luckily indeed, for De Haan was a tireless as well as an open-hearted correspondent. In the literary estates of some Dutch authors, series of letters from him have been saved which reveal his personal and poetic life almost as a historical novel. Letters to De Haan, however, seldom appear, as is the case with manuscripts of his creative and academic work. Evidently, he believed that once a work is printed, all the preparatory stages should disappear.

This makes what remains of the archive of De Haan at the Bibliotheca Rosenthaliana all the more valuable. The vicissitudes of this archive show, according to Ludy Giebels, who compiled an inventory in the early 1980s, a remarkable parallel with his restless and tragic life:

'As we know, De Haan was murdered in 1924 because of his anti-Zionist stand in Jerusalem. The then Dutch consul, Jacobus Kann, sealed the deceased's house and made an inventory of its contents on the order of the British authorities. Via the Dutch Foreign Ministry this inventory was brought to a lawyer who had to settle the estate. According to a report of the late professor Isaak Kisch his father brought De Haan's papers and books to the Netherlands when he visited Palestine in 1925. The books were auctioned and the papers were handed over to his widow, Johanna van Maarseveen. She came into contact with David Koker, who was both a radical Zionist and a great admirer of De Haan's literary works, in the 1930s. De Haan's papers were at this time either given to Koker as a gift by Johanna van Maarseveen or loaned to him for his use. From Vught he gave the documents to his friend Karel van het Reve for safekeeping. After it was learned that Koker had not survived the war, Van het Reve gave them to the Bibliotheca Rosenthaliana as he thought Koker would have intended.'

Giebels based this partially on a letter dated 5 September 1946 from Karel van het Reve to I. L. Seeligmann, then curator of the Rosenthaliana. In this letter Reve wrote that from Vught Koker had brought him into contact with Johanna van Maarseveen in an attempt to ensure that the writings De Haan had left would survive. Because Johanna van Maarseveen had recently died, Reve offered—more or less assuming the role of literary executor—'the whole lot' to the Bibliotheca Rosenthaliana. In a way Van het Reve acted in this regard in the spirit of De Haan himself. De Haan had already given the publication manuscript of his collection *Het Joodse Lied / Tweede Boek* (The Jewish Song, the second volume) to the Bibliotheca Rosenthaliana in 1921.

The extent to which the archive in its current state corresponds to what was discovered in Jerusalem directly after De Haan's death will be shown by future research. Its limited scope, four boxes of handwritten material, and three with copies and newspaper clippings, gives credence to Meijer's statement that De Haan was not one to save things. The contents of the archive are varied and reflect an active and creative spirit, who was struck down in the middle of his creative output.

Not much light has been shed on De Haan's personal life. The correspondence contains only a few letters from his wife or family. A dozen or so date from before 1919. The business letters all come from 1923. Of interest for academic research are the notes of the law lectures which De Haan gave at the University of Amsterdam and the Law School in Jerusalem. The notebooks with drafts and subjects of hundreds of published and unpublished poems, mostly quatrains, could be a source for a future edition of De Haan's poetry.

A superficial first exploration of the almost indecipherable handwriting of De Haan reveals that the new quatrains carry on the resigned/complaining tone of the published specimens. To close with an example:

> *Het oogenblik: waarin miljoenen stralen*
> *Zich vereenigen en breken vaneen.*
> *De Eeuwigheid kan zich zelve nooit herhalen*
> *Alles wisselt, maar 't blijft wisselend één.*

> (*The moment: in which millions of rays*
> *unite and break apart.*
> *Eternity can never repeat itself*
> *Everything changes, but in changing, remains one.*)

MARIJKE T.C. STAPERT-EGGEN

45 Sephardi rabbis in Jerusalem on modern agricultural settlements

Letter from Chief Rabbi R. M. Panigel *a.o.*, 299 x 227 mm

[Archive Pekidim and Amarcalim, VIII, 27 (38-233)]

THROUGHOUT THE AGES the Jews in the Land of Israel were helped by an organized and well-established system for raising money among the Jews of the Diaspora. An important organization active in this field during the nineteenth century was the Amsterdam-based *Pekidim and Amarcalim* ('Officers and Treasurers'). It maintained diverse links with the leadership of the Jewish communities in the holy towns of Hebron, Jerusalem, Safed and Tiberias. I have been able to study some of the letters received by this institution and now kept in the Rosenthaliana collection. These letters reveal the attitudes of the rabbis of the Sephardi Jewish community concerning the idea of working the land and the new settlements. Research has generally concentrated on letters written by the Ashkenazi rabbis about this subject. Contrary to expectations, the opinions of the Sephardi rabbis are largely identical to those of the Ashkenazim. From the letters we discover the reasons for their reservations in supporting the new settlements.

The question was raised whether *Pekidim and Amarcalim* should change its policy of only supporting Jews devoting themselves entirely to the study of the Torah and start collecting contributions for the new settlements. In order to reach a decision, they asked the opinions of leaders of the veteran communities in Eretz Israel. In their replies the rabbis presented the positive aspects of 'working the Land' since it encompassed the fulfilment of a religious commandment based on three fundamental principles:

1 In the opinion of many rabbinical authorities, the commandment of settling Eretz Israel is a duty encumbent on every Jew, at all times.

2 Settlement in the Land would be a means of ameliorating its economic situation, making the communities less dependant on donations from abroad.

3 The fulfilment of those commandments which are linked to the land, such as the heave offering and tithes, are possible only if Jewish agricultural communities exist in Eretz Israel.

However, this essentially positive basis did not prevent the rabbis opting for a more reserved opinion. The reasons they gave for this approach were threefold:

1 Spiritual—the *Pekidim and Amarcalim* should continue to support 'the Spiritual Community' to perpetuate the tradition which guided the founders of the organization, the Lehren brothers. They considered it wrong that an organisation devoted to promoting a society based on Torah scholars engaged in study should redirect its funds to provide economic support of the 'materialistic community in Eretz Israel', as described in the letter.

2 Economic—working the land was not, in their view, the calling of scholars but of simple people and those with physical prowess. The collection of donations for these people would be liable to harm the financial support for the religious elite, giving rise to the fear that 'the Torah will be forgotten by the Holy Community of Sephardim'.

3 Damage to religious observance—people who were not sufficiently strong in their religious beliefs would be attracted to go once they heard about new possibilities of earning a living by working the land, and some would fall prey to missionaries. Hence, support for the idea would lead to breaches of religious observance and neglect of the Torah and its precepts. Furthermore, the orthodox philantropists who consistently supported Jewish communities in Eretz Israel were concerned that the workers of the soil in the Holy Land be 'faithful to God and His Torah'. Word had reached them that the settlers were becoming alienated from religious values. They wanted to know the extent to which these reports were true, and the rabbis did indeed confirm their fears. They criticized the way of life of settlers who were not living according to the precepts of Torah.

Replies such as these by the Sephardi rabbis, like those of their Ashkenazi colleagues, stopped the *Pekidim and Amarcalim* and other orthodox donors from sending money to the settlements.

YEHOSHUA KANIEL

סמוך לגאולה קפ"לה , אהב ה' רחמיך לא הכלה , ונכותב העיר על תלה , ועלו מושיעים
בקבוץ בניך , מלכב ושריה , וכתיהם כבולם יצואו בקהל להבלה , תעבלה כבוד ידידי עליון
מבטן ומהריון , הרכנס והצדיקים פה ידי ואמרכלי אהך' יזבב הישבים ראשונה לראש פנה
כעה"ק **אמשטרדם** יע"א וכל הנלוים אליהם ה' צבאות יגן עליהם !

ארונים נכברים !

מכתבכם הבקיר תעינו ח' אדר אג' הגיעמו לבון שבוע העבר , והלך התקיפה לחלך כוללים קבלמו להלכי לחלק ה' הפארת יזראל ל אזר היקנעב תומן
הרב הצדיק המנפורים לתורה ולהפ'אדיך ר' לבי ה'י"ג ל עביר ן ולה"ב .
רב ברכות וג' תעודות מאת המנקבלים העונכבלים בתורה כהזב'יכך כאורך , יעלו ויבואו לריה'ש' עם קדם הנותכם , ומעגיש' מנהיעם בית ה' י'שם
ה' גמולם , יהי שלום בהילם , ושלוה וכל נבולם !

קראמו בכל לב בקלה ידיעיך אך דבב אהרי מעם הלטודיקות על ההכריח כי לא יוגה לפתוח שערי תעמרתס לעבבות לעביך העושקים בעבודיב
האומה [הכריד כלטבי קולעיצ'אן] וישוב אהרך , לא נכהד מכבודם כי לבקן דברים מהד , וגם עלימו החיוב מוטל להניר כי יזר את אשר בלבבנו אודיב הענבן
הנעגב זה כיידותינו ומכדיינו תבב האהרב , ומלב העם היושב עליה נהפכו עליה לידיך נשו תעצבלותיה **הלא לאמונה צרותה נאמנה**
כל העם היושב בב נפשם בהלה עד מלד ויקלה להם הקהיל'כל בלנס תהנבות ופת הלדיקות אשר ידימו
אחימו הולים זהב להחיות לב נרכביים , ומי יתן להם לדלב בהריס וכונף בגבטוית להביה הפס טרף לביתה בויעת הפס ונפצ עותלב על נמהריך ועל הכללה ,
ואכלם יתם לבנו וידאב בראותינו תלב הריסת הדת אשר נפרלה בכמה פרלות ושמיותיה , המרגי ארך מנדקונ'מתך ועמודיך , יש מנהם אשר עכו ובלו לקיד
השמועב ולהכבול תיגבע כפס ונפלו בפה תנוקבים כפתני התבע'י'אן כדוב , ועוד יומיפו פרך ויגבעפיל לעבלוה ברטת רהל , ולא מוכל לדבר ולהביך צ"ה
נזיקים וההבלות המתהלדים כאשר ראו אשר נבטול התוריך ומלוותיה , ומעבו מן המעמט אשר קנג'ה ירזת ה' בלבס כי ישברי כך לעמוד על תעמרתם
אך ! לא כך דימימו ולא במהשבכך , ולא בהריכור זאלעבי'ס בעלב יהיו ראשון לכל בית יוסף לעבוד אלמוה יקלם הזותומך !! , ‏ ‏ ‏ וסם כך ישעו כל העולם לבכם
טובה וישוב אהך תוריך ותמלוה תמה תהה עליהו ? אחי ! ואמבי ! — כגר טרח ויגע הרב הצדיק הלדיך ר' לבי ה'י"ג ל עביר ן ויהעו המפורסמים למען
יגדיל תורה ויהדיר ועבני קדמו לין היא ביתה חינו , והנה כשטב הטאר יתמעט הכנכסם והלך לבוריות כהברים נהברים אלמעך אזר אין כך להחמים נהם כב הם
לעבני האהלות וברויום , הא ודרסי' שתידיך תוריך שהתכ'כה בעבודה מקך' הפרדיס העביך' אהך עלימו . — עד כאן הארכנו במליך לבלוה אוב ידיך יעכלו
ברוב המתיה ועולם תבומתם את אהר לפניכם , יה' נרהמיו יב'ב זבות לין , יהום על דל ואבין , ויהיח לשלוה לבו מכבר לין ויזכר הכל ואפדיין , נגבל'
וכה'אב דזום תונקירם ומתנכבם כערכם הרם וגשא , ובהמהה וכבשון יהגמ את הג המלות ותדל רני' , וכיה וך ברכ שו ושר''

DER

JUDENSTAAT.

VERSUCH

EINER

MODERNEN LÖSUNG DER JUDENFRAGE

VON

THEODOR HERZL

DOCTOR DER RECHTE.

LEIPZIG und WIEN 1896.

M. BREITENSTEIN'S VERLAGS-BUCHHANDLUNG

WIEN, IX., WÄHRINGERSTRASSE 5.

46 Theodor Herzl's *Der Judenstaat* published in Vienna

Title-page, 213 x 147 mm [ROS. 3803 E 11]

ON 15 FEBRUARY 1896 a slim volume appeared in the shopwindow of M. Breitenstein's Verlags-Buchhandlung in Vienna: *Der Judenstaat. Versuch einer Modernen Lösung der Judenfrage*. It was by Theodor Herzl. The Jewish question had occupied Herzl with increasing intensity since reading Eugen Dühring's *Die Judenfrage als Racen-, Sitten- und Culturfrage* in 1882. In France between 1891 and 1895 as Paris correspondent of the *Neue Freie Presse*, his experience of the mass hysteria surrounding the Dreyfus case had convinced him that legal emancipation had come too late for assimilation to be feasible. A healthy relationship between Jews and Gentiles could only be established through separation: the Jews of Europe needed a country of their own.

The 22 pages of notes which he made for his meeting with Baron de Hirsch on 2 June 1895, whose help he tried to enlist for the realization of his idea, formed the first draft of the *Judenstaat*. After the meeting he spent several days elaborating these ideas. But he was still unsure of the form: a programmatic novel (Alphons Daudet had mentioned the effectiveness of *Uncle Tom's Cabin*), play or political tract—he considered them all. From a 'Rede an die Rothschilds' in mid-June, by November the draft had become a 'Rede an die Juden', and his interlocutors in London and Paris, among them Max Nordau, now assumed that the pamphlet would be published. By mid-January it was complete. However, Siegfried Cronbach (Berlin), publisher of a Jewish weekly, rejected it, objecting to its content, as did the reputable firm of Duncker and Humblot (Leipzig), which had recently published his *Palais Bourbon* but insisted that they never produced anything on 'this question'. On 17 January 1896 the London *Jewish Chronicle* carried a synopsis of the 'pamphlet': 'A Solution of the Jewish Question' by Dr. Theodor Herzl. This led to a meeting with a fairly obscure publisher, Breitenstein. Herzl noted that he was enthusiastic about certain passages, and a definitive title, Der Judenstaat, was decided upon then and there. The precise terms are not known, but later accounts show that Herzl received no royalties and that income from sales barely covered the publisher's costs. By February the proofs were ready, but Herzl was clearly disappointed that only 3,000 copies would be printed—Breitenstein did not expect a commercial success. A far cry from the euphoria of June 1895 when Herzl had dreamt of favouring Duncker and Humblot with the first five editions of the planned *Lösung der Judenfrage*.

Four so-called *Auflagen* appeared during 1896, no real distinction being made between *Auflage, Edition* and *Druck*. They were virtually identical, except for the vignettes on the soft cover and on the last page; those used for the first (unnumbered) edition differed from those used for the second, third and fourth editions. Moreover, the designations *Dritte Auflage* and *Vierte Auflage* were printed on small slips of paper which were pasted on the cover. In April 1896 another printing was under way, and Herzl was able to re-read the proofs. A proposal by Breitenstein, in May 1897, to use remaining copies of the *Erste* for a *Fünfte Auflage*, by incorporating them in an anthology on Jewish subjects, came to nothing. The market was saturated, although—undoubtedly in order to reach as wide a public as possible—*Der Judenstaat* was printed in Latin and not, like Herzl's other writings, in German type. A transcription of the German text into Hebrew characters and translations into English, Hebrew, Russian, Romanian and Bulgarian also, no doubt, reduced the demand for the Breitenstein editions.

Der Judenstaat is Herzl's only work on which he used his academic title. Obviously, he wished to appear as a sober man of affairs, not a utopian. The brochure contained the enthusiastic ideas of the previous summer, now marshalled in an orderly manner, avoiding exaggerations and exuding competence and authority. The division into parts and chapters recalls legal works, and the author appears as sociologist, political scientist and constitutional lawyer all in one.

Reactions to the *Judenstaat* were not long in coming. The well-to-do Jewish middle class of Vienna was aghast, as Hermann Bahr told Herzl at the time and Stefan Zweig recalled in his memoirs. The *Neue Freie Presse* kept silent; for the rest the liberal press rejected the scheme. Encouragement came from Zionist groups in Berlin and Sofia, and the Russian *Hoveve Zion* cautiously took note. Unreserved acclaim came from the Zionists on the margins of Viennese Jewish society. These were the people who catapulted Herzl to the leadership of the nascent movement. By the summer of 1896 Herzl was becoming a man of action: Zionism had acquired a leader. This was the most significant, immediate result of the publication of *Der Judenstaat*.

MICHAEL HEYMANN

47 George Rosenthal and the Spinoza House Society

Addition to the *Catalogus van de Boekerij der Vereeniging 'Het Spinozahuis'*,

275 x 215 mm [ROS. I A 57]

I N HIS MID-EIGHTEENTH-CENTURY biography of the philosopher Benedictus de Spinoza (1632 – 1677), the Amsterdam surgeon Johannes Monnikhoff (1707 – 1787) noted the exact location of the house in which his subject lived in Rijnsburg from *c.* 1661 to 1663. He included this biographical sketch in the copy he made of Spinoza's *Short Treatise on God, Man and his Well-Being*, of which just one copy had been made.

Monnikhoff's copy of the *Short Treatise* and his biography were rediscovered at the end of the nineteenth century. According to Monnikhoff's narrative there was a plaque in the façade of Spinoza's house with the last couplet of Dirck Camphuysen's 'Maysche Morgenstondt' (May Morning): 'Alas! If all men were wise, and benign as well / then the Earth would be Paradise, whereas now it is often a Hell!'

On 16 December 1896 the house was auctioned at the 'Landbouw' coffeehouse in Rijnsburg. Willem Meijer had heard about the sale a few days before and decided to try and acquire the property to preserve it from deterioration and possible demolition. There was not enough time to set up a foundation so B. J. Kruijswijk, a businessman from The Hague, offered to put up the money. Once the foundation had been established, he would transfer the ownership. It was Prof. Dr. B. J. Stokvis who established the Society. Known as the 'Vereeniging Het Spinozahuis', it was founded on 28 April 1897 with the object of preserving Spinoza's house in Rijnsburg in its original state, to maintain it and to turn it into a Spinoza House in which various objects associated with the philosopher's life and work could be collected.

Stokvis managed to persuade George Rosenthal to provide the necessary basis to enable the Society to take over the house and part of the grounds from Kruijswijk and to donate it to the Society.

The first act of the Society's first meeting held on 12 June 1897 was to appoint George Rosenthal honorary chairman in appreciation of his unique gesture.

Spinoza's house was restored to the condition it had been in at the start of the negentienth century. Restoration costs were borne in the main by Rosenthal. Two rooms were turned into a museum in seventeenth-century style together with Spinoza's library. On 24 March 1899 Spinoza House was ceremoniously opened. The first to write his name in the guest register was George Rosenthal. After Spinoza's death on 21 February 1677 the notary W. van den Hove drew up an inventory of his effects. The final section of the inventory was Spinoza's library. Using this list it was possible to reassemble the philosopher's book collection. Great care was taken to acquire the same editions and formats mentioned in the inventory.

In 1914 Prof. Dr. Jan te Winkel compiled a catalogue of the Spinoza House library. According to Van den Hove's list the library had contained 159 titles. George Rosenthal managed in his lifetime to donate 110 of these. He also contributed 35 books about Spinoza's life and philosophy as well as various writings. After his death his widow donated several books, as well as paying the printing costs of the catalogue.

In the annual report of 1899 – 1900, librarian Jan te Winkel noted some of the works donated by Rosenthal: 'including works from the sixteenth century such as a Pesach Haggadah, printed in 1505 in Constantinople; a Basel edition of Seneca's tragedies (1541); the complete works of Machiavelli in five volumes (1550); *Los Dialogos de amor* by Leon Abarbanel (1568); the Syriac translation of the New Testament printed in Hebrew letters by Immanuel Tremellius (1569) and, last but not least, a Spanish translation of Calvin's *Institution*, printed in 1597 but now, as a result of the Spanish Inquisition's zeal, a rare, indeed an extremely scarce edition'.

Willem Meijer, secretary of the Society, wrote in the annual report of 1909 – 1910 that without Rosenthal 'we would never have been able to assemble our library in such a short period [...] we owe it to him that we need have no qualms in inviting the entire intellectual world to Rijnsburg inasmuch as they wish to study Spinoza in any depth'.

At Spinoza House today the first object one notices is the board bearing the names of the Societatis Domus Spinozanæ Socii Perpetui, headed by the name of G. Rosenthal Præses Honorarius. And on the table is the same guest register—now a museum piece itself—in which thousands of visitors from all over the world, including Albert Einstein, have signed their names.

THEO VAN DER WERF

LIJST VAN DE BOEKEN

VAN

BENEDICTUS DE SPINOZA,

zooals die den 2den Maart 1677 is opgemaakt door den Notaris WILLEM VAN DEN HOVE,
belast met de beschrijving zijner nalatenschap.

Nog voorhanden in de Prothocollen van genoemden Notaris, welke bewaard worden in het
Notarieel Archief der Gemeente 's-Gravenhage. (1)

FOLIANTEN.

2 Vol.

1. Buxtorfii Biblia twee folumina cum Tiberiade (sic).
2. Tremellii N T cum Interpretatione Syr: typis Ebr. 1569.
3. Lexicon scapulae. 1652. Lugd.
*4. Tacitus cum notis Lipsii Antverp. 1607. *Aangekocht d. B G v R.*
*5. Livius. 1609. Aureliae.
6. Longomontani Astronomia danica cum appendice de stellis
 Novis et Cometis. 1640. Amstel.
7. Nizolius. 1613. Francof.
8. Aquinatis dictionarium Ebr. Chald. Talm. Lutet. 1629.
9. Diophanti Alexandrini Arithmeticorum Libri 6 Paris. 1621.
 Gr. Lat.
*10. Fl. Josephus Basil. 1540. *Aangekocht door Baron R.*
11. Biblia En Lengua Espagnola. V. T.
12. Aristoteles. 1548. Vol. 2.
13. Nathanis Concordantiae. Ebr.
*14. Tesoro de la lengua Castellana. 1611. Madrid. *Aangekocht d Baron R*
15. Vietae opera Mathematica Lugd. 1646.
16. Hugenii Zulichemii Horologium Oscillatorium. Paris 1673.
*17. Epitome Augustini Operum omnium. 1539. *Aangekocht door Baron R.*
*18. Pagnini Biblia. 1541. „ „ „ „
19. Moreh nebochim. Venetiis. Rabb.
20. Sphaera Johannis de Sacrobosco.
21. Idem.
*22. Don Johannis a Bononia de Praedestinatione. (onduidelijk) *Aangekocht d B G v R*
23. Dictionarium Rabbinicum.
24. Precationes Paschales Rabb.

IN QUARTO.

1. Bibl. Ebr. cum Comment: Deze zelfde Bijbel is te Berlijn.
 Zie S. v. Royen, pag. 210.
*2. Dictionarium Lat: Gall. Hisp. 1599. Bruxell.

(1) De boeken zijn nauwkeurig omschreven in Die Lebensgeschichte SPINOZA's, uitgegeven door Dr. J. FREUDENTHAL,
Breslau 1900.
 Die welke met een * voorzien zijn, ontbreken nog in het Spinozahuis.

*De meeste werken, welke op deze lijst niet met een * voorzien zijn, werden
eveneens voor ekening van Baron R. aangekocht.*

,,בית עובד״ לימות החול. ובית מנוחה״ לשבתות ועמידות
לג׳ רגלים כמ״ס. עם דינים רבים מלוקטים מפוסקים ראשונים
ואחרונים לר׳ יאודה שמואל אשכנזי. כ״כ ליוורנו תר״ג. **3395** — 2½ Hillesum
2 Ldrbde. 8°. Erste Ausgabe.

— בית השואבה. הוא ס׳ תפלה לחג הסכות. שמיני עצרת ושמחת
תורה כמ״ס עם דינים רבים כנ״ל להנ״ל. ליוורנו תרי״ט. **3396** — 7 Geiron
Hldrbd. 8°.

עבודה ומורה דרך כמ״ס. סלאוויטה תקפ״ר. **3397** — 4½ Hillesum
Ldrbd. 8°.

עבודת התמיד כמ״ס עם פי׳ עד״ה לר׳ אלישע האבילייו. **3398** — 1½ Joach
ליוורנו תקנ״ד. Ldrbd. 8°. Am Anfang einige Gebete zugeschrieben.

חסד לאברהם. הוא תפלה לכ״ה מ״ס עם הדינים להרב חיד״א **3399** — 5 Hillesum
ועם האידרא זוטא. פי׳ קצת תפלות מלוקט מהמבהדרהם. לוה
קביעות השנים. ובסופו ,,כתר תורה״ תרי״ג מצות מ״ע מצות דרבנן ע״ם
הרמב״ם וס׳ הדינין. ליוורנו תר״ה. Prgmbd. 8°.

תפלת המועדים כמ״ס. אמ״ד ת״ק. **3400** — 60 Jacobsin
Prgmbd. 8°.

ס׳ תפלות לחדשים ולמועדים כמ״ס. אמ״ד תצ״ט. **3401** — 1 Lazarus
Ldrbd. kl. 8°.

הנ״ל. **3402** — 1 ids
Ldrbd. kl. 8°.

הנ״ל. **3403** — 1 Aschen
3403* אי 1 Aschen ent. 10 Expl. Ldrbd. kl. 8°.

הנ״ל. **3404** — 2 Levison
7 ungeb. u. unaufgeschn. Expl.

ס׳ תפלות למועדים כמ״ס אמ״ד תפ״ז. **3405** — 1 Hamb
Prgmbd. 8°. m. Goldschn.

תפלה ומחזור כמ״ס בר״ב. וין 1836—38. **3406** — 2 Sulzgman
4 Ldrbde. 8°. 1836—38.

ס׳ תעניות כמ״ס. אמ״ד תע״ב. **3407** — 30 Aschen
Ldrbd. kl. 8°.

הנ״ל. דפוס הנ״ל. **3408** — 30 Joach.
Ldrbd. kl. 8°.

הנ״ל אמ״ד תקן׳ן. **3409** — 30 Hilles
Ldrbd. 8°.

ס׳ תפלה להתענות כמ״ס. אמ״ד תפ״י. **3410** — 1½ Joach
Ldrbd. 8°.

הנ״ל כנ״ל. **3411** — 1 Hillesum
Ldrbd. 8°. m. hschr. Randbem. v. David Franco Mendes?

ס׳ ארבע תעניות כמ״ס. אמ״ד ת״ד. **3412** — 50 Joach.
Ldrbd. 8°.

הנ״ל. אמ״ד תע״ז. **3413** — 30 Levison
Ldrbd. 8°. fleck.

הנ״ל. דפוס הנ״ל. **3414** — 30 Joach.
Ldrbd. 8°.

ס׳ חמשה תעניות כמ״ס. אמ״ד תפ״ח. **3415** — 50 ids
Ldrbd. 8°. Bl. פ׳ fehlt.

הנ״ל. דפוס הנ״ל. **3416** — 70 Hillesum
Ldrbd. m. Goldschn.

הנ״ל. דפוס הנ״ל. **3417** — 40 Gans
Ldrbd. m. Goldschn. 8°.

הנ״ל אמ״ד ת״ק. **3418** — 30 Hillesum
Prgmbd. kl. 8°.

תפלה קול יעקב להאר״י ז״ל. סלאוויטה תקס״ר. **3419** — 40 Joach
Ldrbd. 4°. Sehr Schön. Exmpl. Bl. מ״א–מ״ד sehr zierlich handschr. ergänzt.

— — לכל השנה ע״פ׳ נוסחת האר״י ז״ל עם הוספות הרב ר׳ שניאור **3420** — 14 Hillesum
זלמן מלאדי. כ״ח בב״א חמ״ר. Juchtenbd. 4°. Schön. Expl

— — שערי רחמים עם ליקוטי כתבי האר״י. עם קצת תפלות וכוונות **3421** — 4 ids
לר׳ שלמה עכּאדי. שאלוניקי תק״א. Ldrbd. 4°.
Mit einigen hschr. Randbemerk.

— המאיר לארץ. והוא תפלה מכ״ה ע״פ נוסח האר״י ז״ל עם ס
ברכת הנהנין להרב שניאור זלמן. עם הדינים משולחן ערוך הרב
הנ״ל. פ״י על הודו למנהת עש״ק לר׳ ישראל בעש״ט.ווילנא תרי״ל **3422** — 4¾ Levison
Ldrbd. 8°.

— סדר רב עמרם גאון. ב״ח בב״א. ווארשא תרכ״ה. **3423** — 2¾ Joach
2 Thle. 1 HJuchtenbd. 8°.

סור תפלות השנה. כולל תפלה לחול לשבת ולר״ח וכו׳ עם היוצרות
ומחזור לש״ר ול״כ וסליחות לימי התשובה. וד׳ התעניות וקינות
לט״ב וכו׳ כמנהג קהלות רומניא עם פי׳ על מקצת הפיוטים ופרק
אבות ע״פ הרמבם. ובסופו סדר תקופות.ומולדות וכו׳ לר׳ אברהם ב״ר
יום טוב ירושלמי וטופסי שטרות וכו׳ ומפתחות. ב״ח בב״א. **3124** — 81 Hillesum
קושטאנדינה של״ד–ו׳. 2 Thle. 1 engl. Ldrbd. 4°.

Aeusserst selten. Bei Zedner (S. 483) nur ein defectes Expl.
und bei Roest (Cat. Rosenthal S. 732) bloss der zweite Theil, gleich-
falls nicht ganz vollständig. Bietet auch nach den Arbeiten von
Heidenheim und Baer noch manche für die deutsche Liturgie beach-
tenswerthe Lesart. Man vgl. z. B. in der 2. Strophe der Elegie
נבוכדנצר die La. ביתר für das ובתר und in der 8. das allein
richtige יתן für das ויקח der Ausgg. nach deutschem Ritus u. s. w.
Gut erhaltenes Exemplar, vom Anhange fehlen jedoch 5 Bll.

— כמנהג רומא [מתחיל בדף א׳ ע״ב׃ אלו מאה ברכות] עם
הושענות להר״ר ווידום לי״הב׃ פאנו רס״ג (1503) **3425** — 655 Joach.
Ldrbd. 24°.
Nur das Exemplar der k. k. Bibliothek in Wien bekannt. S. Stein-
schneider, Cat. l. h. p. 303 N°. 2062 (H. B. I, 126 Anm. 3).
Fehlt bei de Rossi. Gut erhaltenes Expl. (= Cat. Dubno S. 54
N°. 517?), mit handschl. Stellenangabe der Bibelverse und Randbe-
merkungen in griech. und lat. Sprache.

תפלה כמנהג קהלות בני רומא דפוס ו׳... וויניציא ש״ח. **3426** — 185 Joach
Pergamentdruck. Ldrbd. m. kupf. Schl. Schön Expl. 8°.
Sehr selten.

תפלה לאל עליון בעד שלום מלכותנו עם ה״ה.לר׳ יצחק מינדים די
סולה בשבת להודיש כסלו תקצ״ג. אמ״ד **3427** — 1¾ ids
Brosch. 8°.

תפלה למשה. מאמרים על תועליות התורה וס׳ ק״ש על המטה
ותקונים לר׳ משה אלמושנינו. שאלוניק שכ״ג. **3428** — 4¾ Levison
Hldrbd. 4°.
Sehr selten.

תפלות לימי שמחת תורה וחופה נערים. זמן מילת זכרים. ס׳ מילה
וטבילה. עבדים וגרים. לימי פסח לימי פורים. יום תרועה ולסליחות
ען בי״הב׃ כפי מנהג אנשי שינגלי׳. אמ״ד תקכ״ט. **3429** — 2 Joach.
Carton. 8°.

תפלת הדרך וכל הדינים השייכים להולכי דרך.ווילמרסדארף תס״ב **3430** — 1 Levison
Ldrbd. 8°.
Gebetb. u. s. w. 30 Piecen.

תפתה ערוך׃ שיר מוסרי לר׳ משה זכות ׃ וערן ערוך׃ שירים על
עניני נגהנם ונן גערן לר׳ יעקב דניאל אולמו עם באור המלות ובאור
הענין ועם העתקה כל׳אש. מין תקל״ן. **3432** — 1¾ Hilles.
Hldrbd. 4°.
תיקון חצות תי׳ רחל וכו׳ מ״ע תהלים עם פי׳ משפט צדק

3431 — 1¾ Joach

48 The Lehren/De Lima sale

Auction catalogue, pages 190 – 191, 230 x 290 mm [ROS. I B 63]

IN THE NINETEENTH CENTURY auctions of Hebrew books may not have been exceptional events. But an auction lasting two weeks certainly was. Between 13 February and 2 March 1899 4,288 books were put up for sale at Amsterdam. On offer were the collections of the Lehren/De Lima family of bankers, Jacob Meijer Lehren (1793 – 1861), Akiba Lehren (1795 – 1876) and Moses Hartog de Lima (1819 – 1897) (Collection of Auction Catalogues in the Bibliotheca Rosenthaliana: ROS.VEIL. 30; ROS. I B63). Both Jacob Meijer and Akiba were leading figures in the Jewish community in Amsterdam. In addition, Jacob Meijer and Akiba were successive presidents of the *Pekidim and Amarcalim* ('Officers and Treasurers'), an organisation of Jewish communities in Western and Central Europe for penurious pious Jews in Eretz Israel.[1] Through their efforts for the organisation the Lehren brothers established a name as philanthropists. Their nephew, Moses Hartog de Lima, also a prominent member of the Jewish community and vice-president of *Pekidim and Amarcalim* was married to Jacob Meijer Lehren's daughter. The family lived together with Jacob Meijer at Rapenburgerstraat 126 in Amsterdam. According to the title-page of the auction catalogue, this was also where the 1899 sale was held by publisher and bookseller J. L. Joachimsthal. No one was living in the house at the time; the last occupant, Moses Hartog de Lima, died on 20 October 1897. As was common practice then, the sale was held at the home of the deceased. Joachimsthal's announcement of the auction appeared in the *Nieuw Israelietisch Weekblad* towards the end of 1897. Nevertheless, the organization and the writing of the catalogue descrip-

tions were time-consuming activities, and it was more than a year before the auction could actually take place.

In the catalogue a distinction is made between the Lehren brothers' and De Lima's books. The Lehren library formed the lion's share, 3,529 lots. The Hebrew printed editions were divided into five categories: responsa, Talmud, Hebrew Bibles, prayer-books and other titles. Manuscripts and Judaica formed separate sections. Remarkably, the catalogue starts with a list of 65 incunables and post-incunables printed between 1475 and 1540. Unfortunately, at that time it was not customary to include estimated prices, so we are unable to judge the extent to which supply and demand influenced price levels.

Naturally, an auction of this importance could not fail to attract the attention of Jeremias Meijer Hillesum (1863 – 1943), then librarian at the Bibliotheca Rosenthaliana. It seems that Hillesum attended each day of the sale and bought books. In fact, he spent Dfl 2,397.95 on 605 books, as documented in ROS.VEIL. 30. This was a fortune at a time in which the average worker earned around a guilder a day. The money was probably contributed by George Baron Rosenthal, son of the library's founder. The most expensive book bought by Hillesum was lot no. 3,424 for which he paid Dfl 81.00. This was the rare *Seder Tefillot Ha-shanah*, a prayer-book for the whole year according to the Romanian rite, printed in Constantinople in 1574/6 (ROS. 20 F 23). Several books were also bought for the more modest sum of 30 cents a piece. From the catalogue it appears that Hillesum was trying to purchase books which had once belonged to Wolf Heidenheim (1757 – 1832), a major printer and publisher of Hebrew books in Rödelheim, having begun with critical editions of Jewish prayer-books. Thanks to Hillesum the Bibliotheca Rosenthaliana now has an almost complete collection of the editions published at Heidenheim's press, as well as fourteen books that at one time formed part of the printer's impressive private library. These books are of especial interest for Heidenheim's notes and the light they shed on the editions he produced. As a result of Hillesum's efforts at the Lehren/De Lima auction the Bibliotheca Rosenthaliana now has around 25 works from the former Heidenheim collection.

LIES KRUIJER-POESIAT

49 Jewish book-plates in the Netherlands

Book-plates of (*above*) M. J. Perath and I. van Esso Bzn,

(*below*) M. H. Gans, J. Tal, and J. Gompers, full size

T
HE FIRST ARTICLE about Jewish book-plates
in the Netherlands was written by the biblio-
grapher and collector Sigmund Seeligmann
(1873 – 1941) and appeared in the 8 August
1924 edition of the weekly *De Vrijdagavond*. At the time
only a few book-plates by Jewish-Dutch artists were
known. One of these was a book-plate by Seeligmann him-
self, showing a lion and a deer supporting a Star of David
(Maurits de Groot, 1901).

The first extant Jewish book-plates date from the end of
the eighteenth century. The book-plate of Isaac de Pinto
(1718 – 1787), a wealthy banker and author of several
books about economics, dates from this period. Only a
few book-plates have surfaced from the nineteenth century.
Among them is the heraldic book-plate of David Henriques
de Castro (1826 – 1898), author of the standard work on
the gravestones in the Portuguese-Jewish cemetery in
Ouderkerk. During the course of the twentieth century,
the number of Jewish book-plates in the Netherlands has
increased, but the total probably does not exceed a few
hundred.

The themes of the images depicted can be classified
into several groups. Religion and ritual appear frequently,
for example in the book-plate of the circumciser E. de
Vries (Samuel E. Manukowski, 1900 – 1943).

The menorah, the candelabra with seven branches, was
frequently used and could also be combined with the ser-
pent of Aesclepius, as in the book-plate of Meyer J. Perath
(Meyer Jacob Premsela, 1904 – 1971). Perath, who emig-
rated to what was then Palestine in 1939, was also a physi-
cian in Israel. He recorded a great deal of the prewar his-
tory of the Jews in Amsterdam in his articles in the *Nieuw
Israelietisch Weekblad*. This book-plate was made by his
youngest son, Amram Perath (born 1938).

Another theme is Zionism and the longing for Israel, as
shown in the book-plate of Izaak van Esso Bzn (1880 –
1966), made by Uriel Birnbaum (1939), in which Mount
Zion rises at the end of a street made of books. The owner
of this book-plate was a physician, a Zionist and the secret-
ary of the 'Genootschap voor de Joodsche Wetenschap in
Nederland'.

A number of book-plates reveal a cultural duality, one
example of this being the book-plate of M. H. Gans, the
author of the renowned *Memorbook* (English translation
1977). His book-plate, engraved in 1941 by Alice Horo-
disch-Garmann (1905 – 1984), has Roman script and the
heraldic Dutch lion on one side, and Hebrew script and
grape-bearers on the other (Numbers XIII, 23).

Many motifs were borrowed from history—from bib-
lical data and symbols to anti-Semitism and the events of
the Second World War, such as the burning of the books
in the book-plate of J. H. Coppenhagen (Lea Cohen, 1957),
with a text from the Talmud (bAvodah Zarah 18a): 'Parch-
ments are burned, but the letters fly'. That is to say, the
spirit and the contents of the Torah cannot be destroyed.

A significant group consists of the book-plates of and
with rabbis, although in terms of the images depicted, these
fall into the same categories as others. The book-plate that
E. M. Lilien (1874 – 1925) made in 1900 for the mathem-
atician Reuben Brainin (1862 – 1939) contains portraits of
famous rabbis. It should be mentioned that it is the first
book-plate in which the term *mi-sifre* (from the library
of...) appears.

That one can adhere to Judaism (*judea tenacitas*) and
be open to other cultures at the same time appears in the
book-plate of Justus Tal (1881 – 1954), chief rabbi of
Utrecht and Rotterdam and, after the war, of Amsterdam
(Wilm Klijn). This book-plate depicts on the left an open
Torah scroll and on the right a shelf of books including:
Mathematics, Virgil, Nat. Hist., Faust, Philosophy,
Homer (in Greek), Art History; and in the foreground: a
globe, a retort, a compass and a set square. At the lower
right is a quotation from the Sayings of the Fathers: 'It is
well to combine Torah study with worldly occupation'
(2:2).

The text of the book-plate of Joseph Gompers (1899 –
1945) is also borrowed from the Sayings of the Fathers. It
reads: 'The day is short and there is much to do' (2:15).
This book-plate, made by Fré Cohen (1903 – 1943) shows
the symbol of a farmer ploughing a field with his horse.
Dark clouds suggest the approach of evening. Gompers
himself found this an austere and starkly depicted carving,
which expressed the quotation he had chosen quite well.

Book-plates of Jewish owners with the usual subjects
such as profession, hobby, landscape, general symbols, etc.
are not classified as Jewish book-plates. They may well
have value and significance, for ultimately a book-plate is
an image of the period and can contribute to the know-
ledge of a person's character.

PHILIP VAN PRAAG

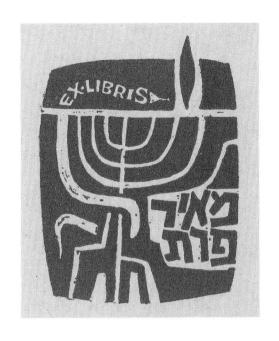

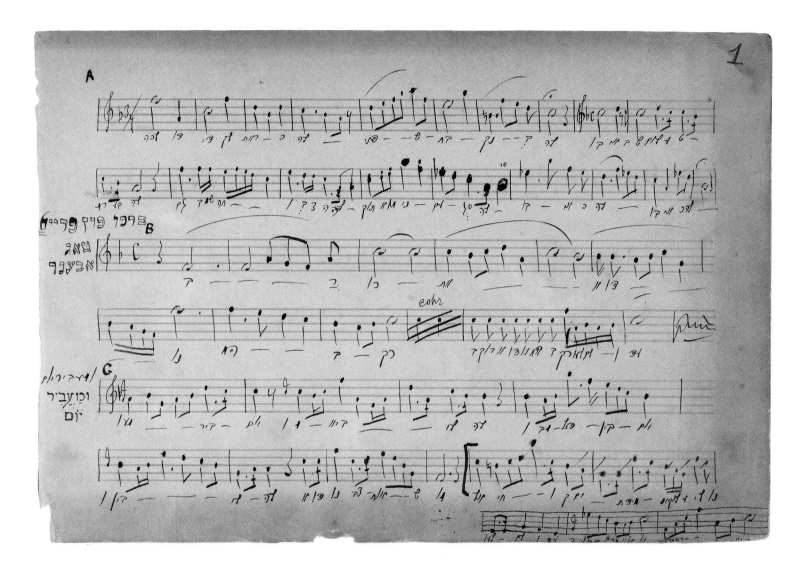

50 Traditional Amsterdam synagogue melodies

Manuscript, 160 x 235 mm [ROS. 19 E 26]

T HE BIBLIOTHECA ROSENTHALIANA collection contains a particularly interesting volume of music connected with the liturgy of the Amsterdam community. At the front, it announces: 'Traditional Amsterdam synagogue melodies, sung by the honourable Dr. I. de Jongh and written down by A. Katz, former first cantor at the Great Synagogue in Amsterdam, for the Bibliotheca Rosenthaliana—J. Veldman'.

First a word about the three names. Dr. I. de Jongh, before the Second World War deputy headmaster of the Netherlands Jewish Seminary, was a renowned expert on Amsterdam chazzanut. Cantor A. Katz succeeded the famous chief cantor Isaac Heijmann at the Great Synagogue, while J. Veldman was cantor at the synagogue on Rapenburgerstraat. It would be tempting to expand on these three figures, but given the short space here a discussion of the book's contents seems more appropriate. The 145 pages of handwritten melodies are preceded by a highly informative introduction in German combining a summary of the contents and a description of the various minhagim (customs) of the service. In fact, the description 'traditional Amsterdam melody' should be taken with a pinch of salt. 'Tradition' suggests melodies handed down over the generations. However, in this work that is not always the case. One example serves as an illustration. Pages 13 and 14 contain two melodies from the Hallel prayer sung on the Sabbath coinciding with Rosh Chodesh: *Hodu* and *Anna* from Psalm CXVIII. The music for these pieces is borrowed from the famous German-Jewish composer of synagogue music Louis Lewandowsky.

It is a little odd that this composer's name is mentioned, while compositions by the most renowned of Amsterdam's cantors, the so-called 'Gneser Chazzan' Isaac Heijmann,

remain anonymous. I realized this as soon as I saw the first page of music. It contains a melody for *Lekha Dodi*, sung to welcome the Sabbath, that was originally composed by Heijmann. But it is only part of the composition. This is *Lekha Dodi* no. 4. The original score for chazzan and mixed choir was in D major. Here the first couplet to be sung by the chazzan is in F, just as expected. Cantor Katz, after all, was famous for his high tenor; he will undoubtedly have sung this melody in the second key. Remarkably, the first line is followed by a melody for *Boi ve-shalom*, the last strophe of the song. In Heijmann's composition *Boi ve-shalom* is only written for the choir. But because in the Amsterdam tradition the chazzan always repeats this part it seems likely that De Jongh heard a cantor singing the melody.

On page 110 we find a second melody for *Lekha Dodi* for Friday nights during the Counting of the Omer. Again the tune is borrowed from the Gneser Chazzan. However, here the original *Boi ve-shalom* melody is given.

One unique feature of Amsterdam chazzanut is that each festival has a separate melody for the Kaddish prayer. These melodies differ significantly from the Kaddish sung in normal Sabbath services. To the best of my knowledge this is the first and only systematic record of these melodies.

Some of Chazzan Katz's melodies are still sung in the same way today. Worthy of mention are the Kaddish melodies for Friday evenings and Sabbath mornings after the Torah is read (page 3); for the Sabbath afternoon service (page 17); for the first day of Rosh Ha-shanah and Yom Kippur before Mussaf (page 25); for Shemini Atzeret (pages 75 and 93); for after the Torah readings on the High Holidays (pages 83 and 84); for the Tal and Geshem prayer for dew and rain in the Holy Land (page 86); for Kol Nidre—the eve of Yom Kippur (page 89); for the two first days of Passover (pages 111 and 112); for the two last days of Passover (pages 116 and 117); for Sukkot (pages 129 and 130) and Shavuot (page 144).

These alone make this a valuable document and practical guide to any aspiring cantors keen to continue Amsterdam's chazzanut traditions.

HANS BLOEMENDAL

51 Emanuel Querido and his publishing house

Binding designed by Fré Cohen, 193 x 135 mm [ROS. 1894 G 20]

'EMANUEL QUERIDO was a Portuguese Jew' is how more than one account of his life begins, but it is surely ironic that this should be considered the most significant feature of a person who as a young man turned his back with such determination on Jewish religion and the Amsterdam Jewish-Portuguese community. In his novel *Het Geslacht der Santeljanos* he described the milieu and family, and the protagonist's shedding of the old traditions and culture. Jewish emancipation and integration into the artistic and intellectual life of Amsterdam, of the Netherlands, and even into that of the larger world was the theme that dominated his whole life. If, therefore, his life and work cannot properly be considered part of the history of Jewish culture of Amsterdam, they certainly belong to a chapter of its sociology.

A grandfather will always be a grandfather; at least, that is how I experience it. Even though he was a publisher and I am bibliographer, I still feel no real temptation to marshal the memories that linger in my mind into the coherence of comprehensive lists, formal descriptions, tabulation and statistics, and all the other paraphernalia of a detached and academic approach. I prefer my memories to remain fragmentary, capable of expansion and contraction, stimulated sometimes by the work of others, in particular A.L. Sötemann's and F.H. Landshoff's recent books. Both are excellent, both stir up deep memories and recollections, and I refer to both for accurate and affectionate accounts of my grandfather's place among the publishers of his time.

I have memories of him as a grandfather, which is what he was for me, but I also remember him in relation to his work, his life as a publisher, and his intense love of books which he began to share with me as soon as I could read. I remember him surrounded by books, arranged on shelves in his study, displayed on a large, flat table, or filling the air with the scent of fresh paper and print in his office.

Best of all, I remember him, the image of concentration, immersed in the making of books, in proofs, in illustrations and layouts. The titles which I still recall from my earliest years must have been of books that were among the last with which he was actively involved: J.W. F.Werumeus Buning's *Ik zie ik zie wat gij niet ziet* (what child could forget such a title?), the Cervantes translation, and above all Jane de Iongh's *Regentessen der Nederlanden*, the illustrations for which he saved from my inquisitive hands while explaining what he was doing with them.

It has often been observed that he attracted remarkable names for the typography and graphical work in his publications. Before starting on his publishing career (which did not begin properly until 1915), he used a device with the letters EmQ designed by Berlage. It can be seen in A.Schopenhauer's *Pererga en Paralegomena*, translated by H.W.P. E. van den Bergh van Eysinga, published in 1908 as an idealistic venture into popular education. In the first successful years after the firm was established, until about 1930, a striking house-style was developed of bold typography combined with the heavy woodcut illustrations and jackets by J.B. van Heukelom and Fré Cohen and with bindings in matching style. It was a personal and extreme interpretation of the 'New Art of the Book' of the first quarter of the twentieth century. In the late 1920s there were some exquisite designs by Raoul Hynckes, exceptional both in lettering and illustration. Querido Verlag, the branch of the firm that published German authors in exile from 1933 to 1940 was fortunate to attract Henri Friedlaender, who designed no fewer than 51 books for them. In the same period many of the bindings, jackets and title-pages of Dutch books show the unmistakable flourishes of Jan van Krimpen, who first designed a book

IS.
QUERIDO
MISLEIDE
MAJES·
TEIT

MISLEIDE
MAJESTEIT
DOOR
Is·QUERIDO

for Em. Querido in 1926. Yet, despite the diverse and personal style of each of these designers, there are common factors in these books (except the German list, which was largely left in Landshoff's competent hands). With hindsight I can only ascribe this to a constant interaction between publisher and designer. From what I recall of the goings on in that warm household where I spent a great deal of time, my grandfather's participation was always lively. Contact with designers was no less intense than that with authors.

I do not remember my grandfather as a particularly talkative man, but rather as one who chose his words carefully, and often savoured their pronunciation with obvious enjoyment. The Salamander series owes its name not to any symbolism attached to the creature, but to the satisfaction of enunciating the word. Words were important to him, and like his brother Israël, like his own son, he could draw on a rich well of language. For each of them, this never-ending source was sometimes a dangerous gift. As a novelist my grandfather's prose was over-contrived, at times impenetrable in its verbose descriptions, over-conscious as he was of constructing images with words. It is different to use words for giving actual, physical shape. When using words to construct, for example, a title-page, they are harnessed within set spaces, with the effect of enhanced value and emphasis. Typography is a medium that imposes constraints, and the balance thus found between language and actual shape can be deeply satisfying. Language can be found to express ideas together with the means to support them physically. I think that the pleasure in arranging words, using them to good visual effect, can be sensed even in the title-page of the Schopenhauer translation of 1908. It can be followed over the years, for example, on the cover of Margot Vos, *Meiregen*, 1925, designed by Raoul Hynckes. Even when the words were entirely dictated by the formulas of an academic occasion, as with my father's doctoral thesis (1926), they seemed to acquire exceptional significance on the title-page on which they were arranged by a proud and grateful father.

With Jan van Krimpen an entirely new style was introduced which contained new elements of lightness. I do not doubt that he soon became my grandfather's favourite designer. The elegant forms that lent emphasis as effectively as the heavy styles used hitherto drew on calligraphic traditions of Dutch high culture. In the final years of my grandfather's activity, this was even turned into playfulness. We see this in some publications of works by J.W. F. Werumeus Buning, who had a command of rhetorical language used with a light hand that greatly appealed to both my grandfather and Jan van Krimpen. In their sensitivity to language and its ornaments, the three were well matched. Buning's half-ironical title-page combined with Jan van Krimpen's layout became a near pastiche of Dutch seventeenth-century printing which was fully appropriate to the anthology *Lof van Nederland* (1941?). I have some mementos of the friendship between my grandfather and Werumeus Buning in the form of little dedicatory poems and jokes ('Queer I did / Queer I do / May it please / Querido'), but no traces of personal contact with Van Krimpen. Yet I think that Van Krimpen more than anyone else knew how to transform emphasis, which ran the risk of being oppressive, into joy in words and language, and that he had interpreted my grandfather's underlying ideas and qualities to perfection. In fact, with the transformation from a heavy style to the more light-footed Van Krimpen style, not only Em. Querido's Uitgevers-Maatschappij moved with its time, but Emanuel Querido (1871-1943) evolved towards an integration of personal style and expression into the larger tradition of Dutch culture.

LOTTE HELLINGA-QUERIDO

52 The return of the Bibliotheca Rosenthaliana— but not without damage

Samuel Usque's history of the suffering of the Jewish people,

195 x 240 mm [ROS. 11 B 36]

'THIS THEN HAS BROUGHT a temporary end to the Rosenthaliana's illustrious history' wrote curator Louis Hirschel to Prof. E. Cohen at the end of November 1940. He was referring to the closure of the Bibliotheca Rosenthaliana reading room, the consequence of his dismissal together with all other 'non-Aryans' in public service by the German authorities.

By that time Einsatzstab Reichsleiter Alfred Rosenberg had already managed to get hold of various collections which had been labelled a threat to the nation, such as those of the International Institute of Social History (Amsterdam), and the Freemasons' Lodges throughout the country. From the very beginning, however, the Germans had also been after the Jewish collections of Judaica and Hebraica.

The second blow to the Bibliotheca Rosenthaliana came on 12 August 1941 when the reading room was sealed off, a fate meted out to other similar large collections such as the Dutch Jewish Seminary and the Portuguese Jewish Seminary (Ets Haim / Livraria Montezinos). Nevertheless the librarian Herman de la Fontaine Verwey, and curator Hirschel managed to get into the reading room undetected —by using seals discarded by the inspecting German officers—and removed many of the most valuable items. These valuable books and manuscripts were hidden in a municipal air-raid shelter in the dunes. Other valuable works were also immured in the storeroom of the library itself.

Although a collection on loan to the University Library from the Study Society for Psychical Research was taken in February 1942, and other collections of Judaica and Hebraica elsewhere in the city were removed during the course of 1943, the Rosenthaliana collection was, at this stage, still protected because of its status as the property of the city of Amsterdam. However, even that protection finally disappeared when 153 crates of the books were packed by Einsatzstab Reichsleiter Rosenberg's staff and removed from the reading room and storeroom on 27,

28, and 29 June 1944. These were to be sent to Germany 'to be incorporated into the Library for the Investigation of the Jewish Question in Frankfurt am Main', so the librarian was informed.

In a secret report of 8 April 1945, a lieutenant in the American army mentioned that 'north of Frankfurt, in the small village of Hungen a tremendous collection of Jewish cultural treasures and other objects are stored away that were looted by the Nazis from all the formerly occupied countries'. 'Among the looted museums, libraries... [was] the complete ROSENTHALIANA library.' [1] It was probably in Hungen (where the Institute for the Investigation of the Jewish Question was based from the end of 1943) that the book displayed here was damaged by a bullet. The projectile may easily have been fired from a British-made Sten gun. [2] Allied soldiers probably fired shots in the repository in question thereby unintentionally hitting a crate and several books.

The damaged book is a twentieth-century reissue of a sixteenth-century Portuguese work by Samuel Usque, which was meant to instruct and encourage Marrano Jews. It deals with the history of the suffering of the Jewish people and the solace to be found through insight into the pattern of Jewish history gained from reading the Torah and the Prophets.

The speedy return of the books looted from the Bibliotheca Rosenthaliana to the Netherlands was made possible because the great majority of the crates from the collection had been left unopened by the Germans; and thanks to the persistence and energy of the American (at that time captain) Seymour J. Pomrenze (born 1916, now living in New York), the first director of the Offenbach Archival Depot, and Dr. D. P. M. Graswinckel (1888 – 1960), head of the Dutch Public Record Office.

'Die Rosenthaliana kehren wieder', is how a German Jewish correspondent described the event when the crates were delivered to the library on the Singel at the beginning of April 1946. Once the books had been classified, the Bibliotheca Rosenthaliana was officially reopened on 6 November 1946. The new curator, the Old Testament scholar I. L. Seeligmann, son of the well-known bibliographer Sigmund Seeligmann, used the occasion to commemorate his predecessors who had been killed during the war: Louis Hirschel and his assistant M. S. Hillesum and his father J. M. Hillesum. Quoting from Ezekiel XVI, 6 *Be-damaykh chayyi* ('When thou wast in thy blood, Live!'), he expressed the hope that the Bibliotheca Rosenthaliana would flourish despite the blows it had suffered.

F. J. HOOGEWOUD

נחם ישראל

CONSOLAÇAM ÁS TRI-
BVLAÇOENS DE
ISRAEL.

COMPOSTO POR SA-
MVEL VS-
QVE

II

*Impreſſo em caſa de Francisco França
Amado em Coimbra a 27 de
Outubro de 1906*

שתילי־הזית

והם
שירי ספר »אילת אהבים« של המדקדק
המשורר
ר' שלמה בן דוד די אוליוירא

דפוס

מה חדש

הובאו למכבש הדפוס
עתה בידי
צעיר המדפיסים
אוד"ה

אמרספורט — תשמ"ג

53 An ambitious publication of the Quid Novum Press

Shetile Ha-zayit, 210 x 108 mm [ROS. KK-1]

I N THE EARLY 1970S there was a revival in the
Private Press Movement in the Netherlands. This
was a direct result of the modernisation of the print-
ing industry. Traditional skills became obsolete and
materials were sold off en masse. Meanwhile, the fact that
printing with moveable type was becoming a thing of the
past inspired enthusiasts to collect this old printing equip-
ment and to learn the skills needed to use it.

Quid Novum Press was set up in Amersfoort in 1973 by
the present author. A considerable number of publica-
tions followed in small quantities using a mid-nineteenth-
century manual press, as well as equipment which had
been acquired as usual on the second-hand market. Be-
cause private presses generally reflect to a large extent the
interests of their owners, more than half of Quid Novum's
productions consist of Hebrew texts or translations of
Hebrew texts. By their very nature these publications are
moderately sized; in many cases they consist of a single
page.

Copies of all of Quid Novum's Hebrew editions have
been acquired by the Bibliotheca Rosenthaliana. Among
these are a collection of medieval Hebrew epigrams and
poems found on the flyleaves of the Leiden Hebrew manu-
script collection, the text of Psalm CXXXI with seven
different rhymed versions in Dutch, and a collection of
old rabbinic legends on the Binding of Isaac (Genesis

XXII). Most of the single-page editions contain Hebrew
poetry. Some are translations from the Dutch, others are
original Hebrew works with or without Dutch transla-
tion, but always in an appropriate typographical format.

Two examples are cited here as illustrations. The first is
a single-page edition from 1980 containing an epigram by
the Hebraist Beer Halberstad (*The 'Practice' of Hebrew Po-
etry*, from the collection of the Bibliotheca Rosenthaliana)
in which he asks his doctor for a remedy to quell a fever. It
was explained and translated by the late Dr. Jaap Meijer
and dedicated to the Bibliotheca Rosenthaliana to mark
the library's centenary.

The second item is Quid Novum's most ambitious pro-
ject to date. The book *Shetile Ha-zayit* (1983; 11, 29,
111 pp.) contains the Hebrew poems included by the Am-
sterdam rabbi Selomoh de Oliveyra in his extensive ad-
aptation of the Binding of Isaac. De Oliveyra called his
masterwork *Ayyelet Ahavim* (A Loving Doe, from Proverbs
v, 19), and the book first appeared in Amsterdam in 1665.
In high-sounding Hebrew prose the many rabbinic legends
surrounding the Binding of Isaac are told anew and re-
worked. De Oliveyra followed an old literary tradition, in-
terspersing his prose with appropriate verses, but his nar-
rative style was that of the contemporary Iberian novella.
Among the various features the author included several
interesting riddle verses in his narrative.

This Quid Novum edition contains only the poems.
They are connected with extracts from De Oliveyra's prose
texts so that the continuity of the narrative is maintained.
The title *Shetile Ha-zayit* means 'olive shoots' and is a
reference to the author's name, a practice that is common
in early Hebrew literature.

ALBERT VAN DER HEIDE

54 Recent limited editions of the poetry of Saul van Messel

Groningen-Gassiedisch, Bedum, Exponent 1985,

340 × 525 mm [ROS. KG 7]

JAAP MEIJER, whose sudden death on 9 July 1993 came as a shock despite his eighty years, will be remembered chiefly as a historian of the Jews of prewar Holland. Besides his numerous articles on the subject in the period from 1946 up to his death, he also published many works in book form—either through recognized publishers or privately. Less well known is that from the second half of the 1960s he published a great many volumes of poetry under the pseudonym Saul van Messel. This poetry was mostly suffused with memories. The first collections were brought out by established publishers; many of the later ones he published himself.

However, it was not until 1975 that he allowed several of his poems—mostly ballads—to appear in limited editions. Most of these editions appeared in the mid-1980s in runs of no more than twenty Roman- and one hundred Arabic-numbered copies and were intended primarily for good friends. Since these were not always sent to the same people, virtually nobody has a complete set. Bibliotheca Rosenthaliana does, however, have a very fine collection. Much of it has been donated by the author and is accompanied by handwritten dedications by him.

Jaap Meijer, who lived in Heemstede for many years, may have been inspired to create his own limited editions by S. L. Hartz, who designed much of the printed matter produced by the well-established Haarlem printing firm of Johan Enschedé. Hartz himself ran a small-scale, limited edition press called Tuinwijkpers; he was the same age as Meijer and also had a Jewish background.

Two of the limited editions owned by Bibliotheca Rosenthaliana are dedicated to Sem Hartz on the occasion of his seventy-fifth birthday on 28 January 1987. The first, in quarto format with a print run of 60 was inscribed 'Ad Sem Hartz' and was printed on a Mercator press; it was presented at Heemstede public library. The second, a personal testimony to Jaap Meijer's friendship for S. L. Hartz, is a small single-sheet print in blue and yellow bearing the motif of the celebrated eighteenth- and nineteenth-century Amsterdam-Jewish printing family of Proops.

The emblem depicts two hands raised in the blessing of the Jewish priests or cohanim, from whom Hartz, according to tradition, is also descended.

Most of Jaap Meijer's limited editions, and indeed most of his poetry in general, deals with one of two subjects: either the Ahasuerus motif and the rootlessness of the wandering Jew or his troubled memories of Jewish life in prewar Holland, especially of his childhood in the eastern part of Groningen (in which almost no Jews remain today). Many of these later poems are in East Groningen dialect. The Ahasuerus motif is also the subject of his earliest and privately published limited edition: *Vagans Judæus. Tien Joodse Gedichten* (Heemstede, 1975). Tuinwijkpers published his *Ahasverus* in 1986.

A beautiful piece of work with regard both to text as well as design is Meijer's *Chewre kadiesje* (folded broadsheet, set manually in large wooden Columbia type by Menno Wielinga in cobalt blue on cream-coloured paper. Bedum, Exponent 1985, 120 numbered copies). This ballad tells of pious Jewish ladies who meet regularly to sew shrouds for deceased members of the Jewish community but who are themselves fated to die without shrouds.

The moving ballad 'Westerwolde' is dedicated to the region of East Groningen and the Jews who lived there before the war. The edition, set in Romanee, was printed by Priegelpers in 1986 (150 copies).

His 'Jodenhoek / Dodenhoek' eloquently evokes the tension between Jewish Amsterdam's past and present. The ballad was published in Heemstede on 3 May 1987 on the occasion of the opening of the Jewish Historical Museum in the former synagogue complex on Amsterdam's Jonas Daniel Meijerplein.

To Heemstede, where he lived, he dedicated the small limited edition entitled *Heemstede en omstreken* (Heemstede 1986, 75 copies), set manually in Cancelleresca Bastarda. It includes a poem dedicated to the prewar Zionist rabbi S. P. de Vries of Haarlem, and another to Mea Nijland-Verwey (Albert Verwey's daughter) of Santpoort.

Following Jaap Meijer's death two exquisite and full-colour broadsides were exhibited in the reading room of the Bibliotheca Rosenthaliana, his poem 'WINSCHOOT-sjoel zonder joden' (Bedum, Exponent 1985, 85 numbered copies) and 'Groningen-Gassiedisch', typeset in Columbia (Bedum, Exponent 1985, 115 numbered copies).[1] The latter work features two vaguely visible characters representing the Jewish theologian and scholar Martin Buber and the Groningen compositor H. N. Werkman, who also printed Buber's Hassidic legends as an evocative illustration of Meijer's combined Jewish, Groningen and bibliophile interests.

HENRIËTTE BOAS

twee gassiediem naar kleur en naar woord
onder matte belichting van het nattige noord
twee symbolisten naar snit en naar sfeer
onder doffe glans van het echt groningse weer

waar zijn hier de joden gebleven
vroeg buber – donkere blik terneer –
over hen wordt nog wel veel geschreven
zei werkman – zij zelf zijn niet meer

hun sjoel werd in feite een kijkspel
al klinken er soms nog gebeden
buber knikte bedroefd – ik begrijp wel
wij schuilen daar voor ons verleden

stempelafdruk van stervende resten
voegde hij er verbitterd aan toe
waar waart gij destijds in dit westen
zég het eens: hakadosj baroeg hoe

middels mijn muze in joodse balladen
aan drukker – aan denker : twee kameraden

Notes and suggestions for further reading

1

'The completion of the *Esslingen Mahzor*'
Gabrielle Sed-Rajna

READING

E. M. Cohen & E. G. L. Schrijver, 'The Esslingen Mahzor. A
Description of the "New Amsterdam" and "Old Amster-
dam" Volumes', *Studia Rosenthaliana* 25 (1991) p. 51-82
(with a full bibliography on the Esslingen Machzor, p. 55,
note 2).

G. Sed-Rajna, 'The Decoration of the Amsterdam Mahzor'
in: A. van der Heide & E. van Voolen, eds., *The Amsterdam
Mahzor* (Leiden 1989) p. 56-70.

2

'*Sefer Or Zarua* and the legend of Rabbi Amnon'
Menahem Schmelzer

NOTES

[1] I. G. Marcus, 'Kiddush ha-shem be-ashkenaz we-sippur
Rabbi Amnon mi-Magenza' in: I. M. Gafni *et al.*, eds.,
*Sanctity of Life and Martyrdom: Studies in Memory of Amir
Yekutiel* (Jerusalem 1992) p. 131-147 (in Hebrew).

[2] A. N. Z. Roth, 'U-netanneh tokef ve-ha-ir Magenza',
Hadoar 44, 36 (1964) p. 650-651.

[3] Menahem H. Schmelzer, 'Maaseh Rabbi Amnon ve-ha-
selicha ta shema', *Hadoar* 44, 38 (1964) p. 734.

READING

E. G. L. Schrijver, 'Some Light on the Amsterdam and Lon-
don Manuscripts of Isaak ben Moses of Vienna's "Or
Zaru'a"', *Bulletin of the John Rylands University Library
Manchester* 73, 3 (1993).

E. E. Urbach, [Introduction to] *Sefer Arugat Ha-bosem* 4
(Jerusalem 1963) p. 40, n. 92.

3

'Hannah bat Menahem Zion finished her copy of the *Sefer
Mitzwot Katan*'
Colette Sirat

READING

C. Sirat, 'Les femmes juives et l'écriture au Moyen Age', *Les
nouveaux cahiers* 101 (1990) p. 14-23.

4

'Mordecai Finzi's copy of a work by Averroes'
Malachi Beit-Arié

NOTES

[1] On the original scientific writings of Finzi, see the recent
article by Y. Tsvi Langermann, 'The Scientific Writings of
Mordecai Finzi', *Italia* 7 (1988) p. 7-44.

[2] A. Z. Schwarz, *Die hebräische Handschriften in Österreich*
[...] IIA (New York 1973) No. 298, p. 29-34.

READING

M. Beit-Arié, 'The Codicological Data-Base of the Hebrew
Paleography Project: a Tool for Localising and Dating
Hebrew Medieval Manuscripts', *Hebrew Studies. Papers
Presented at a Colloquium on Resources for Hebraica Held at
the School of Oriental and African Studies, University of Lon-
don*, 11-13 September 1989/11-13 Elul 5749. (British Library
Occasional Papers 13, London 1991), 165-197.

5

'The *Defensorium Fidei contra Judæos* printed at Utrecht'
Gerard van Thienen

READING

W. & L. Hellinga, *The Fifteenth-Century Printing Types of the
Low Countries* I (Amsterdam 1966) p. 10 – 13, Table II; 2,
Plate 15, p. 446 – 447.

Lotte Hellinga, 'Problems about Technique and Methods in
a Fifteenth-Century Printing House (Nicolaes Ketelaer
and Gherardus de Leempt, Utrecht, 1473 – 1475) with an
Appendix on Paper by Wytze Hellinga' in: *Villes de l'im-
primerie et moulins à papier du XIVe au XVIe siècle. Col-
loque International, Spa 11 – 14 IX 1973* (Brussels 1976)
p. 301 – 315.

*De vijfhonderdste verjaring van de boekdrukkunst in de Neder-
landen* (Brussels 1973) p. 90 – 95 (Exhibition catalogue,
Koninklijke Bibliotheek Albert I).

6

'Four Italian Judaica incunabula'

Dennis E. Rhodes

NOTE

[1] A full summary of the contents is given in the British Museum's *Catalogue of Books Printed in the xvth Century*, Part 5, p. 533.

READING

Catalogue of Books Printed in the xvth Century Now in the British Museum. Parts 4 – 7, 12 (London 1916 – 1935 [reprinted with additions, 1962], 1985) (On Italy).

7

'The first printed book produced at Constantinople'

Adri K. Offenberg

READING

A. K. Offenberg, 'The First Book Produced at Constantinople. (Jacob ben Asher's 'Arba'ah Tûrîm, December 13, 1493)' in his *A Choice of Corals. Facets of Fifteenth-Century Hebrew Printing* (Nieuwkoop 1992) p. 102 – 132 (*Bibliotheca Humanistica & Reformatorica* 52).

A. K. Offenberg, 'Arba'ah Turim. Aan de wieg van de mediterrane boekdrukkunst', *Streven. Cultureel maatschappelijk maandblad* 60 (1993) p. 714 – 727.

8

'Elijah Levita's *Shemot Devarim* printed at Isny'

Herbert C. Zafren

NOTE

[1] M. Weinreich, *Shtaplen* [in Yiddish] (Berlin 1923) p. 83-86.

READING

H. C. Zafren, 'Variety in the Typography of Yiddish: 1535 – 1635', *Hebrew Union College Annual* 53 (1982) p. 137 – 163.

9

'Christopher Plantin's *Biblia regia*'

Elly Cockx-Indestege

READING

B. Rekers, *Benito Arias Montano 1527 – 1598. Studie over een groep spiritualistische humanisten in Spanje en de Nederlanden op grond van hun briefwisseling* (Groningen 1961).

Leon Voet, *The Golden Compasses: a History and Evaluation of the Printing and Publishing Activities of the Officina Plantiniana at Antwerp* (Amsterdam 1969) (2 vols).

Lotte Hellinga-Querido, *De Koningsbijbel van de Prins in de Stadsbibliotheek te Haarlem. Examination Report* (Haarlem / Amsterdam 1971).

Leon Voet, 'De Antwerpse Polyglot Bijbel', *Noordgouw* 13 (1973) p. 33 – 52.

L. Voet & J. Grisolle, *The Plantin Press (1555 – 1589). A Bibliography of the Works Printed and Published by Christopher Plantin at Antwerp and Leiden* 1 (Amsterdam 1980) p. 280 – 315 (extensive bibliography on p. 313).

Paul Valkema Blouw, 'Was Plantin a Member of the Family of Love? Notes on his Dealings with Hendrik Niclaes', *Quærendo. Quarterly Journal from the Low Countries Devoted to Manuscripts and Printed Books* 23 (1983) p. 3 – 23.

10

'A Hebrew map in a work by Hugh Broughton'

Jan W. H. Werner

READING

H. F. Wijnman, 'Jan Theunisz alias Joannes Antonides (1569 – 1637) boekverkoper en waard in het muziekhuis "D'Os in de Bruyloft" te Amsterdam' in: *Vijfentwingtigste Jaarboek van het Genootschap Amstelodamum* (1928) p. 29 – 123. (Reproductions of map and title-page opp. p. 58 and 60). Wijnman mentions the *Parshegen nishtevan* in his bibliography as nr. 27 (p. 109 – 121), and as nr. 32 he mentions a Dutch translation of the booklet *Antwoort op een Hebreuschen brief...*, also from 1606 (copy in the Amsterdam University Library under call number PFL. L 21a, which also contains a Hebrew map).

L. Hirschel in *Het Boek* (1928) p. 199 – 208 and in the *Eenen-dertigste Jaarboek van het Genootschap Amstelodamum* (1937) p. 65 – 79.

AND FURTHER:

Rodney W. Shirley, *The Mapping of the World. Early Printed World Maps 1472 – 1700* (London 1983).

David Woodward, 'Medieval Mappaemundi' in: J. B. Harley & David Woodward, eds., *The History of Cartography. Volume One: Cartography in Prehistoric, Ancient and Medieval Europe and the Mediterranean* (Chicago etc. 1987) p. 286 – 368.

Cassandra Bosters et al., *Kunst in kaart. Decoratieve aspecten van de cartografie* (Utrecht 1989).

11

'Isaac Franco's memorandum on the legal position of Sephardi Jews in Holland'

Arend H. Huussen Jr

NOTE

[1] The Portuguese text of the memorandum can be found in H. P. Salomon's *Portrait of a New Christian: Fernão Álvares Melo (1569-1632)* (Paris 1982) p. 323-325; cf. A. H. Huussen jr., 'The Legal Position of Sephardi Jews in Holland circa 1600' in: J. Michman, ed., *Dutch Jewish History 3: Proceedings of the Fifth Symposium on the History of Jews in the Netherlands. Jerusalem, November 25-28, 1991* (Jerusalem etc. 1993) p. 19-41 (the author was not yet aware in 1991 of Prof. Salomon's edition).

12

'Nicolaes Briot and Menasseh ben Israel's first Hebrew types'

John A. Lane

NOTE

[1] L. Fuks & R. G. Fuks-Mansfeld, *Hebrew Typography in the*

Northern Netherlands 1585 – 1815. Historical Evaluation and Descriptive Bibliography 2 (Leiden 1987) No. 441.

READING

Leo & Rena Fuks, 'The First Hebrew Types of Menasseh ben Israel', *Studies in Bibliography and Booklore* 12 (1979) p. 3 – 8.

13

'Benedictus de Spinoza'
Richard H. Popkin

READING

Marjorie Grene, ed., *Spinoza. A Collection of Critical Essays* (New York 1973).

Edward Curley & Pierre-François Moreau, eds., *Spinoza. Issues and Directions* (Leiden 1990).

14

'Jacob Judah Leon Templo's broadsheet of his model of the Temple'
Adri K. Offenberg

READING

A. K. Offenberg, 'Jacob Jehuda Leon (1602 – 1675) and his Model of the Temple' in: J. van den Berg & Ernestine G. E. van der Wall, eds., *Jewish-Christian Relations in the Seventeenth Century. Studies and Documents* (Dordrecht etc. 1988) p. 95 – 115. (*Archives internationales d'histoire des idées / International Archives of the History of Ideas* 119).

A. K. Offenberg, 'Een vrijwel onbekende, ingekleurde prent op groot formaat van Jacob Juda Leon Templo', *Studia Rosenthaliana* 26 (1992) p. 132 – 135.

A. K. Offenberg, 'Jacob Jehudah Leon en zijn tempelmodel: een joods-christelijk project', *De Zeventiende Eeuw. Cultuur in de Nederlanden in interdisciplinair perspectief* 9 (1993) p. 35 – 50.

17

'Saul Levi Mortera's *magnum opus*'
Herman P. Salomon

READING

H. P. Salomon, *Saul Levi Mortera en zijn 'Traktaat betreffende de waarheid van de wet van Mozes'* (Braga 1988).

P. Cohen, 'S. L. Mortera's historische opvattingen in zijn Traktaat betreffende de waarheid van de wet van Mozes' in: H. den Boer, J. Brombacher & P. Cohen, eds., *Een gulden kleinood* (Apeldoorn / Louvain 1990) p. 105 – 120.

18

'The Sabbatean movement in Amsterdam'
Yosef Kaplan

READING

Gershom Scholem, *Sabbatai Sevi. The Mystical Messiah 1626 – 1676* (Princeton 1973).

Y. Kaplan, 'The Attitude of the Leadership of the Portuguese Community in Amsterdam to the Sabbatean Movement, 1665 – 1671', *Zion* 39 (1974) p. 198 – 216 (in Hebrew).

19

'Romeijn de Hooghe and the Portuguese Jews in Amsterdam'
Judith C. E. Belinfante

NOTES

[1] Prints produced on the occasion of the consecration of the Portuguese Synagogue on 2 August 1675: (a) Temple of the Jews in Amsterdam / *Templo o Synagoga de los Judios in Amsteldam*. Published by Johannes van Keulen. (b) Side View of the Synagogue. (c) The Former Synagogue of the Jews. (d) The Pulpit and Inner Sanctum. (e) The Ark of the Scrolls of the Law. (f) The Schools. (g) The Courtyard and Women's Entrance.

Eight smaller prints which depict the new synagogue and which are well-known as a single printed sheet and as an illustration of the sermons during the consecration week have also been attributed to Romeijn de Hooghe, but the inferior quality of these prints gives cause to doubt their provenance.

[2] Jonathan I. Israel, 'Gregorio Leti (1631 – 1701) and the Dutch Sephardi Elite at the Close of the Seventeenth Century', in: *Jewish History. Essays in Honour of Chimen Abramsky* (London 1988) p. 277.

READING

John Landwehr, *Romeyn de Hooghe, the Etcher. Contemporary Portrayal of Europe, 1662 – 1707* (Leiden etc. 1973).

John Landwehr, *Romeyn de Hooghe (1645 – 1708), as Book Illustrator. A Bibliography* (Amsterdam etc. 1970).

20

'Two Yiddish Bibles printed in Amsterdam'
Marion Aptroot

READING

Marion Aptroot, *Bible Translation as Cultural Reform: The Amsterdam Yiddish Bibles (1678 – 1679)* (Oxford 1989).

I. H. van Eeghen, *De Amsterdamse boekhandel 1680 – 1725.* Vol. 4 (Amsterdam 1967) p. 211 – 217.

L. Fuks, 'De twee gelijktijdig te Amsterdam in de 17e eeuw verschenen Jiddische bijbelvertalingen', *Het Boek. Nieuwe reeks* 32 (1955 – 1957) p. 146 – 165 (cf. the Hebrew version in *Gal-ed*, 1 (1973) p. 31 – 50).

Erika Timm, 'Blitz and Witzenhausen' in: Israel Bartal, Ezra Mendelsohn & Chava Turniansky, eds., *Studies in Jewish Culture in Honour of Chone Shmeruk* (Jerusalem 1993) p. 39* – 66*.

Marion Aptroot, '"In *galkhes* they do not say so, but the *taytsh* is at it stands here". Notes on the Amsterdam Yiddish Bible Translations by Blitz and Witzenhausen', *Studia Rosenthaliana* 27 (1993) p. 136 – 158.

21
'Isaac [Fernando] Cardoso's *Las excelencias de los Hebreos*'
Yosef Hayim Yerushalmi

READING

For a thorough account of Cardoso's life and work see: Yosef
Hayim Yerushalmi, *From Spanish Court to Italian Ghetto:
Isaac Cardoso. A Study in Seventeenth-Century Marranism
and Jewish Apologetics* (New York-London 1971; 2nd edi-
tion, Seattle-London 1981) (Also available in French,
Spanish and Italian translation). On *Las excelencias* see
chs. 8 and 9.

22
'Daniel Levi de Barrios's *Triumpho del govierno popular*'
Wilhelmina Chr. Pieterse

READING

Kenneth R. Scholberg, ed., *La poesía religiosa de Miguel de
Barrios* [Columbus, Ohio *c.* 1961].
Wilhelmina C. Pieterse, *Daniel Levi de Barrios als geschied-
schrijver van de Portugees-Israëlietische Gemeente te Amster-
dam in zijn 'Triumpho del govierno popular'* (Amster-
dam 1968).

23
'Two Hebrew books with silver bindings'
Karel A. Citroen

NOTES

[1] M. de Jong & I. de Groot, *Ornamentprenten in het Rijks-
prentenkabinet 1, 15de & 16de eeuw* (Amsterdam 1988)
p. 268, No. 597.
[2] R. Edelmann, 'Hebraiske bøger med solvbind' in: *Fund og
forskning i det Kongelige Biblioteks samlinger* 8, 1961 (Copen-
hagen 1961) p. 129-130 and Fig. 1.
[3] C. Roth, 'Stemmi di famiglie ebraiche Italiane' in:
D. Carpi et al., eds., *Scritti in memorie di Leone Carpi*, [...]
Saggi sull'Ebraismo Italiano (Jerusalem 1967) p. 165 – 184.
[4] In: *Journal of Jewish Art* 3, 4 (1977) p. 60 – 62, Figs. 5 – 8.
[5] See note 1, pp. 138 – 139.

24
'Hebrew printing on coloured paper'
Brad Sabin Hill

READING

Wisso Weiss, 'Blaues Papier für Druckzwecke', *Gutenberg-
Jahrbuch* (1959) p. 26 – 35.

25
'Stephanus Morinus's *Exercitationes de lingua primæva*'
Nico A. van Uchelen

READING

Jan de Clercq, *La réception des sciences du langage dans les jour-
naux savants de la fin du XVIIe siècle* (Leuven 1993)
(*Preprints* [van het] *Departement Linguistiek, Katholieke
Universiteit Leuven, 148*).

N. A. van Uchelen, 'The Jewish Sources of Morinus' Exerci-
tationes' in: J. Michman, ed., *Dutch Jewish History* 3 (Jeru-
salem etc. 1993) p. 127 – 135.
Irene E. Zwiep, 'The Unbearable Lightness of Hebrew. Di-
dactic Trends in Seventeenth-Century Dutch Grammars
of Biblical Hebrew' in: Jan Noordegraaf & Frank Vonk,
eds., *Five Hundred Years of Foreign Language Teaching in the
Netherlands 1450 – 1950* (Amsterdam 1993) p. 27 – 55.

26
'A Portuguese festival poem from Amsterdam'
Harm den Boer

READING

H. den Boer, *La literatura hispano-portuguesa de los sefardíes de
Amsterdam en su contexto histórico-social (siglos XVII y
XVIII)* (Amsterdam 1992) (Diss.).

27
'The portrait of Jechiel Michel ben Nathan of Lublin'
Anna E. C. Simoni

READING

A. E. C. Simoni, 'Terra Incognita: the Beudeker Collection in
the Map Library of the British Library', *The British Lib-
rary Journal* 11 (1985) p. 143 – 175: 173f.

28
'The Grand Tour of Abraham Levi ben Menahem Tall'
Emile G. L. Schrijver

READING

M. Roest, 'Het verhaal van een reis door een groot deel van
Europa in het eerste vierde der 18e eeuw door een Israëliet',
Israëlietische Letterbode 10 (1884) p. 148 – 189; 11 (1885)
p. 21 – 38, 93 – 147.

29
'Nathan ben Simson of Meseritz's *Prayers for the New Moon*'
Edward van Voolen

NOTES

[1] Sotheby's New York, 26 June 1984, lot 42 (1728), Chris-
tie's London, 9 December 1981, lot 307 (1730), Israel Mu-
seum Jerusalem MS. 181/23 (1732) and Sotheby's Zurich
21 November 1978, lot 14 (Sassoon 504, 1739).
[2] Dave Verdooner & Harmen Snel, *Trouwen in Mokum /
Jewish Marriage in Amsterdam (1598 – 1811)*, 2, The
Hague 1991 (Index 13) p. 553 – 599.

READING

E. G. L. Schrijver, *Towards a Supplementary Catalogue of Heb-
rew Manuscripts in the Bibliotheca Rosenthaliana* (Amster-
dam 1993) p. 104 – 106.

31
'The Rosenthaliana *Leipnik Haggadah*'
Iris Fishof

NOTES

[1] For a detailed study of Leipnik's work see: Iris Fishof, *The Hamburg — Altona School of Hebrew Illuminated Manuscripts of the First Half of the Eighteenth Century* (Ph.D. Thesis; Jerusalem 1992).

[2] See: Emile G.L. Schrijver, 'Mozes, Aaron, David en misschien Esther. Hebreeuws in de STCN', *Vingerafdrukken. Mengelwerk van medewerkers bij tien jaar Short-Title Catalogue, Netherlands* (The Hague 1993) p. 88.

READING

W.Turnowsky (Tel Aviv) facsimiled the Rosenthaliana Leipnik Haggada (HS.ROS. 382) in 1987. (With an introduction by E.G.L.Schrijver.)

32
'Eleasar Soesman's *Mohar Yisrael*'
Jan Wim Wesselius

READING

J.Nat, *De studie van de Oostersche talen in Nederland in de 18e en 19e eeuw* (Purmerend 1929) p. 105 – 108.

J.W. Wesselius, 'Eleazar Soesman en de Amsterdamse polemieken van 1742', *Studia Rosenthaliana* 27 (1993) p. 13 – 35.

33
'The "Otiyyot Amsterdam" of Jacob ben Judah Leib Shamas'
Emile G.L.Schrijver

READING

I.Fishof, 'Yakob *Sofer-mi*Berlin: a Portrait of a Jewish Scribe', *The Israel Museum Journal* 6 (1987) p. 83 – 94.

E.G.L.Schrijver, '"Be-ôtiyyôt Amsterdam." Hebrew Manuscript Production in Central Europe: the Case of Jacob ben Judah Leib Shamas', *Quærendo. Quarterly Journal from the Low Countries Devoted to Manuscripts and Printed Books* 20 (1990) p. 24 – 62.

U.Schubert, *Jüdische Buchkunst* 2 (Graz 1993) p. 117 – 119.

34
'The Tablets of the Law at the Bibliotheca Rosenthaliana'
Shalom Sabar

READING

R.Mellinkoff, 'The Round-Topped Tablets of the Law. Sacred Symbol and Emblem of Evil', *Journal of Jewish Art* 1 (1974) p. 28 – 43.

Ben Ami G.Sarfatti, 'The Tablets of the Law as a Symbol of Judaism' in: B.-Z. Segal & G.Levi, eds., *The Ten Commandments in History and Tradition* (Jerusalem 1990) p. 383 – 418.

S.Sabar, 'Hebrew Inscriptions in Rembrandt's Art' in: M.Weyl & R.Weiss-Blok, eds., *Rembrandt's Holland* (Jerusalem 1993) p. 169 – 187 (in Hebrew).

E.G.L.Schrijver, *Towards a Supplementary Catalogue of Hebrew Manuscripts in the Bibliotheca Rosenthaliana* (Amsterdam 1993) p. 115 – 117.

36
'David Friedländer's *Lesebuch für jüdische Kinder*'
Zohar Shavit

READING

Dov Rappel, 'Jewish Education in Germany in the Mirror of School Books' in: *Sefer Aviad* (Jerusalem 1986) p. 205 – 216 (in Hebrew).

Z.Shavit, 'From Friedländer's Lesebuch to the Jewish Campe. The Beginning of Hebrew Children's Literature in Germany', *Year Book [of the] Leo Baeck Institute* 33 (1988) p. 385 – 415.

David Friedländer, *Lesebuch für jüdische Kinder*. [Neu hrsg. und mit Einl. und Anhang versehen von Z.Shavit.] (Frankfurt 1990).

37
'A Yiddish chronicle of the Batavian Republic'
Ariane D.Zwiers

READING

A.D.Zwiers, 'Jiddisch in Amsterdam. Eerste schets van een onderzoek naar achttiende-eeuws Amsterdams Jiddisch', *Studia Rosenthaliana* 26 (1992) p. 152 – 157.

38
'The *Diskursen* of the *Neie* and the *Alte Kille*'
Jozeph Michman

READING

J.Michman, 'De "Diskursen fun die Neie un die Alte Kille"', *Studia Rosenthaliana* 24 (1990) p. 22 – 35.

39
'Leeser Rosenthal's only Yiddish manuscript'
Renate G.Fuks-Mansfeld

READING

Leo & Rena Fuks, 'Jewish Historiography in the Netherlands in the 17th and 18th Centuries' in: [Saul Lieberman & Arthur Hyman, eds.,] *Salo Wittmayer Baron Jubilee Volume* 1 (New York etc. 1974) p. 433 – 466: 451sqq.

Hetty Berg, 'Jiddisch theater in Amsterdam in de achttiende eeuw', *Studia Rosenthaliana* 26 (1992) p. 10 – 37.

40
'The *Protocol* of the Jewish community of Uithoorn'
Odette Vlessing

READING

On the history of the communities in the Netherlands:
Jozeph Michman, Hartog Beem & Dan Michman, eds., *Pinkas Hakehillot. Encyclopaedia of Jewish Communities. The Netherlands* (Jerusalem 1985) (in Hebrew).

Jozeph Michman, *Pinkas. Geschiedenis van de joodse gemeen-schap in Nederland.* Eindred.: Joop Sanders & Edward van Voolen. (Ede etc. 1992).

41
'The Binger manuscript: the case of the vanishing illustrator'
Marja Keyser

NOTES

[1] Emile G.L. Schrijver describes the manuscript (HS.ROS. 681) in detail in his dissertation entitled *Towards a Supplementary Catalogue of Hebrew Manuscripts in the Bibliotheca Rosenthaliana. Theory and Practice* (Amsterdam 1993) No. 18 (p. 98-102).

[2] *Adresboek van kooplieden te Amsterdam voor 1820* (Amsterdam 1820).

[3] *Patentboek*, compiled and edited by I.C. de Potter (Gorinchem 1842) p. 114-115.

[4] Advertisement in the *Amsterdamsche Courant*, 30 December 1830.

[5] B.P.M. Dongelmans, *Van Alkmaar tot Zwijndrecht* (Amsterdam 1988), reports that Meijer set up his business in 1808 but not what Hijman did.

[6] P.A. Scheen, *Lexicon Nederlandse beeldende kunstenaars 1750 – 1950*, Part 1 (1969) p. 96.

42
'The Hebrew textbooks of David Abraham Lissaur'
Irene E. Zwiep

READING

I. Maarsen, 'Tongeleth. Een Joodsch letterkundig genootschap uit de XIXde eeuw', *De Vrijdagavond. Joodsch Weekblad* 1/1 (1924) p. 390 – 393, 1/2 (1924) p. 135 – 137, 146 – 148, 199 – 201 (separately published in 1925).

J. Meijer, *Voorvaderlijke vooroordelen. Het joodse type bij Jacob van Lennep 1802 – 1868* (Heemstede 1979) p. 60 – 66 (*Diasporade* 6).

A. van der Heide, 'Problems of Tongeleth Poetry', *Studia Rosenthaliana* 19 (1985) p. 264 – 274.

43
'Hanover loses Leeser Rosenthal's library'
Norbert P. van den Berg

READING

Peter Schultze, *Juden in Hannover. Beiträge zur Geschichte und Kultur einer Minderheit* (Hannover 1989) incl.: 'Beth Hachajim – Haus des Lebens. Der jüdische Friedhof An der Strangriede in Hannover' p. 102 – 130: 114.

N.P. van den Berg, 'Een geschenk aan de stad Amsterdam, achtergronden van de Bibliotheca Rosenthaliana', *Jaarboek Amstelodamum* 84 (1992) p. 131 – 185.

44
'The Rosenthaliana's Jacob Israel de Haan Archive'
Marijke Stapert-Eggen

READING

Jaap Meijer, *De zoon van een gazzen. Het leven van Jacob Israël de Haan 1881 – 1924* (Amsterdam 1967).

Ludy Giebels, 'De archivalia in de Bibliotheca Rosenthaliana', *Studia Rosenthaliana* 20 (1986) p. 200 – 209.

Ludy Giebels, *Inventaris van het Archief van Jacob Israël de Haan in de Bibliotheca Rosenthaliana, Universiteitsbibliotheek Amsterdam* (Amsterdam 1994).

45
'Sephardi rabbis in Jerusalem on modern agricultural settlements'
Yehoshua Kaniel

READING

A. Morgenstern, 'The Correspondence of Pekidim and Amarcalim as a Source for the History of Eretz-Israel', *Cathedra* 27 (1983) p. 85 – 108 (in Hebrew).

46
'Theodor Herzl's *Der Judenstaat* published in Vienna'
Michael Heymann

READING

Theodor Herzl, *Briefe Anfang Mai 1895 – Anfang Dezember 1898*. Bearb. von Barbara Schäfer (*Briefe und Tagebücher* 4) (Frankfurt a.M. 1990) passim.

47
'George Rosenthal and the Spinoza House Society'
Theo van der Werf

READING

Catalogus van de boekerij der Vereeniging 'Het Spinoza Huis'. Comp. by Jan te Winkel (The Hague 1914).

Catalogus van de bibliotheek der Vereniging Het Spinozahuis te Rijnsburg. Comp. by J.M. Aler (Leiden 1965) spec. 'Ter inleiding' p. 5 – 9; 'Introduction' p. 11 – 15.

A.K. Offenberg, 'Spinoza's library. The Story of a Reconstruction', *Quærendo. A Quarterly Journal from the Low Countries Devoted to Manuscripts and Printed Books* 3 (1973) p. 309 – 321.

48
'The Lehren /De Lima sale'
Lies Kruijer-Poesiat

NOTES

[1] Mordechai Eliav, 'R. Akiva Lehren: The Man and his Work' in: J. Michman, ed. *Dutch Jewish History* 2 (Jerusalem etc. 1989) p. 207-217.

49
'Jewish book-plates in the Netherlands'
Philip van Praag

READING

Sigmund Seeligmann, 'Joodsche Boekmerken', *De Vrijdag-avond. Joodsch Weekblad* 1/1 (1924) p. 309 – 311.

A. M. Habermann, *Jewish Bookplates (Ex libris)* (Safed 1956) . .
(in Hebrew).

Philip Goodman, 'Jewish Bookplates of Dutch Interest' in:
his *Illustrated Essays on Jewish Bookplates* (New York 1971)
p. 157 – 169.

H. Boas, 'Amsterdams-joodse ex-libris' in: her *Herlevend Bewaard. Aren lezen in joods Amsterdam* (Amsterdam 1987)
p. 20 – 30.

Ph. van Praag, *Joodse symboliek op Nederlandse exlibris* (Zutphen 1988).

50
'Traditional Amsterdam synagogue melodies'
Hans Bloemendal

READING

Hans Bloemendal, *Amsterdams Chazzanoet. Amsterdam Chazzanut.* Ed. by Joppe Poolman van Beusekom. 2 vols. (Buren 1990).

51
'Emanuel Querido and his publishing house'
Lotte Hellinga-Querido

READING

A. L. Sötemann, *Querido van 1915 tot 1990: een uitgeverij.* (Amsterdam 1990) (Jaarboek van Querido, no. 42).

F. H. Landshoff. *Amsterdam, Keizersgracht 333. Querido Verlag. Erinnerungen eines Verlegers.* Mit Briefen und Dokumenten. Auswahl der Briefe und Fotos: Isolde Schloesser. Anmerkungen, Bibliographie, Auswahl der Abbildungen im Text und Register: Christa Streller (Berlin 1991).

52
'The return of the Bibliotheca Rosenthaliana—but not without damage'
F. J. Hoogewoud

NOTES

[1] USA, National Archives, Suitland,
RG 94: box no. 6779 (305-2.2, 1 – 12 April 1945).
[2] With acknowledgments to J. Lenselink of the Army Museum, Delft.

READING

H. de la Fontaine Verwey, 'De Bibliotheca Rosenthaliana tijdens de bezetting', *Studia Rosenthaliana* 14 (1980) p. 121 – 127 (repr. in: his *De verdwenen antiquaar en andere herinneringen van een bibliothecaris* (Amsterdam 1993) p. 85 – 94).

F. J. Hoogewoud, 'The Nazi Looting of Books and its American "Antithesis"', *Studia Rosenthaliana* 26 (1992) p. 158 – 192.

53
'An ambitious publication of the Quid Novum Press'
Albert van der Heide

READING

A. van der Heide, '"Defus Mah Chadash". Defus perati 'ivri be-Holland', *Mahut* 1 (6) (1989) p. 160 – 165 (lists the Hebrew production of the press between 1972 and 1985).

A. van der Heide, 'Selomoh de Oliveyra: *Ayelet Ahavim*. Een zeventiende-eeuwse bewerking van het verhaal van Abrahams offer' in: L. Dasberg & J. N. Cohen, eds., *Neveh Ya'akov. Jubilee Volume Presented to Dr. Jaap Meijer* (Assen 1982) p. 207 – 242.

J. A. Brombacher, *Handen Vol Olijven. De Poëzie van Salomoh d'Oliveyra, rabbijn en leraar van de Portugese Natie te Amsterdam* (Leiden 1991) (Diss.).

54
'Recent limited editions of the poetry of Saul van Messel'
Henriëtte Boas

NOTE

[1] The text of the ballad 'Groningen-Gassiedisch' was reprinted with a black and white reproduction of a print by H. Werkman in his *Voorbijganger. Late gedichten* (Oosterwold 1989).

READING

A. K. Offenberg, 'Bibliografie van het afzonderlijk verschenen dichtwerk van Saul van Messel' in: Pieter Jonker *et al.*, *Hou vremd ik blief. Saul van Messel, joods dichter in het Nedersaksisch* (Oosterwolde 1985) p. 61 – 72.

Index of names